Selling Your Photography

Other books by TAD CRAWFORD:

Legal Guide for the Visual Artist

The Writer's Legal Guide

Edited by ARIE KOPELMAN:

ASMP Guide to Professional Business Practices in Photography

ARIE KOPELMAN and TAD CRAWFORD

Selling
Your
Photography

The Complete Marketing, Business, and Legal Guide

ST. MARTIN'S PRESS • New York

To Ruth, Ben, George and Maureen
for the many years together,
with love
A.K.

For my wife Lee, and my family, with love
T.C.

Library of Congress Cataloging in Publication Data

Crawford, Tad, 1946-
 Selling your photography.

 1. Photography—Business methods. 2. Photographs—
Marketing. I. Kopelman, Arie, joint author. II. Title.
TR581.C72 770'.68 80-14720
ISBN 0-312-71255-3

Manufactured in the United States of America

Summary Contents

Complete Contents

Introduction: How to Use This Book

THIS BOOK CONTAINS three separate guides in one volume: A *Marketing Guide,* a *Business Guide,* and a *Legal Guide.* Selling and marketing are emphasized in the first section, with good reason. You must have a steady flow of jobs or stock photo (file) sales to succeed on any level—from full or part-time professional to beginner or student just getting started. The business guidance and legal protection outlined in the last two sections are crucial to your continued achievement in the field as either experienced professional or accomplished amateur supplementing other income.

The marketing strategies and data in Part I are unique; they have never before been digested in book form. Nevertheless, they include the widely respected approaches of sóme of today's most successful photographers, studios, and stock photo agencies. The business and legal sections cover virtually everything you need to know about contracts, pricing, taxes, copyrights, starting a business, and invasion of privacy and other legal risks.

In addition, throughout the book you will find some of the most easily understood standard business forms ever published, to protect you in situations involving commercial and editorial assignments, estimates, invoices, portrait and other jobs, model releases and stock photo sales and submissions.

The *Marketing Guide* confronts the most basic questions that a photographer must deal with: Where are my markets? How can I reach them effectively? What techniques can I use to promote myself and my work effectively?

In reply, we start by evaluating *all* the major markets (there are over a dozen) and describe the numerous photographic specialties (there are nearly two dozen). For each market we provide the basic

tool or market guide that will lead you to the clients in that field. Each market has its own guide—no single "photographer's guide" published anywhere in the world contains more than a small fraction of the names and addresses in *each* of the nearly 30 guides discussed in our text.

We cover photography assignments and stock sales from your existing picture files, with considerable emphasis on markets you (and many others) may not have previously considered.

Much attention is given to the use of direct-mail promotions of your work and how these can be executed efficiently and inexpensively.

The last chapter in the *Marketing Guide* describes the functions of agents and galleries for selling photos or prints and securing assignments. We discuss where the agents and galleries can be found and how to handle your contracts with them.

The *Business Guide* starts with pricing (jobs and stock photos) and billing expenses. This data is critical because you must charge enough to cover costs but you can't price yourself out of the market. We show you an easy-to-use method for calculating the price you need to charge on each job to cover overhead expenses and assure your own required profit level. The range of going rates is then presented for virtually all types of professional work, depending on the use, the media in which it will appear, and the size of the market. Negotiation tactics are also covered.

In the contracts chapter we focus first on simple letters that you can write and use as agreements. We then move on to the more complex assignment, licensing, stock photo and royalty agreements, including book contracts. Most importantly you are provided with simplified but highly protective standard forms to use in connection with your day-to-day jobs and studio work, or when submitting and selling photos from your stock files. Throughout the chapter, and in using the forms, you will learn how to protect yourself on all basic issues, including fees, use rates, travel time, weather days, cancellations, postponements, expense reimbursement, advances, client usage rights, ownership of originals, and credit lines.

The chapter on taxes explains the kinds of deductions you can take as a full-time or part-time professional, or as a beginner. We also review the steps you *must* take to secure a deduction for the expenses of your "office at home." For the beginner and part-timer especially, we explain the rules for taking deductions from your regular income as a result of "losses" you incur from your fledgling photographic activities.

Other chapters in the *Business Guide* show you how to get your business started, what records and reports you need to keep or file with the IRS to stay out of difficulty, tax advantages of various forms of business (including incorporation), what to look for when signing a lease, how to deal with sales taxes, and techniques for organizing your files to increase stock photo sales.

In a separate chapter we take much of the mystery out of personal and business insurance. You will learn how to protect your property *and your income,* and the methods used to minimize insurance cost while maximizing coverage.

In the *Legal Guide,* we deal with the major legal problems confronting photographers. The foremost area is copyright, which, simply defined, is the exclusive right of reproduction. We explain how federal law works to protect your copyright ownership, when and exactly how to register your copyright (including a step-by-step explanation of government forms), and the techniques for registering many photos for a single $10 fee. Also covered is the operation of the notorious "work for hire" agreements, how to sell only a portion of your copyright, the proper form for copyright notices, and exactly where the notice must be placed.

The chapters on invasion of privacy and "beyond privacy" deal with some of the gravest legal risks facing photographers. Lawsuits for tens of thousands of dollars (and more) have been brought against photographers when their photographs were improperly used without a release. Explained clearly, perhaps for the first time in a book for photographers, are the specific situations in which a photograph's use may be invading someone's privacy, whether the photographs are taken in public or in private places, in connection with either public figures or lesser-known individuals. Also covered are the legal dangers involved with photographs of other peoples' property and animals, and the potential risks of libel and misappropriating a celebrity's right of publicity. Easy-to-use model release forms complete the discussion in this field.

The final chapter explains what to look for and where to go for assistance in choosing a lawyer (including places where you may find a volunteer lawyer). Tips on using small claims courts and collection agencies are also included.

Following the main text are two appendices. The first summarizes the most innovative techniques now being employed to secure grants. The second is a handy guide to the many organizations of professional photographers, covering a wide variety of specialties.

When you have absorbed most of this material you may well

conclude that selling photography at any level requires a serious understanding of the business. While it may seem to be a complex business at first, it is also a challenging field full of promise and considerable opportunity. For this reason we hope that the chapters that follow will serve to clarify and simplify for you matters that might otherwise remain bewildering and obscure, if not altogether impenetrable.

PART I

Marketing Guide

CHAPTER 1

Finding Assignment Markets and Clients

SELLING PICTURES or photographic services is like selling anything else. It requires time, talent, energy, and a knowledge of where the markets are. Unless you are famous you cannot expect the market to come to you. You must seek it out. This chapter will guide you to the markets and will tell you what they expect.

The photographic markets are huge but largely hidden. The published material you see every day gracing newsstands, billboards, book stores and the like represents only a tiny fraction of your actual sales potential.

Given the range of possibilities, your marketing strategy becomes critical. An art director recently provided a gathering of younger photographers and artists with the key considerations:

> I just want to know what you do best—your distinctive style, taste level, or specialties. I'm looking for the right person for each type or style of work I have to produce. Your versatility is not my big concern.

That attitude dominates client thinking in major media towns such as Chicago, Los Angeles, and New York. It is also an influence (though less so) in smaller cities wherever a fair amount of commercial work is shot. Even customers of local portrait studios seek specific samples for specialty markets, such as weddings, model portfolios, schools, children, babies, or the like.

These conditions require you to emphasize specialized skills in your marketing efforts. To accomplish this you must be familiar with

the range of photographic specialties and the markets they serve, as provided in the table that follows.

This chapter then turns to finding clients and shows you how to identify specific buyers for markets mentioned in the table. Chapter 2, *Beyond Assignments,* covers the market for your existing file (or stock) photos and how you can reach many of the often-overlooked clients in that field. Chapter 3, *Marketing Tools and Techniques,* describes the sales ammunition you will need and how to use it. Chapter 4 completes the Sales and Marketing section with a discussion of how agents and galleries can supplement your marketing efforts.

Photographic Specialties and Their Markets, Summarized

Specialty	*Subspecialties and Market Summary*
ADVERTISING	Still life (food, products, and so on, illustration, fashion and beauty, catalogs, vehicles). Top pay, top overhead, very demanding. The work is primarily for ad agencies, also directly for companies and occasionally for designers, record companies, and publishers.
AERIAL	High pay, high skill, high risk; broadly marketable material for stock files.
ARCHITECTURAL	Exteriors, interiors; large-format-camera work. Sometimes applied to home furnishings advertising. Primarily for architects, builders, home furnishings publications, company facilities promotion, and chambers of commerce.
ART/ACADEMIC	Teaching, grant support, and fine print and portfolio sales. Limited field. Teaching aside, few make it on a full-time basis. "Art" side rather elitist. Part-time teaching is common among professionals, however.
AUDIOVISUAL (AV)	Usually documentary-style for trade slide shows and educational film strips; ranges from resort and travel to company facilities coverage and all other documentary subjects (see *Documentary* below).
CORPORATE *(SEE INDUSTRIAL)*	
DOCUMENTARY	Many subspecialties, such as animals, nature/outdoor (may be called *environmental*) marine/underwater, sports, and theatrical. Primarily

Specialty	Subspecialties and Market Summary
	editorial (publishing market). Vast use as stock sale material.
FASHION AND BEAUTY	The glamour biz, editorial for "women's service" magazines, advertising, and sometimes celebrity portraiture. Bread and butter of the field, however, is catalogs and brochures.
ILLUSTRATION	Depiction of client's "concept." Usually based on ad, album cover or book jacket layout, or magazine story. Generally involves people in preconceived situations.
INDUSTRIAL	Annual reports, company brochures, in-house publications, slide shows, AV productions. Sometimes "industrial journalism" in style, but pay is better than journalistic fields. Assignments come from companies directly and from many design firms. Major corporations often have versatile full-time staffers.
INSTITUTIONAL	Industrial-type documentary work primarily for nonprofit organizations such as hospitals, universities, and foundations. Often overlooked field, usually for fund-raising brochures, AV, other educational materials, and student recruitment. Pay is between journalism and industrial.
LEGAL/INSURANCE	Personal injury, auto, fire, and other claims work; also documentation of art and other collectibles.
MILITARY	Emphasis on versatility; where many presently established pros obtained their initial training years ago.
MOTION PICTURE/ TELEVISION	Natural extension for many still photographers, especially in growing areas of television commercials and industrial film making, working both as directors and director-producers. These markets are beyond the scope of this book.
PHOTOJOURNALISM/ NEWS	"Hard news" coverage, for newspapers—primarily by full-time staffers, and for magazines—primarily by freelancers. The field is both news event and celebrity-oriented, for

Specialty	Subspecialties and Market Summary
	both single shots and picture stories. Highest incomes usually derived from worldwide syndication and use of material in stock files. Otherwise, a tough struggle solely on freelance basis.
PORTRAIT AND WEDDING	Classic family and personal portrait studio, seemingly one in every community. Portfolio for weddings and other family events. May include passports and model portfolios. Subspecialties include children's and babies' portraits. Top of the field may involve celebrity portraits at high rates. Some overlap with school photography.
SCHOOL	High schools and colleges, primarily for yearbooks. Frequently dependent on student orders of personal portraits to succeed financially. Overlap with portrait and wedding work (and possibly institutional).
SCIENTIFIC/ PHARMACEUTICAL	Complex and demanding work; often involves special effects and macrophotography techniques. Clients are in drug and medical fields, or magazines and ad agencies serving them. Highly technical, highly rewarding.
SPECIAL EFFECTS	Stroboscopic motion, multiple image (photo montage), computer graphics and solorization. Highly technical (as with scientific). Markets are in all major fields (advertising, editorial, and industrial). Fees are high and opportunities fairly broad, but chances of learning the techniques are modest for beginners.
STILL LIFE	Usually large format (4 x 5 and 8 x 10) specialists for advertising, catalogs (soft goods and hard goods), general product work and "service" magazines (food and interiors). At the top this may be the industry's highest-paid specialty. A major subspecialty is the food field.
TOURISM AND TRAVEL	A branch of documentary work, but largely oriented to the travel industry (hotels, airlines) and publications in that field. Frequently combined with some writing. Vast potential for building marketable stock files.

Specialty	Subspecialties and Market Summary
WRITER- PHOTOGRAPHER	Use of writing (extended captions, short travel pieces) to accompany and aid in marketing of photos. Major potential may be in travel field and in authorship of "how to" books about photography techniques.

The approach below is necessarily organized market by market. You need not, however, be that mechanical in your own selling.

For example, several years ago a photographer graduated from school with no clients, no job, and very little money. He did, however, have a strong and very distinct visual style. He carefully went through all the trade publications and annual award books in the advertising and editorial fields (see pages 50–56), seeking samples relating to his style and, thereby, the names of art directors who might respond to his work.

He culled only 200 names and thereafter pooled his modest resources to print several hundred copies each of two nicely illustrated cards. These were sent to the people he had on his list. Within a few months he was working regularly. The story is unusual only in that recent graduates generally require a year or two (and often longer) to develop a clearly defined visual style in their work.

A parallel case may be closer to home for some readers. A part-time professional had developed great ease and facility in photographing children and wished to expand commercially. She searched through an array of local and regional magazines, newspapers, retailing catalogs, and brochures, pulling out advertisements and samples that featured children. She called virtually all these advertisers, got the names of the various ad agencies and in-house corporate art directors involved, and arranged for appointments whenever possible or sent illustrated card samples in other cases.

She had reasoned, correctly, that children's themes struck a special note with these people. Her work with children was, in fact, excellent enough to secure several assignments from this initial marketing effort. As a result, she soon emerged as a full-time professional. Needless to say, this technique could be applied to any area of photographic specialization that you have developed.

You should keep such creative uses of the information provided below in mind, as we proceed to describe the various markets and how you can reach the individual clients in each field.

National and Regional Markets

The names of clients or buyers in most photographic markets are readily available if you know where to look. They are identified, at least by company name and often by individual contact, in specialized trade directories each covering one particular industry (advertising, audiovisual, magazine publishing, book publishing, public relations, and so on).

No single reference can possibly provide the necessary information for all those industries together, since there are thousands of firms and potential clients in *each* field. The few so-called marketing or sales guides in photography that claim to have all this information in one volume are frequently dated or strikingly incomplete.

The sections that follow show, market by market, the sources of information you need for your business, where to find them, and how to use them.

It will take some effort and perhaps expense on your part to secure this information, but it will definitely be worth it. If you are willing to spend many hundreds or thousands of dollars on your equipment, you must be prepared to allocate a small percentage of that money to securing material that will give you a head start in selling what the equipment produces. Many fine photographers who refuse to make a serious marketing effort fail in business. Others with less talent for pictures than for business have been known to succeed. For some these consequences may be dismaying; for others the lesson is clear.

ADVERTISING AGENCIES

In every market—national, regional, and local—the work of illustrating print advertisements created primarily by ad agencies is one of the best paid, though most highly competitive, photographic fields.

While the advertising business is centered in New York City, there are over 2,700 ad agencies throughout the United States, including many hundreds in each region of the country.

Indeed, some of the largest agencies are headquartered in Chicago. Regional centers for the field are in Atlanta, Boston, Dallas, Houston, Los Angeles, Philadelphia, San Francisco, St. Louis, and other major cities.

Two-thirds of the 2,700 recognized agencies in the United States each have annual billings in excess of $1 million. That is, their clients paid the agency at least that amount in the past year for fees,

advertising space purchased (in magazines, newspapers, and other publications), and/or television or radio time purchased as well as production and preparation costs for the ads involved.

Your Best Guide to This Market Is:

STANDARD DIRECTORY OF ADVERTISING AGENCIES ("The Advertising Red Book"). Published by the National Register Publishing Company, 5201 Old Orchard Road, Skokie, Illinois 60077, telephone (312) 470-3100.

This book is available in most business and reference libraries. Single copies are $47 from the publisher. While the book is updated three times each year, you only need one copy to begin building your mailing and contact list. You will probably make most changes on the list from information you personally develop in phone calls and agency visits. Thus, if you buy the book for the convenience of using it in your own place of business, it will probably only result in the one-time charge of $47.

In this guide look for:
1. Alphabetic listing of over 3,000 agencies with addresses and telephone numbers (plus 1,000 foreign agencies).
2. Geographic cross-reference by state and city enabling you to pick up needed data about all agencies in your region and permitting you to cast the net as widely as you require.
3. Name of senior art director in many (but definitely not all) cases. The remainder of the art buying staff is rarely named. The latter is a minor shortcoming, since you usually must call for an appointment anyway and you can check for the correct name or names at that time with a secretary or receptionist. Of course in large agencies there may be a dozen or more art directors to see. In addition, sometimes a single "art buyer" in those agencies will be in charge of having portfolios reviewed by the rest of the art department.
4. A listing of agency clients and specific accounts. This is an important tip-off to direct you in what work to show the agency and whom to ask for when telephoning the agency for an appointment. For example, you may want to ask for the art director on an account that is likely to use photography of a type that you may specialize in, such as fashion, food, or industrial, depending upon the listing of accounts provided in this book.
5. Gross billings. The size of the agency given by these dollar

amounts may indicate financial stability; it may also indicate the value of your marketing effort. You will find that the larger agencies usually have the most work and, further, the greatest competition for that work. The gross billings information frequently indicates the percentage of those billings devoted to print media (as opposed to television or radio). The larger agencies usually spend 60 to 80 percent or more on television, but the gross dollar amount left over for print is still very substantial. Smaller agencies often spend higher percentages in the print media than in television, but the dollar amounts including photographic and other production costs may be modest.

6. Agencies in five specialized fields. Five specialties and the agencies in those fields are listed at the front of this book. The specialties are: catalogue and direct mail (85 names); financial (27 names); medical (48 names); minorities including black and Hispanic (31 names); resort and travel (41 names).

Madison Avenue Handbook, as a supplementary reference, lists by name a significant number of the art directors and buyers at over 200 agencies in New York City, 100 in Chicago, over 50 each in Atlanta, Boston, and Los Angeles, and several dozen more in Dallas, Detroit, and Houston. It is available in many business libraries or for $13.95 from the publisher, Peter Glenn Publications, 17 East 48 St., New York, New York 10017, telephone (212) 688-7940.

AUDIOVISUAL PRODUCERS

The rapid growth of the audiovisual field is immense but rarely appreciated. The 35mm audiovisual slide market increased from $168 million in 1968 to $1.9 billion in 1978; that is a 1600 percent increase in a decade.

Approximately one-half the work in this field is in graphics and text, but the balance is still enormous and is largely a photographic market. Further growth is projected because educational, governmental, and corporate users find the audiovisual medium an exceptionally economical format when compared to film or tape.

Some still photographers are themselves producers of the entire audiovisual package from script to finished product. Others simply shoot the stills for the various producers in this field.

Your Best Guide to This Market Is:

AUDIO-ViSUAL MARKET PLACE, published annually by R. R. Bowker, 1180 Avenue of the Americas, New York, New York 10036, telephone (212) 764-5100; available in many business, reference and educational libraries, or for $29.95 from the publisher.

In this guide look for:
1. Listing of 500 firms (alphabetically and by state) that produce for their own accounts (often hiring or buying services or stock photos from others).
2. Listing of 400 production companies (alphabetically and by state) that produce under contract to others (many production companies hire still photographers and/or buy rights to stock photos).
3. For each of the listings indicated above, note the ratio of filmstrip and slide show work to other production (such as motion picture or sound cassette). Most firms provide this directory with that data, thereby giving a clear indication of their potential for the still photographer.

BOOK PUBLISHERS

Book publishers require a certain amount of photography for hardcover book jackets and paperback covers. There are nearly 50,000 new titles published every year, and the jackets and covers are seen as important tools in the struggle for "visibility" and book sales. In addition, textbook publishers can occasionally be a source for documentary assignments. Finally, encyclopedia and textbook publishers together constitute one of the most important markets for stock photo usage.

Your Best Guide to This Market Is:

LITERARY MARKET PLACE; published annually by R. R. Bowker, 1180 Avenue of the Americas, New York, New York 10036, telephone (212) 764-5100; available in virtually all library reference sections, or for $26.95 from the publisher.

In this guide look for:
1. Alphabetic listings of over 2,000 publishers and their primary publishing specialty categories.

2. Geographic breakdown (by state) indicating publishers in your area that would be accessible for a personal visit.
3. Art directors' names, which are frequently included in the alphabetical listings of publishers. Art directors are the people who are usually responsible for assigning book covers or jacket photography and handling requests for stock photo submissions.
4. The number of titles published in the prior year by each publisher. This is a key determinant of whether the time spent in visiting or otherwise contacting this company would be potentially productive.

COLLEGES AND UNIVERSITIES

Work in this field usually involves documentation of campus life for catalogs, brochures, student recruitment, alumni bulletins, and the like.

The further off the beaten track you go, the less likely you are to face a hoard of competitors, especially in this field. In most cases, the person to see at a college or university is the publications or public relations director. Many campuses also have a development or funding office that could be interested in professional quality documentation of important projects.

There are a number of standard directories covering the 2,000 American colleges and universities. They are invariably broken down by state, and this is critical because you will want to schedule trips so that you can visit at least two or three campuses in a single day. Obviously it makes sense to call in advance for an appointment, since scheduling is such a critical factor in making the most effective use of your marketing time.

Among the standard references are:

AMERICAN UNIVERSITIES AND COLLEGES, published by the American Council on Education, 1 Dupont Circle, Washington, D. C. 20036.

EDUCATION DIRECTORY; COLLEGES AND UNIVERSITIES, published by the National Center for Education Statistics, United States Department of Education, Superintendent of Documents, U.S. Government Printing Office, Publications Department, Washington, D. C. 20402 (Stock #017-080-02011-4, $6.25 per copy).

If these two standard references are not available in your local library, it is virtually certain that the reference room will have some other equally authoritative source for this information.

CORPORATIONS

Photographic work directly for corporate clients may consist of material prepared for advertising, public relations, annual reports, and a vast array of other corporate communications. There are two primary and quite distinct markets involved in this area. Many companies handle a significant proportion of their advertising program directly, rather than through advertising agencies. The officer you want to reach for this is the advertising manager. Equally significant, many companies prepare a broad range of illustrated corporate material such as brochures, press releases, annual reports, and recruitment publications through the public relations or corporate communications office.

Your Best Guides to This Market Are:

O'DWYER'S DIRECTORY OF CORPORATE COMMUNI-CATIONS, published annually by J. R. O'Dwyer Co., Inc., 271 Madison Avenue, New York, New York 10016, telephone (212) 679-2471; available in business and some reference libraries or for $60 per copy from the publisher.

In this guide look for:
1. A basic listing of public relations executives at over 2,000 companies and 300 major trade associations.
2. A geographic breakdown detailing companies in your area and whom to see within those companies.
3. A listing of investor relations officers (who may have responsibility for producing annual reports) and employee communication officers (who may be responsible for producing house organs).
4. A breakdown into 37 industry groups of all the companies listed in the directory (for example, among the industries covered are drugs, transportation, leisure time, and of course many others that may relate to your own specialties in photography).

STANDARD DIRECTORY OF ADVERTISERS, published by the National Register Publishing Company, Inc., 5201 Old Orchard Road, Skokie, Illinois 60077, telephone (312) 470-3100; available in reference and business libraries, or for $99 per single copy from the publisher. The separate "classified" edition is also $99. The classified edition provides an industry-by-industry breakdown of the companies named.

In this guide look for:

1. An alphabetic and geographic breakdown of 7,000 companies that advertise with the key advertising and public relations personnel indicated.
2. A special classified version, which can be more valuable because it provides the same names broken down into 51 separate business categories such as transportation, sports, hotels, and amusement and entertainment to dovetail with whatever specialty you bring to the marketplace.

GRAPHIC DESIGNERS

Graphic designers have recently become a key client group for photographers. They produce, under contract, the annual reports, brochures, and other publications of many corporations, large and small. As a result, they are constantly hiring photographers who work in the corporate-industrial field and other specialists where the needs arise.

Your Best Guides to This Market Are:

MEMBERSHIP DIRECTORY OF THE AMERICAN INSTITUTE OF GRAPHIC ARTS (AIGA), to be published by AIGA, 1059 Third Avenue, New York, New York 10021, telephone (212) PL2-0813. A large number of the leading graphic designers are members of AIGA, and this directory, when and if available, will indicate which among the approximately 2,000 members of AIGA work in the graphic design field (some 50 percent do). The directory is currently in preparation and is likely to be available to members only (though a limited number *may* be placed on sale). Membership is, however, open to photographers who may benefit as well from the AIGA's exhibit and other activities. Membership costs $100 per year if you are within a 100 mile radius of New York City and $50 per year otherwise.

PHOTOGRAPHY MARKET PLACE, second edition, by Fred W. McDarrah, editor, published in 1977 by R. R. Bowker, 1180 Avenue of the Americas, New York, New York 10036, telephone (212) 764-5100. This book is not easy to find, although it may be in some reference libraries or some other collections. It is available at a cost of $15.50 from the publisher and is currently in print. The book lists 163 major designers on pages 92–102. This is a small but significant portion of those active in the field. Though prepared

several years ago and therefore in need of some updating, it remains basically accurate though not nearly as extensive as the AIGA membership directory.

THE BEST EVER. A catalog of the Mead Library of Ideas— International Annual Report Exhibit. This catalog lists 15 to 20 annual winners of one of the top shows in the graphic design field. It includes the designers' names and the addresses of their firms and shows samples of pages from the prize-winning reports. The catalog is available free of charge from Mead Library of Ideas, World Head-quarters, Courthouse Plaza Northeast, Dayton, Ohio 45463, tele-phone (513) 222-6323. Mead, of course, is one of the major manufacturers of quality papers in the country. If you can secure catalogs for the past few years, you will have an excellent list of several dozen or more top designers. If Mead is out of stock you might try the libraries of major photography or art schools, or trade associations active in the design field.

AMERICAN SHOWCASE. This is a book that photographers, illustrators, and designers purchase space in for illustrated self-promotion. Each section includes a listing of professionals in the field. The section on designers lists approximately 1,000 designers and their telephone numbers. Unfortunately, it does not list addresses. None-theless, from the area codes you can spot the designers in your area and contact them by phone or look up the addresses yourself for a mailing.

American Showcase is sold in some bookstores (usually in the art sections) and by the publisher: American Showcase, Room 1929, 30 Rockefeller Plaza, New York, New York 10020; telephone (212) 245-0981 ($25 in soft cover).

L.A. WORK BOOK. This is a communications-industry hand-book for the Los Angeles area listing the names, addresses, and telephone numbers of nearly 1,000 designers in the Los Angeles area. It is available for $18 from Alexis Scott, publisher, 6140 Lindenhurst Ave., Los Angeles, California 90048, (213) 657-8707.

HOUSE ORGANS (COMPANY PUBLICATIONS)

You never see most of these house organ publications, but there are literally thousands of them. Many are slick and extremely professional, comparable to major consumer magazines. Others are rather modest affairs, to say the least. A great many of these publications hire photographers on a freelance basis, and the ones with the highest circulations tend to pay on a level comparable to the

sums paid by consumer magazines, and in a few cases even more than that.

Your Best Guide to This Market Is:

WORKING PRESS OF THE NATION, VOLUME V: INTERNAL PUBLICATIONS DIRECTORY, published annually by the National Research Bureau, 424 North Third Street, Burlington, Iowa 52601, telephone (800) 553-2345; available in library reference sections, business libraries or for $71 from the publisher.

In this guide look for:
1. Basic alphabetical list (with addresses but not telephone numbers or personnel) of the publications of several thousand companies, clubs, government agencies, and other groups.
2. The industrial categories cross-reference, which pinpoints publications related to your work specialty.
3. Circulation cross-reference, which pinpoints the publications with the largest circulations (usually the better-paying markets). Some 1,600 publications are below 10,000 circulation and would probably be less attractive markets than the 600 publications with circulations between 10,000 and 50,000 or, most significantly, the 100 with circulations from 50,000 to 100,000, and the additional 150 house organs that have circulations exceeding 100,000.

The significance of this market should not be underestimated. That latter group of 150 company publications with over 100,000 circulation is nearly as large, in number, as the entire group of well-known general-circulation publications currently published in the United States and sold on newsstands.

An indirect source for this market would also be the corporate communications officers named in the *O'Dwyer's Directory of Corporate Communications,* listed above under the section entitled "Corporations." In addition, some 100 of the more widely circulated house organs are mentioned in *Photography Market Place, Second Edition* (for publisher information and availability see the listing of this book under "Graphic Designers" above).

INDUSTRIAL COMPANIES (SEE "CORPORATIONS" ABOVE)

MAGAZINES (CONSUMER AND TRADE)

For corporate in-house magazines see "House Organs" above. The remainder of the magazine field consists of three elements: (1) consumer magazines, including regional and Sunday supplements, (2) business (trade) magazines, and (3) foreign publications.

The consumer magazines represent the smallest element of the magazine market, though this may be the best-paying group for a modest number of well-established professionals. These, of course, are primarily the newsstand publications covering such subjects as fashion, news, shelter, sports, men's interests, women's service, and regionals. Business (trade) magazines are usually aimed at a single professional, trade, or industrial group and are most frequently distributed exclusively by mail to qualified professionals in that field, often free of charge (this is generally referred to as "controlled circulation").

Foreign publications can be classified under both the consumer and the trade groups, but contacting them presents special problems. A number of the largest and better-paying foreign consumer magazines have New York City editorial offices through which they may be approached—in addition, naturally, to their home base locations for which a reference will be provided below.

Your Best Guides to This Market Are:

GEBBIE PRESS ALL-IN-ONE DIRECTORY: Published by Gebbie Press, Box 1000, New Paltz, New York 12561, telephone (914) 255-7560; available in reference and business libraries or for $40 from the publisher.

In this guide look for:
1. Names, addresses, circulation figures, and brief description of target audience for over 7,500 American consumer and trade publications (no phone numbers).
2. Breakdown of all these magazines into 200 well-defined categories that should line up well with photographic specialties. Among the categories are: Airline travel, architecture, auto, clothing and fashion, drugs and pharmaceutical, farming, financial, home furnishings, music, sports, tourism, and women.
3. Separate listings of newspaper-distributed magazines (19, of

which nine are over 1 million in circulation), daily and weekly newspapers listed by state and city (with addresses and circulation figures), and the major news and feature syndicates.

While the information in Gebbie's is not as comprehensive as the information in the two directories published by the Standard Rate and Data Service which follow, the format is much easier to use, and the information should be adequate for most photographers. In addition, Gebbie's breakdown of the domestic magazine market into 200 categories appears to be the most useful presentation available for matching photographers' specialized interests with existing magazine specialties. After finding the publications that relate to the work you do, you can contact them to determine what specific needs they may have. Bear in mind, however, that a major drawback of Gebbie's is that the book does not list phone numbers, thereby limiting you primarily to mail inquiries.

CONSUMER MAGAZINE AND FARM PUBLICATIONS: published by Standard Rate and Data Service; 5201 Old Orchard Road, Skokie, Illinois 60077, telephone (312) 470-3100; available in reference and business libraries or for $45 for the single annual volume (without updates) from the publisher.

In this guide look for:
1. Names, addresses, and telephone numbers for 1,400 consumer magazines, large and small, general circulation and specialized.
2. Circulation and advertising space rates for all magazines listed in the book. Advertising agencies rely on the book for this information in order to establish their print advertising budgets. You will find it tells you how successful the publication actually is in relation to others, and where they should be in the scale of payments to photographers, based on those numbers.
3. General editorial policy—usually a simple publisher's statement.
4. Most importantly, 51 separate categories of magazines from "Airlines" to "Youth" so that you can key your marketing effort closely to your own specialties and interests.

This book does not list art directors or picture buyers and does not discuss picture-buying policy. You can secure that data easily, once you have selected the magazines in the guide that tie in well with your specialties.

You should also notice that within each category of magazine there are two groups listed: "Audited" and "Unaudited." The

audited magazines are those whose circulation claims are verified by independent checking services. This serves as an assurance to advertisers of the validity of the publisher's claims. For photographers it also indicates which magazines are likely to be the better-paying publications (obviously those in the audited group).

BUSINESS PUBLICATIONS, published by Standard Rate and Data Service, 5201 Old Orchard Road, Skokie, Illinois 60077, telephone (312) 470-3100; available in reference and business libraries or for $45 from the publisher for the main annual volume (without monthly updates).

In this guide look for:
1. Names, addresses, and telephone numbers for approximately 4,000 business and trade publications.
2. Separation of all listings into 159 categories that will match well with photographers' special interests.
3. Circulation and advertising rate figures that provide a reasonable clue to the capacity to pay for photographic contributions.
4. A modest-size international section covering some 200 foreign publications in approximately 40 categories.

This is the most complete and up-to-date listing in the industry. Once you have selected the magazines that relate to your special interests, the data you require regarding picture policy and people to deal with can easily be secured on the telephone. In selecting magazines to contact, bear in mind that audited publications, those that have their circulation figures independently verified, are more likely to be a better market than unaudited publications.

ULRICH'S INTERNATIONAL PERIODICALS DIRECTORY, published annually by R. R. Bowker, 1180 Avenue of the America, New York, New York 10036, telephone (212) 764-5100; available in some reference and business libraries or for $64.50 from the publisher.

This book is truly for the lionhearted. It covers some 60,000 periodicals worldwide in over 1,000 specific subject headings.

The value of the book is in its subject headings. They are so specific that, if you have specialized material, you can easily determine whom to contact abroad. For most of the publications listed, circulation figures are provided. Many, of course, are extremely low-circulation publications. You can be sure that if the circulation is only a few thousand, the likelihood of a significant payment is remote.

Thus, start out by contacting only the large-circulation periodicals in the categories that specifically relate to your kind of work.

A number of the largest foreign consumer publications also have New York City offices and frequently deal directly with United States photographers. Indeed, some of these magazines pay as much for photographs as their counterparts in the United States. The publications themselves are usually available from newsstand dealers who specialize in out-of-town or foreign periodicals. The name of the publication, if listed in the Manhattan telephone directory, may be found under the magazine's own logo name or that of its corporate parent. Both names, of course, are usually indicated in the publication's masthead, which may also provide the address of the New York City office.

Two other publications are worth noting:

Magazine Industry Marketplace '80 provides detailed listings on some 2,600 magazines, with the names of art directors specified for about 25 percent of them. Many of these magazines, however, are scholarly or technical; only about 500 are consumer publications and about 400 are trade publications. It is available in reference libraries or for $24.50 from the publisher R.R. Bowker, 1180 Avenue of the Americas, New York, New York 10036, telephone (212) 764-5100.

New York Publicity Outlets may be more useful because it lists the names of the art directors of some 300 major consumer magazines nationwide, together with the usual telephone numbers and addresses, and a breakdown into 15 specialty categories. It may be found in some reference libraries or for $47.50 from the publisher Public Relations Plus, Inc., P.O. Box 327, Washington Depot, Connecticut 06794, telephone (203) 868-0200. The $47.50 includes the annual volume plus an update in six months.

MUSIC AND RECORDING COMPANIES

The expansion of the music business in the 1970s produced many album cover and other promotional assignments for photographers.

Your Best Guide to This Market Is:

THE INTERNATIONAL BUYER'S GUIDE OF THE MUSIC-TAPE INDUSTRY. This book is published annually by Billboard Publications, 1515 Broadway, New York, New York 10036 or 9000 Sunset Blvd., Los Angeles, California 90069 ($35). It lists several thousand recording companies in the United States and abroad,

providing names, addresses, and telephone numbers. It does not list art buyers or picture buyers.

PHOTOGRAPHY MARKET PLACE, cited above under the subject of graphic designers, has a modest listing of some 100 of the largest recording companies including art directors and public relations people. Owing to its publication in 1977 it will definitely require some updating but remains useful.

NEWS SYNDICATES

The photographer who is fortunate enought to capture a major and exclusive news photo or picture story must exercise great care. Many often sell out to the first bidder, for an amount that is many times below actual market value. The key is to contact all relevant parties, to see if they are prepared to bid against each other. The major American news organizations which are in this market and distribute to newspapers are Associated Press (AP) and United Press International (UPI). They usually prefer to buy all rights, or at least all newspaper rights, and do not act as agents. On the magazine side, you could go directly to the magazines yourself, consider bids from AP and UPI, or use one of the major photojournalism agencies with domestic and foreign marketing capability such as Black Star-Sipa, Gamma or Sygma. They usually act as agents, paying a percentage of all reproduction fees, but occasionally purchase rights on their own, for subsequent resale. In general, magazines pay more for photographs of this nature than newspapers, but both markets can be approached simultaneously.

The headquarters of these organizations are as follows: Associated Press (AP), 50 Rockefeller Plaza, New York, New York 10020, (212) 262-4000; United Press International (UPI), 220 East 42 Street, New York, New York 10017, (212) 682-0400; Black Star-Sipa, 450 Park Avenue South, New York, New York 10016, (212) 679-3288; Gamma-Liaison, 150 East 58 Street, New York, New York 10022, (212) 888-7272; Sygma Photo News, 225 West 57 Street, New York, New York 10019, (212) 765-1820. AP and UPI have offices throughout the country, in every major city. Many are listed in the *Gebbie Press All in One Directory* described in the section on magazines, above.

Gebbie's also provides the names and addresses of numerous others news and feature syndicates. For references to additional agents, some of which specialize in photojournalism, see Chapter 4, which covers the subject of agents in detail.

PUBLIC RELATIONS FIRMS

A significant portion of corporate and other photographic portraits are commissioned by public relations firms on behalf of their corporate clients. These firms may also require documentation of corporate facilities, performances (theatre, dance, and film), and numerous other areas.

Your Best Guide to This Market Is:

O'DWYER'S DIRECTORY OF PUBLIC RELATIONS FIRMS, published annually by J. R. O'Dwyer Co., Inc., 271 Madison Avenue, New York, New York 10016, telephone (212) 679-2471; available in reference or business libraries or for $35 from the publisher.

In this guide look for:
1. An alphabetical list of 905 public relations firms throughout the United States.
2. A geographic cross-reference to identify firms in your own area.
3. A breakdown of these firms into 14 industry groups (such as fashion, beauty, entertainment, finance, food and health, and travel to key into your particular special abilities and interests.
4. The list of accounts for each firm as well as another cross-reference that lists 6,000 clients so that you can find the public relations firm for a company that you believe will have a special interest in your work.
5. The size of each public relations firm, indicated by the number of employees and fee income, so that you can determine whether or not your marketing effort is likely to be worthwhile.

SPECIAL RANDOM RESOURCES

American Showcase is a promotional book discussed in the section below concerning advertising and self promotion. Photographers who advertise in this book are permitted to mail promotion pieces to the entire list of 13,000 art directors, buyers and others who receive the book. In addition, the list can be used by nonadvertisers for a fee of $250 plus postage and handling (for up to 5,000 names).

The list is strongest in the advertising and corporate sectors, and you can limit your order to names from a specific geographic area and category (for example, advertising art buyers from the West Coast). The policies of the publisher are, of course, subject to change on the issue of list availability. The address is *American Showcase,* Suite

1929, 30 Rockefeller Plaza, New York, New York 10020, telephone (212) 245-0981.

The L.A. Work Book is a well-researched listing of art directors in advertising agencies and magazines, graphic designers, and others associated with the print and commercial photography media in the Los Angeles area. It also lists photographers, stylists, hair and makeup specialists, and reps. It is published by Alexis Scott, 6140 Lindenhurst Avenue, Los Angeles, California 90048, telephone (213) 657-8707 ($18).

The *Thomas Register* is the annually updated standard reference of American manufacturers. It should be available in virtually all reference and business libraries. The seven-volume set is probably too costly and cumbersome for photographic studios.

The book lists manufacturers in thousands of different industrial classifications, breaking them down by state and providing an indication of the size of each company listed. Many of the industrial classifications are consistent with photographic specialties. For example, the listing contains 500 pharmaceutical companies and 200 sporting goods companies. In addition, it also lists some firms in the novelty and decorative markets, including 78 poster companies and 87 greeting and postcard companies. The *Thomas Register* is strongest in listing manufacturing companies and somewhat weaker in areas relating to art and media services. Nonetheless, if you have an interest in a select few industries and want to reach the companies in those industries in a particular geographic area, these volumes can be most helpful.

Contact Book is an annually updated trade directory of the entertainment industry. It is particularly useful for locating motion picture, television production, concert management, theatrical production and recording companies. It is available for $8 from the publisher, Celebrity Service, Inc., 171 West 57 Street, New York, New York 10019, telephone (212) 757-7979.

The *World Travel Directory* provides an annually updated guide to certain segments of the travel industry. The main feature is a complete listing of travel agents and tour wholesalers. In addition, and most interesting for photographers, the back of the book contains a complete listing of the world's tourist bureaus, both for states within this country and for various foreign countries. These tourist bureaus will often lend support to, or become clients of, photographers engaged in projects that may encourage tourism in the areas involved. For example, you may find that a magazine is interested in a photographic piece concerning certain areas of the world or regions of

this country. However, the magazine may not be in a position to pay the necessary travel expenses. The tourist board may be able to arrange for free or reduced-rate transportation, plus room and board, if it feels the project is legitimate and will lead to sufficient coverage for its area. Usually such assistance will depend on the credentials of the photographer and the credibility of the publication involved. The directory is available from Ziff-Davis Publishing Co., 1 Park Avenue, New York, New York 10016, telephone (212) 725-3500 ($45) and is also found in many reference and business libraries.

The *Mail Order Business Directory* lists some 6,300 active mail-order and catalog houses by state. This is an important market for photographers because mail-order and catalog firms rely on the use of large amounts of product photography in the compilation of their brochures and other mail pieces. The book also indicates which among these companies are the 500 largest firms. The book is available in many reference and business libraries or can be ordered for $45 from the publisher, B. Klein Publications, P.O. Box 8503, Coral Springs, Florida 33065, telephone (305) 752-1708. The publisher also makes this list available in the form of perforated Cheshire labels in zip code order at $35 per 1,000 names, or the complete list on labels for $220. (That cost goes up by an additional $7 per thousand for single-state selections. The minimum order is 3,000 names.)

Local Markets

(Portraits, Weddings, and Schools; Architects and Builders; Chambers of Commerce; Hospital and Other Nonprofit Groups)

Your local area of course has its own assortment of advertising agencies, designers, and publishers. The national and regional references cited above in connection with clients can be used for your local market as well. Those sources may indeed provide more information about such details as specific clients, size of billings, and circulation figures than you might know personally. You, however, will personally have unique access to the special sources of local information that rarely find their way into national reference books. For these media-oriented clients, the combination of your local information and the data available in the resource books cited above should create a high degree of marketing capability.

Accordingly, this section will be limited to markets that are both preeminently local in character and less favored with media. We will be concerned here with such clients as portrait and wedding photogra-

phy patrons, local nonprofit groups engaged in fund raising, and builders or architects engaged in local building projects. It's likely that you will personally know the people and organizations involved in these connections. Thus, the function of this section is limited to pulling together available information about marketing approaches to such clients that have worked well for others.

In addition to the material cited on the following pages, you may wish to refer to a warmly personal and informative book that deals to a great extent with marketing on the local level: *How To Start A Professional Photography Business* by Ted Schwarz, published by Contemporary Books, Inc., Chicago, Illinois (1976), $12.95.

PORTRAITS/WEDDINGS/HIGH SCHOOLS

The three areas of portrait, wedding and school photography are very closely related. The high school yearbook photographer will develop a reputation among the younger people who are approaching marriage age. Thereafter, the relationship may lead to handling all weddings and family portraits for special occasions.

You may find it advantageous to bid on the official photos required for some of the local high school yearbooks in your area if you are equipped to handle that work. Some photographers will do one official portrait of a graduating class for a modest fee in order to secure referrals for the graduates' yearbook portraits. The possible trade-offs are endless.

Promotion in this area tends toward advertising in high school newspapers and local weekly (not daily) newspapers, and using direct-mail campaigns to reach likely prospects.

It also appears that most photographers take very special pains with the work on display within and in the front of their studios to meticulously convey the specific image that they are trying to establish. In this manner you may wish to distinguish yourself as an exceptional photographer of candid personal work on the one hand or of formal and studied portraiture on the other hand. You might also find it useful to arrange exhibits of your best work in local banks, office building lobbies, or shopping center malls. Continued exposure of one's work, as widely as possible within the local area, is a useful if not essential marketing tool.

If your portraits are to appear in a local newspaper item about one of your clients or customers, make sure you get a credit line. This point is often overlooked. Let each of your clients or customers know that you would appreciate this courtesy. You might also consider stamping on the back of each print that reproduction rights are

granted only with the permission of the photographer, or alternatively where a credit line is provided.

ARCHITECTS AND BUILDERS/CHAMBERS OF COMMERCE

Every new building facility generates the potential for a substantial number of photographic clients. Builders and architects are usually interested in documentation of the site as it progresses from an empty lot to a completed facility. The builders or renting agents are interested in photographs of the completed structure in order to attract additional tenants. The architect is interested in having excellent photographic samples of his or her architectural work, and the construction company will be interested in documentation of each stage of construction for similar promotional reasons. In addition, if the new facility has some element of prestige attached to it, then the ultimate users—incoming businesses, tenants, and the like—may desire photographs of their new offices or headquarters to establish a particular image. In like manner the local chamber of commerce may have an interest in photographs of the new structure as a means of promoting local business activity and civic accomplishment.

Obviously it is useful to keep track of local building activity, starting with the earliest possible moment. To do this you should check with the city or town office that issues building and related permits. In this way you will stay abreast of the news regarding each emerging project and be informed of who the principals are in connection with that project.

Your objective will be to secure some type of client relationship with one or more of those principals. Thereafter you can hope to contact the others to multiply your markets.

HOSPITAL AND THEATRICAL AND OTHER NONPROFIT GROUPS

Hospitals, local charities, private schools, religious organizations, and theatrical and other performing arts groups are continuously engaged in fund raising and often require documentation of the results of their latest efforts, such as hospital wings, library acquisitions, community activities, theatrical performances and the like.

If you are just starting out professionally, you may at first find it useful to document some of this material on your own. You might be able to sell your initial work to the organization involved or, equally possible, interest the organization in becoming an occasional client for future documentation of such situations.

The local media, such as a newspaper or a television station, may have an interest in your work if the material you are documenting is newsworthy. This type of work may involve a modest payment. The greater value to you, however, will be the credit line associated with your published work as a means of establishing your name and reputation in the community.

In the larger cities, of course, or any place where you have become an established professional, you will find that the services rendered in this area are accompanied by normal professional fees, at least in those situations involving the larger nonprofit organizations.

SUMMARY

The interrelated quality of all local work is fundamental. For example, your documentation of a local building project happens to involve a new hospital wing; the builder and hospital need some of this material; the local newspaper runs it with your credit line; the hospital administrator is impressed and asks about your portrait work, and so on. The chain is potentially endless once you see and follow through on the connections involved.

Beyond Assignments: Markets for Stock Photos and Fine Prints; Teaching Opportunities

Stock (File) Photo Sales

WHAT'S AT STAKE

The market for stock (file) photos is extraordinarily broad. A photographer in Connecticut sells rights to about 20 photographs per year for use on greeting cards. The fee is $150 per photograph as an advance against a royalty of 5 percent of the greeting card company's receipts from each card. The yield is almost $5,000 per year from this market alone, including royalties. On the other end of the spectrum, a stock photo agency in New York recently granted one-time rights to an ad agency for the use of 10 photographs solely for packaging in the Japanese market. The fee: $15,000, divided equally with the photographers involved.

It is no wonder that many photographers are deriving 25 percent to 50 percent of their income by selling rights to use existing photographs from their files. This is often referred to as licensing. It usually involves granting limited reproduction rights (for example, one-time use in a magazine or newspaper, or use in an annual report, specific ad, or greeting card). Such usage hardly ever involves an outright sale of all rights; it almost always requires return of the original photograph or negative to the photographer (or photographer's agent).

Markets include *all* the media discussed above in connection with commissioned work and assignments, from advertising to public relations and everything in between.

The ability to regularly and effectively market stock photos

requires an exceptional degree of organization. You need to be in regular contact with dozens or possibly hundreds of different photographic buyers and users, to make submissions (using registered mail for original negatives and transparencies), to fill print and transparency orders, to track originals that are in client's hands, and to negotiate prices and rights. In addition you will need to keep exceptionally thorough files, carefully cross-indexed as to photographic subject matter, with accurate lists of contents to send out as sales tools. Finally, you will have to develop effective sales techniques and brochures. If you can do this well and efficiently, then you should find the effort worthwhile. Many photographers, however, are not suited for those tasks. Some hire staffers to handle these functions or are fortunate enough to have a spouse, companion, or partner interested in that area.

Others prefer to send their stock materials to a picture agency (or picture library), which is a firm specializing in the organization and marketing of stock photos. (For additional material on stock photo agents, see the chapter dealing with agents, starting on page 60.)

Stock photo material comes from several sources. It may result from the out-takes of commissioned work (for stock sales purposes, you may need releases as discussed in the section on right of privacy, pages 191-192, and you should be sure that the original client has no publication rights to those out-takes). Photographs are also produced for the express purpose of making file sales by experienced photographers who have developed a clear understanding of what material is marketable. Obvious examples of material that doesn't risk becoming dated would include exceptional scenics or endearing animal photographs. Obviously the market is not limited to such well-worn subjects, although photographs in those areas continue to be in demand.

In marketing your file photographs, there are two important things you should do:

1. Pinpoint the right material for a specific market.
2. Exercise care and professionalism in your presentations, submissions, and documentation.

MULTIPLE-MARKET THINKING

Let's assume you have some excellent outdoor shots of skiers, surfers, tennis players, golfers, joggers, and other amateur sports nuts. The material might be suitable for a general-circulation sports magazine and/or trade or in-house company magazines in the sporting

goods field. Magazines in these classifications can be easily spotted in the guides to magazine markets referred to on page 17. Another market might be calendars produced by a calendar company (sources for these are noted in the section that follows).

Lastly, if you have releases on the photos, they might be used by a sporting goods manufacturer in advertising brochures or press material. In that case you might find yourself approaching several companies directly or through their public relations firm or advertising agency (the guides to these markets are indicated above, in the section on assignment photography).

This kind of multiple-market thinking can be applied over and over again to any related body of photographic materials. Your own energy, time, and imagination are the only limiting factors.

PROFESSIONAL SUBMISSIONS AND DOCUMENTATION

If you send your finest photographs to companies without having received a request in advance, they can throw all those photographs away without incurring any liability to you whatsoever. Most responsible people won't do that, but you must be aware of what risks are involved when you are too casual about your own material.

When considering a submission of file material, you should observe the following rules whenever possible:

1. Send duplicates (dupes), contact sheets, proof sheets, or the like (even color photocopies may do for showing general layouts). Avoid sending original transparencies and negatives unless they have been specifically requested, and never send them unsolicited. Remember that high-quality reproduction-grade dupes will satisfy all but the most demanding reproduction requirements.

2. Call in advance to find out what type of material is needed, exactly to whom it should be sent, and that person's precise job title.

3. If you are sending original transparencies or negatives, send them by registered mail, bonded messenger, air freight, or United Parcel Service. Never send them by ordinary mail. Certified mail is just ordinary mail with a number; it cannot be traced, and postal insurance won't cover the value of most lost originals. Registered mail is the only way to assure yourself that an item can be traced. Other professionals have known this for years. Diamond dealers, for example, have traditionally shipped

small quantities of diamonds by registered mail—insured. This provides the most security without calling undue attention to the potential value of the goods enclosed.

4. Enclose a submission form with your material as indicated on page 104. Describe exactly how many photographs are contained and what the business terms of the submission are.

5. Enclosed a stamped self-addressed envelope for the return of material. This is especially necessary in the case of unsolicited submissions.

6. Back all prints and transparencies with light but firm material, either corrugated board or eggshell polyplastic shipping material, whichever is most readily available. If you don't do this, you can assume your photographs will be ruined.

7. Always place 35 mm transparencies in sheets or well-marked slide boxes, and 2¼ and larger sizes in protective sleeves. Never send glass-mounted material.

8. If you are sending high-quality exhibit-grade prints, be sure they are taped down from behind to protective board, with acetate taped over the face of the print. Otherwise the print is likely to be returned with marks, fingerprints, or worse.

9. Send only the very best samples of your work, attractively and intelligently laid out and organized. Remember that a stock submission is like a mini portfolio. It can leave a lasting impression that will effect two crucial matters: future calls for stock submissions and future assignment possibilities. Many an excellent stock submission has led an art director or editor to request a photographer's portfolio.

THE STOCK MARKETS—USUAL AND UNUSUAL

All the national and regional media and markets for assignments referred to above are candidates for stock sales, from advertising to public relations. They form the bulk of the market.

One huge area, however, is uniquely oriented toward the use of stock material and rarely if ever involves assignments. That market consists of novelty items, gifts, and decorative and accessory products. The items using photographic images include greeting cards, calendars, posters, wall decor, T-shirts, and more. This is one of the few markets in which your work can generate substantial royalties once you become well established—royalty payments that sometimes continue for years.

This is an easy market to dismiss. It is not particularly glamorous,

but the revenue potential is probably greater than in many other areas. It is truly mass merchandising. But the thought of securing royalties for images on, for example, wall decor sold in every city and town in North America has to be given most careful consideration.

The standard guide to this industry has not been cited in any of the photographic references we have seen published, perhaps indicating a wider than usual area for your marketing opportunity.

Your Best Guide to This Market Is:

GIFT AND DECORATIVE ACCESSORY BUYERS DIRECTORY, Published by Geyer McAllister Publications, 51 Madison Avenue, New York, New York 10010, telephone (212) 689-4411; available only from the publisher. The directory is usually offered in conjunction with a subscription to the magazine titled *Gift and Decorative Accessories Magazine*. This monthly magazine costs $18 per year, and that charge includes a free copy of the directory.

In this guide look for:
1. A classified index of companies that may be using photographs, incorporated into the following products: calendars (75 companies); graphics, including etchings, lithographs, and serigraphs (100); greeting cards (200); pictures in frames (175); pictures without frames (100); posters (50); prints (100); and wall accessories (200).
2. An alphabetic index at the beginning of the book providing each company's name and address and an indication, in most cases, as to whether the company is a manufacturer, importer, jobber, or representative. You will be primarily interested in manufacturers of those products, unless you manufacture your own line (such as greeting cards), in which case you might be interested in finding a jobber or representative.
3. A listing of regional buying centers in the back of the book. This list provides the address and telephone numbers of the major merchandising marts in the gift field throughout the country and tells which companies are exhibiting at those centers. If you are interested in this market and one of the centers is in your area, it is advisable to pay a visit so that you can become familiar with the uses made of photographs in the field. The book lists centers in Atlanta; Boston; Chicago; Cleveland; Columbus, Ohio; Dallas; Denver; Detroit; High Point, Michigan; Indianapolis; Kansas City; Los Angeles (four centers); Miami; Minneapolis;

Montreal; New York City (four centers); Pittsburgh; San Francisco (three centers); and Seattle.

GIFT AND DECORATIVE ACCESSORIES MAGAZINE, referred to above, lists the major buying trade shows that occur throughout the year. Information about them is published month by month and compiled twice a year in the special May and November calendar issues, which publish the locations of trade shows throughout the country for the following six months. By going to a few of these trade buying shows you will become familiar with the products and meet people in some of the companies you might wish to do business with. Indeed, you might even be able to make sales of your photographs at the shows. In addition, if you are producing a line of your own items (such as cards or posters) you might wish to take space at one of these shows for the purpose of making sales to the retail buyers who usually attend in very large numbers.

Another important guide to this market is *Decor,* a monthly magazine of fine and decorative arts. The special annual edition titled *Sources* is a directory of suppliers in the wall decor field. That publication lists some 500 publishers and manufacturers of wall art, posters, fine prints, and graphics, with breakdowns based on the subject matter of visual material and types of media used (photography, illustration, and so on. The *Sources* issue is $6 from Commerce Publishing Company, 408 Olive Street, St. Louis, Missouri 63102.

You might also want to try contacting some of the English wall decor publishers, since that foreign market presents no language barrier problems and names are readily available. *Kelly's Manufacturers & Merchants Directory* (The Buyers' Guide) lists some of these publishers under such titles as "Greeting Cards," "Christmas Cards," "Posters," and "Fine Arts." In the 92nd edition (1978–1979), there were 14 listed in the London area and 36 listed for the rest of England, Scotland, Wales, and Northern Ireland. This huge volume is most readily available in reference and business libraries. (Published by Kelly's Directories Ltd., Neville House, Eden Street, Kington upon Thames, Surrey KT1 1BY, England.)

The interior design field, including both designers and their suppliers, is at the upper income end of the decorative markets. It can be of considerable importance to photographers seeking to sell fine prints and decorative graphics. This is certainly not a mass market, but the prices involved may be higher than in other aspects of the decorative accessories field.

Three important publications, each updated annually, provide

the marketing information you will need to reach this market: *Interior Design Buyers Guide* ($5 per copy) is published as an extra September issue of *Interior Design* magazine, 850 Third Avenue, New York, New York 10022, telephone (212) 593-2100. Included in this directory are the names of several hundred publishers of photomurals, paintings, prints, graphics, and scenics. Additional names in these fields can be found in *Contract—Directory of Sources,* the special January issue of *Contract—The Business Magazine of Commercial Furnishing and Interior Architecture.* The directory issue is available from Gralla Publications, 1515 Broadway, New York, New York 10036, telephone (212) 869-1300 ($3 per copy).

A different slant is provided by the *Membership Directory of the American Society of Interior Designers, N. Y. Metropolitan Chapter* (available from the Society at 950 Third Avenue, New York, New York 10022, telephone (212) 421-8765, for $50 per copy). This directory lists some of the most respected designers in the country. They are often in a position to recommend to business and residential clients the purchase of selected art and fine photographic works for inclusion in decorative schemes. You might also find out whether a local chapter of the American Society of Interior Designers in your area publishes a membership directory, to guide you to local participants in the design field.

Fine Print and Gallery Sales

A small number of photographers, probably no more than 150, derive a modest living from the sales of their fine prints to collectors. Many hundreds more, perhaps even thousands, sell a few prints a year merely to supplement income they derive from other sources. Of course, there are exceptions, such as Ansel Adams whose signed prints can sell for many thousands of dollars each.

We are referring here primarily to the sale of black-and-white prints to collectors. The market for color prints, while growing, remains well behind the market for black-and-white prints. Color prints are, however, doing somewhat better in decorative and architectural markets (see stock sale section immediately above).

Despite all the hoopla in the press, this entire field is astonishingly small. According to two leading gallery owners, the total sales of photographic prints (as of 1978) were running at $5 to $8 million per year, with the work of living photographers accounting for only about 25 percent of that amount. According to their estimates, the top 20 to 25 people account for about 75 percent of the sales

among living photographers, leaving approximately $500,000 to $700,000 for the hundreds, or possibly thousands, of other photographers who sell an occasional print.

Average black-and-white fine print sales for living contemporary photographers with modest reputations among collectors are in the $150 to $250 range. Prices for reprints of unknowns are much lower. Portfolios of 10 to 12 prints on a related theme will sell for a 25 percent to 50 percent discount (per print). For the recognized masters, probably a few dozen names at most, the usual price range is closer to $500 to $1,000 per signed print, with a few lower and a few higher. This is not a field one should enter with excessive expectations of making a reasonable living. Artistic aspirations are, however, rarely dulled by such harsh realities. In any event, the pleasure of seeing your work exhibited is a principal gratification for creating fine prints, though your income may be derived elsewhere (for example, from commercial assignments or teaching).

There are some 200 to 250 places throughout the country that more or less regularly exhibit photographic work. Twenty-five percent of these are in New York City and nearly 20 percent are in California. The regular exhibit places and galleries are listed in two books:

1. *Photography Market Place,* second edition, published by R. R. Bowker, 1180 Avenue of the Americas, New York, New York 10036, telephone (212) 764-5100 ($15.50).
2. With a somewhat smaller number of listings: *Photographer's Market,* published by Writer's Digest Books, 9933 Alliance Road, Cincinnati, Ohio, 45242 (published annually, $12.95).

While some of the places listed in these books are regular galleries with a clientele of collectors, most are primarily exhibit spaces with only a marginal ability to sell prints.

In addition to the listings in those books you should check exhibit listings in your local area in newspaper and regional magazines, or if the key New York market is your objective you should check the following:

1. *Art Now Gallery Guide,* an extensive monthly listing of some 300 museum and gallery exhibits, covering all of the visual arts in New York City (Art Now, Inc., 144 North 14th Street, Kenilworth, New Jersey 07033; $10 per year).
2. The "Arts and Leisure" section of the *Sunday New York Times,* which carries a selected listing of current New York exhibits and

has a separate section for photography (229 West 43rd Street, New York, New York 10036).
3. *New York Magazine,* 755 Second Avenue, New York, New York 10017, which carries a similar photo exhibit listing. For California, current exhibits can be found in the bi-weekly listings of *New West Magazine,* 9665 Wilshire Boulevard, Beverly Hills, California 90212.
3. *The Soho News,* 514 Broadway, New York, New York 10012, currently lists the largest number of photographic exhibits in New York City (published weekly, $26 per year).

As an alternative to gallery sales, some photographers have developed a strategy of marketing their own portfolios through direct mail. They also make sales efforts at annual industrywide symposia that attract collectors and dealers (such as the one at George Eastman House, in Rochester, New York).

The direct-mail approach, however, requires extreme care. A good mailing list of regular buyers and collectors will probably be difficult to develop. (No such list has yet been published.) The cost of printing and mailing can be overwhelming unless you have reasonably good sales prospects arising out of prior contacts or exceptional reviews in significant publications.

One common technique used with some success is to offer the first 15 to 20 portfolios at a handsome discount, while charging enough to allow you to publish the edition. Thereafter the additional portfolios produced from this initial printing can be sold at a significant profit. The discount offering allows you to print more than you might otherwise be able to, while providing the buyer with a significant incentive to act.

As one gallery director states, you should bear in mind that there are two types of collectors: those passionately dedicated to having the best of every field represented in their collection and those who just want to know the artist's or photographer's commercial track record and what the work will be worth next year.

Finally, should you decide to seek gallery representation, bear in mind certain "rules of the game," such as:

• Approach a gallery with the same care you would use in dealing with a potential client.
• Show only your best work and only the most exceptional prints of that work.
• If the work is in color it is acceptable to show slides, but you

should have at least one print to give the presentation a more tangible quality (this is especially true if you are showing color work for the specific purpose of making a sale at that time).
- Try to recognize that you may be turned down by a gallery for a number of reasons that have nothing whatsoever to do with the quality of your work (for example, you work in a literal vein and the gallery's artists and photographers tend to be highly abstract, or vice versa).
- Establish a precise businesslike relationship with a gallery that represents you, making sure to have specific arrangements regarding the terms of any exclusivity, the split on commissions, and other items as discussed in the contract section on pages 69-72.

An excellent introduction to the collecting market is *The Photograph Collector's Guide,* by Lee D. Witkin and Barbara London, published by The New York Graphic Society, Boston, Massachusetts ($32.50).

Opportunities in Teaching

There are at least five levels of income-producing instructional activity in the photographic field:

1. Full-time regular faculty at a university, college, or technical school.
2. Part-time regular faculty at a university, college, or technical school.
3. Part-time occasional faculty with an adult education program.
4. Regular part-time or one-shot appearances at workshops, often offered as summer programs.
5. Operation of a course or workshop for aspiring professionals or amateurs out of your own studio.

In addition, some photographers simply contribute instructional services to community groups in need of their assistance.

For the first four categories above, motivation for participation differs widely. For some, teaching is simply another mode of self-expression and is enjoyed on that level. For others, the motivation is the need for money.

The number of opportunities in the instructional area is substantial. In the years 1976 through 1977 (the latest for which we have published data), there were 110,000 students enrolled in approximately 3,800 courses of photography at the hundreds of degree-

granting institutions in the field. (Only a small percentage of those students, however, majored in photography.)

Your Best Guide to This Market Is:

A SURVEY OF MOTION PICTURE, STILL PHOTOGRA-PHY AND GRAPHIC ARTS INSTRUCTION, by Dr. C. William Horrell, published by Eastman Kodak Company, Motion Picture and Audio Visual Markets Division, Rochester, New York 14650; Kodak Publication No. T-17 (currently free upon request). This book lists all but a few of the degree and diploma-granting institutions in the photographic field. It provides an alphabetic listing, by state, for each such institution. It also lists the courses currently offered at each school, thereby allowing you to determine whether the courses would be of interest to you from an instructional point of view, and whether you could develop a course not currently offered at an institution.

As another source you might try: *Photography Marketplace,* second edition, Fred W. McDarrah, editor, published by R. R. Bowker, 1180 Avenue of the Americas, New York, New York 10036. This book contains somewhat fewer listings than the Kodak offering and does not provide as much detail about courses. Nonetheless it contains the names of some 200 universities (listed geographically by state) that provide photographic instruction (pages 411–436). It also lists nearly 100 additional smaller schools and regular workshops, again geographically by state (pages 436–44).

Finally, you should check local newspapers and other media for adult education classes, community centers, and other groups that may require instructors.

After locating the most convenient educational institutions or organizations, you should then secure their catalogs and become thoroughly familiar with the courses they provide.

You will find that some places will be interested in you only if you can develop a new course to attract additional students, while others with a fixed curriculum will expect you to teach only what is already in the course catalog.

In any event you will have to document some degree of status in the profession by means of degrees, honors, awards, articles by you or about you, activities in the community, and the like. All this should be compiled into a short résumé with accompanying documents as necessary.

The last item in our list of possibilities concerns teaching out of

your own studio. This can be fairly profitable if you have a knack for that kind of business.

One outstanding professional in Connecticut gives a week-long seminar for six to eight aspiring professional photographers who pay $400 each to work by his side and receive personal guidance on technical, esthetic, and business matters. At the other end of the spectrum, some photographers give classes once or twice a week for 10 to 15 advanced amateurs who each pay anywhere from $10 to $25 per session (or $75 to $250 per seven- to 10-session course).

If you become an instructor you will need to set a price that reflects both a portion of your overhead and direct costs (such as advertising, materials, and so on) and a reasonable fee compensating you for your time.

Whatever your direction, you may well find that instructional work provides both personal satisfaction and a reasonably attractive income supplement. This may be especially true in the early years of your professional career. Some highly accomplished amateurs have also supplemented their incomes by providing instruction to beginners.

CHAPTER 3

Marketing Tools and Techniques

THE TWO SUBJECTS COVERED in this section are virtually inseparable. The first is portfolios and presentations. The impact and competitive qualities of your portfolio and presentations will determine your sales prospects. But advertising and promotion, the second topic, is what generates calls to see your work and serves as a continuous reminder to people after you have seen them.

Art directors, art buyers, photo editors and other clients see hundreds upon hundreds of portfolios and samples every year. Their initial reaction to a portfolio may be positive, but sweet remembrance is the more ample reward. As one art director recently commented:

> I love to see portfolios but I hate to get callbacks every week. Please send something that reminds me of your style of work rather than your tone of voice.

That thought, however biting, is based on reality in any market—from national ads to local weddings. The time that elapses from your first presentation to the client's need for photography may be considerable. A visual reminder about the quality of your work has to be considered a part of your presentation.

Accordingly, even though we have separated the subject of portfolios and presentations from advertising and promotion you must consider them together in your business approach.

Portfolios and Presentations

WHAT TO SHOW—QUALITY VERSUS QUANTITY

The essence of most professional advice on the subject of portfolios and presentations is easy enough to summarize: impact

counts; less is more; where excellence is required, pretty good is worthless.

If you fully understand those points, you have grasped the essentials of successful marketing.

Portfolios and presentations are the means by which most assigned work is secured, both in the media world and in local portrait or wedding work. The samples you show have to be directed toward the client's specific needs. Great car shots and extraordinary scenics will be ignored by most fashion art directors. Evocative wedding shots will probably not impress administrators who are contracting out school photography.

In some way you have to provide something the client isn't getting at present. If you are very well established it might just be the ability to deliver good work on time. More frequently, and invariably for the beginner, the "something else" is a fresh and valid visual approach, with absolutely flawless execution.

Usually, this means showing only razor-sharp focus and exposure. If you show soft focus or diffusion work, be sure it is clear that that is the intended esthetic result, rather than an accident.

Impact often results from uncluttered graphics—single bold statements—that are easier said than done but are the invariable hallmark of recognized professionals. For commercial and journalistic photographers, as well as others, samples of such work abound in the following books: *Art Directors' Index to Photography, American Showcase,* and *The Creative Black Book,* as well as in trade magazine publications such as *Art Direction, Communication Arts, News Photographer,* and *Print.* The addresses and telephone numbers for these publications are provided either in the next section covering advertising and promotion or in the bibliography.

Review carefully the images you find in these publications. Ask yourself why some work and others don't. Then scrutinize your own portfolio with the same degree of detachment.

As one art director stated:

> You are establishing *taste* in what you are showing, so I judge you by the *worst* piece you show in your portfolio.

Or as another art buyer put it:

> I am looking for a consistent individual viewpoint that will apply to some of the work I produce, not a hodge-podge of styles. I'll get the best person for each different style I need.

In short, though it may seem contradictory, most clients want predictability even in a fresh viewpoint. One bad piece amid many good ones, or too broad a mixture of styles causes confusion. Alternatively, a couple of well-delineated and professionally related styles would probably be acceptable and welcome.

How much should you show? An art director, editor, or buyer should be able to go through your portfolio comfortably in ten minutes *at most.* Attention spans wander beyond that point, often sooner.

The concensus on the optimal number of slides to be shown in a slide tray is about 30 to 40, and the same number seems to hold true for prints, tearsheets and the like. How many great pieces do you have anyway?

One rule is invariable in all markets: Ten great pieces will be remembered; 20 fair ones will be forgotten. Ten terrific shots mixed with 10 fair ones will only cause confusion.

In addition, you must leave behind a visual reminder or mail one soon after your meeting with a potential client or customer in any market. It needn't be elaborate—anything from an illustrated postcard to a poster. (The economics, production, and effects of various mailers and promotion pieces are discussed in the next section.)

APPOINTMENTS

Obviously you have to call first for appointments. Persistence or, better yet, tenacity, is invariably required. When you are at an agency, corporation, design firm, or publisher, try to see some extra people. A receptionist may let you know who else buys photography. Sometimes the person you are seeing will want you to show your work around the organization. If the situation is informal, discreetly ask for the names of other people who might buy photography there, and see whether they are free. You can save a tremendous amount of time and energy that way, covering several potential clients on one trip.

Unfortunately, sometimes your first appointment won't be an appointment; that is, it won't be in person. It may consist simply of your leaving your portfolio at a potential client's office and picking it up later.

This "drop-off" system presents a number of problems. It is not advisable to leave your portfolio all by itself in a strange place. It might get lost or copied. This will not happen often, but a lost portfolio is a disaster, even if lost only once, whether or not someone signed for it where you left it.

It's always best to get a personal appointment, but many art directors, buyers, and editors are busy people. You could wait months to see some of them in person, if at all. In addition, some honestly don't want to see you because, alone, they can go through a portfolio in a couple of minutes flat. They often do know exactly what they are looking for, and unless your work relates to their specific needs, many would prefer not to have to deal with a complete interview situation. Frequently, though not always, the established professional will be accorded more favorable treatment.

The result is this: There are some places where you will have to leave your work if you want it seen. As to procedure, be sure you pick it up the next day or at the end of the same day if possible. Don't leave it over a weekend, especially a long weekend. Have someone sign for its having been received, if at all possible. Keep a record of exactly what's in your portfolio and which items are original chromes or negatives, if any.

As to contents: Keep them short and sweet. Don't assume you need to be there to explain how a photograph was done. Most art directors and buyers will tell you, as one recently told a New York symposium, *"A good portfolio doesn't need explanation, it explains itself."*

Another art director, who sees about 1,000 portfolios a year (20 per week during the one evening he sets aside for that purpose), candidly stated:

> Of the one thousand portfolios I see each year, I find two or three with so much impact and fresh vision that I will call those people in and use them. *The portfolio must compel you to work with that photographer.*

Many will tell you that those standards are a bit on the tough side, but the idea of presenting only your most excellent and compelling work is basically correct in any market.

Finally, when you do have an appointment, consider the image you create. There are no uniforms, but sloppy jeans, T-shirts, and sneakers might spell doom if you aren't an established "star."

A certain degree of informality is expected, perhaps required, in this field, but it is usually a rather studied informality. It might consist of slacks (or a skirt for the woman photographer) and a jacket, with variations on that theme. Showing a portfolio in an art director's or corporate executive's office is a different task from executing the work in the privacy of your studio or out on the journalistic battlefields.

Your portfolio and personal presence together must convey one feeling: that you can do an exceptional visual job reliably, on time, and within a preestablished budget.

As for return engagements, don't ask for a new appointment until you have plenty of new work to show. Art directors and other clients do not appreciate repetition. The best strategy is to hold some pieces in reserve the first time. Use the first meeting to find out more about your potential client's specific interests. Next time you can gear your portfolio more exactly to that person's requirements, adding the pieces you held back at first, while dropping the ones that are irrelevant. The results can be striking in terms of what will now be a well-targeted marketing effort.

WHAT FORMAT TO USE

Most photographers use a zippered leather or leatherlike case holding a ring binder of acetate protectors in which they slip prints and tear sheets. Preferred sizes for the acetate protectors are 11 × 14 and 14 × 17. If your samples are double page spreads you may need to have a size 13 × 20 made to order.

Tearsheets are often irreplaceable. They also become discolored over time and are easily made unpresentable with even modest handling. Accordingly, they should be laminated. You may prefer lightweight laminates to keep the overall weight of the portfolio manageable.

Some photographers use a rigid or semirigid case containing loose prints and laminated tearsheets. The size of the prints is not the crucial issue—after all, problem solving comes in many different sizes. Nonetheless, most photographers restrict their presentations to a few fairly uniform sizes for prints and tearsheets. Some of the more established professionals rely on showing work exclusively in slide carousel form.

A recent innovation is the use of a self-contained (briefcase type) rear-view slide projector that can be viewed in daylight. The image, however, is often not as sharp as an original print, tearsheet, or carousel projection. Accordingly, while this technique may be convenient for a wedding photographer making an informal "at home" presentation, its use at an ad agency or publication may be less effective than the traditional methods described above.

As to security measures, be sure your name, address, and telephone number are attached to the portfolio case and are stamped or written on the back of every individual piece including slide mounts, tearsheets, and prints. This can be done discreetly so as not

to interfere with the presentation. The purpose here is to allow for identification in the event that a piece is inadvertently misplaced.

Neatness is essential. Sloppiness is always noticed and rarely tolerated. *You are selling taste.* Keep the case clean. Replace the acetate sheets when they are worn.

The visual context of each piece may well determine its impact. If your news or brochure photos appear on a large page of typeset material, trim out some of the copy; place several pictures of this type together to form a better-looking, simulated single page. You might want to trim out all the copy except the caption and run several together under the publication's logo that you should have saved. This will invariably have more impact than a one-column cut lost in a page of type, regardless of how good the photo is.

Work carefully on the sequence of your presentation. Does it tell a story? Are there groups of related images, or just abrupt jumps from one unrelated subject to another? Obviously the latter will distract from the image you must create of fully comprehending the interrelated qualities of your visual images.

Advertising and Self-Promotion

This discussion of advertising and promotion focuses on local, regional, and national markets in commercial, media, and journalistic photography. The advertising and promotional aspects of such local photographic markets as portraits, weddings, and schools were discussed in the section beginning on page 24.

When you budget for your own advertising and self-promotion, two factors should dominate: continuity and quality.

One solution that will satisfy those requirements, whether you are just starting out or are well established, is the effective use of mailing pieces. A good mailer sent to a select list is always helpful, especially when coupled with a well-organized follow-up program of telephone calls and the like.

You must plan such promotion over the period of an entire year, possibly making mailings every two or three months. Thus the basic problem becomes cost containment.

CONTROLLING PROMOTIONAL COSTS

A photographer's agent, noted for exceptionally effective promotional techniques, recently explained his methodology at a New York business seminar. It is astonishingly simple. He regularly negotiates for 300 to 500 run-on copies (either free or at nominal run-on cost) as

a part of *every* job his photographer is doing that will produce an interesting sample. He sends out no more than 50 to 100 at a time and follows up each mailing piece with telephone requests for an appointment to show the portfolio. Those leads that show promise get sent second and third mailings from the next run-on samples, and so on. Usually, the only cost in the entire operation is postage (admittedly important) and envelopes. The agent claims that every mailing produces one or two jobs.

Another photographer arranges with a typesetter, designer, and printer to give each of them well-placed credit lines in exchange for drastically reduced charges for printing and producing mailers. Since they all have the same clients (magazines and ad agencies), the arrangement makes a lot of sense. Indeed, such arrangements are quite common in this field.

Other techniques abound. One successful studio has two basic layouts for a postcard, professionally designed. Using those two formats they annually produce 12 different cards using 12 different examples of their best photographic work, six placed in one format and six in the other. All 12 are printed at one time, with a single set of separations whenever possible.

Each buyer and editor on this studio's mailing list is sent one card each month, alternating the formats to avoid repetition, while maintaining identity through the use of one distinct logo. The beauty of postcards, as used in this case, is that they require no separate envelope, provide a modest savings in first-class postage, and afford immediate visual impact. The continuity of a monthly (or, for that matter, bimonthly or quarterly) mailing has a number of important consequences. Among them:

- You are less likely to be forgotten amid the hundreds of other people a potential client sees in a relatively short time.
- You convey a personal image of stable presence in a field where many clients need to be assured that the photographer they work with today will be around tomorrow.

The studio in this case even has plans for expanding its postcard lines, making them available to the public through novelty distributors.

They recently began visiting local merchandise marts and contacting card manufacturers through information provided in the *Gift and Decorative Accessories Buyer's Guide,* discussed on p. 32.

Along with continuity, you should consider the possibility of creating a particularly powerful impact at the very outset of your promotional campaign. You might, for example, mail one card or other sample to 25 to 50 people, and then send another to the same individuals two weeks later. With immediate telephone followup, you can quickly gauge the value of your effort.

The cost of producing and distributing mailers has many variables, such as:

- The number of separations you group together.
- Whether you use black-and-white or color photography. Color is much more expensive unless you are grouping separations and putting many pieces together to bring your costs down. For example, 12 cards produced with one separation and one print run may sacrifice a bit of quality but can reduce costs approximately eight to tenfold.
- Whether or not you can get numerous reprints (at your client's nominal print run-on cost or possibly free).
- The number of pieces you get on one sheet for a single print run (some cards, for example, can be run six or 12 at one time, vastly reducing press time and stock wastage).
- Whether you use bulk mail or first class. Bulk mail can save as much as 10 cents per unit, but it requires a special permit, it is not delivered on a set schedule, and it therefore does not allow for a predetermined telephone follow-up. You're better off with first class, if you can afford it, while using the reduced first-class rate especially for postcards if available. Nonetheless, if you are sending out several thousand pieces at one time, the bulk-rate saving would be extremely significant.

After you weigh all the variables, certain conclusions emerge:

- An aggressive monthly or bimonthly program for mailing several hundred pieces at a time can probably be handled for under $2,000 to $2,500 per year (including postage), provided you don't print expensive posters or fold-outs.
- A modest quarterly mailing program, which should be adequate for most beginners, can be organized for $750 to $1,000 per year.
- A concentrated effort, possibly two mailings within a week or two to a limited number of key people may be needed to create initial impact.

- You must think in terms of *annual* costs. If you print one piece at a time, every few months, your costs will be much higher than if you prepare an entire year's promotions at one time.

ELABORATE MAILERS AND PAID TRADE ADVERTISING

As you become established, you may feel the need for a more substantial effort in the arena of advertising and self-promotion. For example, a few studios produce elaborate annual color booklets, incorporating their best work of the year. They distribute these booklets in the hope that they will stay on an art director's or art buyer's desk as a reference tool. At the least such efforts convey a message of success, but the cost in time and money is likely to be in the thousands of dollars rather than the hundreds required for a simple mailer.

For others, a similar effort is put into producing an exquisite poster-size sheet that is then sent out as a kind of prestige mailer. While these major projects are indeed impressive, one must question their value in relationship to the effectiveness of a simple postcard or other mailers that can be distributed with far greater frequency.

Some photographers attempting to secure national and large regional clients may also consider paid advertising in trade media that reach such art buyers. Among the possibilities are the various industry directories, such as *American Showcase, Art Director's Index to Photography,* and *The Creative Black Book.* Advertising in these directories can be quite expensive and requires caution. If your samples are anything less than exceptional, you will be wasting your money. In addition, the directories generally aren't designed for photographers living outside major urban media areas.

On the positive side, these promotional books, and others, have worked effectively for a number of photographers. They often reach audiences that are unfamiliar with your work and stay on shelves and desks as more or less permanent reference tools, unlike mailers which disappear far sooner.

The Creative Black Book is an industrywide telephone and address directory for people in all the visual creative media. Your name and address will be listed free of charge upon request (if they aren't already there), and the book has become a standard information reference for that reason. While the book is more expensive to advertise in than any other publication in the field, it is generally acknowledged to be in wide use throughout the nation among art directors, art buyers, and others in the field.

American Showcase and *Art Director's Index to Photography* are large-format, carefully reproduced art reference sources for art buyers and others in the field. They are also widely distributed throughout the industry.

Art Director's Index provides an interesting, all-inclusive marketing program for the cost of an ad, which includes mailings and out-of-town presentations of work samples. The much less costly *American Showcase* does, however, provide mail list access and a discount to advertisers using the directory's promotional mail handling services.

In addition, there has been a veritable explosion of promotional directories recently on the national and local scene. The American Society of Magazine Photographers (ASMP) will be publishing its first members-only book in 1981 with an extremely attractive cost per page. The *Madison Avenue Handbook,* a traditional industry reference tool, has also begun taking color advertising for the first time. On the local level, creative directories have sprung up or expanded in Chicago, Los Angeles, New England, and the Sun Belt (Houston-centered) while a book titled *RSVP* serves the New York area as something of a new talent directory.

The best way to find out about the possible value of an ad in one of these books is to buy or borrow a copy and then call advertisers, preferably ones whose work might be similar to yours. Ask about the results of their ads. Are they going to advertise in the next edition? If not, why not? Also check with as many art directors and art buyers as possible about their views on the book you are considering. Do they receive it? Do they use it for reference when hiring a photographer? Are there other books they consider more valuable?

In two tables below we cover, first, nationally distributed books and, second, regional and local books. We show the circulation, contact phone numbers, and current cost of advertising in these promotional books. In addition, and by way of contrast, the cost of advertising in some of the trade magazines that are seen by art directors, art buyers, and others in the field is provided in a third table. Traditionally, photographers have not advertised in these media magazines. Nonetheless, it may be worth considering whether an advertisement in one of these magazines every three months might be as effective as a single ad in one of the promotional books, since the costs of those two situations would be roughly comparable. Bear in mind, in making such a comparison, that the directories may remain in use for a year or more while the magazines may not receive such sustained attention.

NATIONAL PROMOTIONAL BOOKS

	American Showcase	*Art Directors' Index to Photography, Film & Media Production*	*The ASMP Book*	*Creative Black Book*	*Madison Avenue Handbook*
Basic Rates ($) color page	1,600 before June 15	3,400	1,000 before April 15	4,250	2,500
b&w page	1,375 before June 15	2,800	850 before April 15	2,750	1,600
Reprints (run-on mailers)	2,000 free	1,000 free	$100 for 2,000	$325 for 2,000 (free before May 15)	500 free
Circulation U.S. Free U.S. Sales Foreign	28,000 13,000 10,000 5,000	38,000 12,500 5,000 21,500	25,000 (est.) 20,000 " 5,000 "	40,000 13,000 17,000 10,000	20,000 6,000 13,000 1,000
Size/Format	Large	Large	Deskbook	Deskbook	Deskbook
Basic Price ($)	25.00	22.00	Not yet determined	25.00	13.95
Address and Telephone	Suite 1929, 30 Rockefeller Plaza, New York, New York 10020; (212) 245-0981	John S. Butsch Assoc. 415 West Superior St. Chicago, Illinois 60610 (312) 337-1901	Amer. Soc. Mag. Photog. 205 Lexington Avenue, New York, New York 10016; (212) 889-9144	Friendly Publications 401 Park Ave. South, New York, New York 10016; (212) 684-4255	17 East 48th St. New York, New York 10017 (212) 688-7940
Special Features	Will handle your promotional mailings at cost plus $125 to any specialized group of art buyers in any geog. area, for first 5,000 names.	Includes: (1) Design help for your page layout (2) Consultation on use of promo mailing (3) Out-of-town presentations of your work (4) Possible representation on selected basis (5) handling promo mail'g.	Must be an ASMP member to advertise; 1st year of publication, so circ. is an estimate	Standard reference for names, addresses & telephones of illustrators, photographers and others throughout the industry	Offers discounts members of professional organizations such as ASMP.

REGIONAL PROMOTION & OTHER BOOKS

	ART DIRECTORS ANNUAL	CHICAGO CREATIVE DIRECTORY (MID-WEST)	CREATIVE DIRECTORY OF THE SUN BELT	L.A. WORKBOOK	RSVP (NY)	THE BOOK (NEW ENGLAND)
Basic Rates ($) color pg / b&w page / ½ b&w pg	1800 / 1200 / —	1400 / 725 / 375	1200 / 900 / 500	1450 / 850 / 500	400 / 175 / —	1800 / 1000 / 600
Mailers	—	500 free	500 free	$50-$100 for 500	$75-$125 for 500	color pg: 1000 free
Circulation	20,000	7,500	10,000	7,500	6,000	12,000
Format	Large	Deskbook	Deskbook	Large	Deskbook	Deskbook
Price ($)	34.95	20.00	17.95	18.00	12.00	18.00
Address and Telephone	Supermart Graphics (producer for Art Directors' Club) 22 E. 31st St. New York, New York 10016; (212) 889-6728	Suite 311, 333 North Michigan Ave., Chicago, Illinois 60603; (312) 236-7337	Ampersand, 1103 South Shephard Drive, Houston, Texas 77019; (713) 523-0506	6140 Lindenhurst Ave., Los Angeles, California 90048; (213) 939-9869 or 657-8707	P. O. Box 314, Brooklyn, New York 11205 (212) 857-9267	P.O. Box 749; 431 Post Road East, Westport, Connecticut 06880; (203) 226-4207
Comment	Primarily for the Award Winners & Annual Show, plus some ads	Must be Chicago based or have Chicago rep to advertise		Most ads, talent, art director & other listings of regional books	Oriented toward selected newer talent	

COMMUNICATIONS INDUSTRY MAGAZINES (VISUAL)

	ART DI-RECTION	COMMUNI-CATION ARTS (CA)	GRAPHICS TODAY	GRAPHICS USA (GRAPHICS NY)	PRINT	PUSH PIN GRAPHIC
Page Rates* ($) color pg. b&w page ½ b&w pg.	1190 590 354	1400 1000 Not available	Merging with a new publication to be called TO-DAY'S ART & GRAPHICS with 85,000 circulation & a mixture of fine and applied art coverage. Rates not yet available.	1590 1100 620	1670 995 655	1100 700 375
Circulation	10,000 paid	41,000 paid		20,000 free (con-trolled)	16,000 paid	3,000 paid 8,000 free (con-trolled)
Frequency	Monthly	Bi-monthly		Monthly	Bi-monthly	Bi-monthly
Telephone	(212) 354-0450	(415) 326-6040		(212) 759-8813	(212) 682-0830	(212) 674-8080
Address	19 West 44th Street, New York, New York 10036	P.O. Box 1300 410 Sherman Ave., Palo Alto, California 94303	6 East 43rd St. New York, New York 10017 (212) 949-0800	120 East 56th St., New York, New York 10022	355 Lexington Ave.., New York, New York 10017	67 Irving Pl. New York, New York 10003

* Primarily special rates for studios: designers, illustrators and photographers (not including Graphics USA/NY rates)

In addition to the these national publications, there may be local trade publications or newsletters worth considering. For example, a number of photographers and stock picture agencies advertise in the *Newsletter of the American Society of Picture Professionals* at a cost of $150 per full page and $65 per quarter page.(Box 5283 Grand Central Station, New York, New York 10017.) This primarily New York organization (with Boston, Chicago, and Washington, D.C. chapters) counts among its members several hundred picture researchers who are constantly seeking out stock photographs for their hundreds upon hundreds of clients and employers. You should talk to art directors and art buyers in your area. Find out what trade publications they use and then contact the publishers to secure information about advertising rates and schedules.

Bear in mind that you may be able to get editorial coverage in these publications even though you don't advertise in them. As explained earlier, it is probably worthwhile to subscribe to some of them just to keep up with visual developments in the field. In addition, you may find in the course of reviewing them that you have work suitable for their type of editorial coverage. If you do, you should send it to them yourself. With all the competing material cascading off the presses, you cannot rely on their stumbling on your material by chance, though of course that happens from time to time.

PROFESSIONAL AWARDS AND COMPETITIONS

The major national and local art directors and communications awards shows can provide valuable exposure for a reasonable, and in some cases minimal, cost. The best of them publish winning entries in a single widely distributed volume that usually becomes an important trade reference for art buyers, art directors, editors, and others throughout the country. This is also true for a few local and regional competitions that distribute a catalog of the accepted entries within their geographic areas. Inclusion in such publications, especially if you have won a major award, can act as an important supplement to your own direct-mail and other advertising efforts. Accordingly, before entering, check with the sponsoring organization, and make sure it gives the photographer full credit in any publication. If it does not, the time and money you spend will be nearly worthless. In addition, be sure to contact each show that interests you for official forms, before sending in any of your work.

NATIONAL AWARDS IN THE COMMUNICATIONS FIELD

Name, Address and Telephone Number	Categories	Basic Entry Fee Per Item	Additional Hanging or Publication Fee, If Accepted	Entry Due Date	Publication of Accepted Entries
American Institute of Graphic Arts (AIGA) 1059 Third Avenue New York, New York 10021 (212) 752-0813	Separate shows for communication graphics (corporate publications), books, and cover art.	$7 members and $9 nonmembers	$40 members and $55 nonmembers	Varies with topic. Contact AIGA.	In new volume, covering finalists of all shows, to be titled *AIGA Graphic Design USA* (Vol. 1 due in fall of 1980, approx. $45)
ANDY Advertising Club of New York 3 West 51 Street New York, New York 10019 (212) 541-4350	Advertising, promotion and corporate—all media.	$10	$50	Mid-November	All exhibited work reproduced in black-and-white in *The Andy Awards* ($17.50 from the Advertising Club of New York or Crain Communications, Chicago). Paid ads are accepted for the book. (Approx. $500 per page; circulation 3,000 increasing to 5,000)
Art Directors Club of New York 488 Madison Avenue New York, New York 10022 (212) 838-8140	Advertising—all media; editorial—print media; promotion—print media. Separate awards in photography and illustration.	$12	$55	Late November	All exhibited work reproduced in the *Art Directors Annual* ($34.95). Circulation approximately 20,000.
CA Communication Arts Magazine P.O. Box 10300 Palo Alto, California 94303 (415) 326-6040	Many advertising, editorial, and design categories.	$ 5	None	Mid-March	No exhibit; accepted work reproduced in *Art Annual* July issue of *Communication Arts* (41,000 circulation).

Name, Address and Telephone Number	Categories	Basic Entry Fee Per Item	Additional Hanging or Publication Fee, If Accepted	Entry Due Date	Publication of Accepted Entries
Chicago Communications Collaborative 54 East Erie Chicago, Illinois 60611 (312) 787-6118	All print media, editorial and advertising plus television and radio advertising.	$25	$50 to $75	Varies. Contact their office.	Accepted work reproduced in black-and-white in the show's catalog ($12 to $15 from the Chicago Communications Collaborative).
Cleo 30 East 60 St. New York, New York 10022 (212) 593-1900 or 5900 Wilshire Blvd. Suite 2200 Los Angeles, California 90036 (213) 937-7337	All advertising, some emphasis on radio and television; many print categories, broken down by product lines.	$45 increasing to $60	None	December 1 generally; February 1 for work published after December 1.	No reproduction of finalists' (accepted) work. Names and addresses of all prize winners and finalists listed in an issue of *Cleo* magazine.
Creativity *Art Direction* magazine Suite 802 19 West 44th Street New York, New York 10036 (212) 354-0450	Advertising and editorial—wide range of print media categories and separate categories for photography and illustration.	$4	$9	Mid-May	All exhibited work reproduced in the annual *Creativity* ($24.50 distributed by Art Direction Book Company, New York).
Mead Annual Report Competition Mead Library of Ideas, Marketing Communications Department, Mead Paper Corporation Courthouse Plaza— Northeast Dayton, Ohio 45463 (513) 222-6323	Annual report design, with photographers and illustrators credited.	None	None	Mid-June	Portions of top 20 annual reports reproduced in black-and-white in *The Bestever*, a catalog of the exhibit (available free of charge from Mead).

Name, Address and Telephone Number	Categories	Basic Entry Fee Per Item	Additional Hanging or Publication Fee, If Accepted	Entry Due Date	Publication of Accepted Entries
Pictures of the Year University of Missouri School of Journalism 100 Neff Hall Columbia, Missouri 65211 (314) 882-4882	Photojournalism awards cosponsored by the University of Missouri and Nikon. Thirteen newspaper, nine magazine, and five editing categories.	None	None	Mid-January	Award winners' work reproduced in *The Best of Photojournalism Annual* (Available from Newsweek Books, New York).
Publication Design Society of Publication Designers 3 West 51 Street New York, New York 10019 (212) 582-4077	Design photography and illustration awards for editorial contents of consumer, trade, and corporate magazines and newspapers.	$5 (members) and $7 (nonmembers)	$50 members and $60-65 nonmembers	Mid-January	All exhibited work reproduced in annual volume of *Publication Design* ($25 from Hasting House, New York). Paid ads are accepted for the book at approximately $500 per page. (Circulation is currently 3,000 copies.)
Pulitzer Prizes Columbia University School of Journalism Room 702 New York, New York 10027 (212) 280-3841	Photography in United States newspapers: 1 prize in spot news, 1 prize in feature reporting.	None	None	February 1	No publication by Pulitzer organization.
Robert F. Kennedy Photojournalism Awards 1035 30 St. NW Washington, D.C. 20007 (202) 338-5753	Outstanding published coverage of the disadvantaged.	None	None	Late January	No publication by the program; cash awards vary from $1,000 to $3,000.

Important shows and awards that tend to focus more on local or regional submissions include the following.

Art Directors Club of New Jersey
841 Mountain Avenue
Springfield, New Jersey 07081
(201) 232-6800; closing date December 1.

Art Directors Club of Philadelphia
2017 Walnut Street
Philadelphia, Pennsylvania 19103
(215) 569-3650; closing date early February.

Belding Awards
Advertising Club of Los Angeles
3105 Wilshire Boulevard
Los Angeles, California 90010
(213) 382-1228; closing date in March.

Best in the West
American Advertising Federation
Suite 425
50 California Street
San Francisco, California 94111
(415) 421-6867; closing date in February.

CASLA Awards
Communication Arts Society of Los Angeles
1258 North Highland Avenue
Suite 102
Hollywood, California 90038
(213) 469-8301; closing date mid-November.

Connecticut Art Directors Club
P.O. Box 1974
New Haven, Connecticut 06521
Closing date varies; usually late April.

An important aspect of these competitions frequently is their quasi-commercial character. Entry fees are usually modest, but hanging fees, if there is an exhibit, are usually high. The economics are designed, reasonably enough, to help support the sponsoring organization.

You, on the other hand, should try to get your client on the job submitted to pick up part of or all the costs of the entry (and hanging fee, if accepted). All parties are usually credited anyway, so it makes no sense for you to give someone else a free ride on your initiative in entering. Art directors, editors, and others in the field are usually in a position to secure such entry and other payments from their employers. The prestige of winning can be as important for your clients as it is for you. With three or four important shows per year, and perhaps two to three pieces in each show, if you are fortunate enough to be accepted in all of them, you could end up with a bill for $500 for entering and exhibiting. That is great exposure for the money, and even better if you are splitting the cost with clients or associates.

SUMMARY

- For under $2,000 per year, you can probably develop a modest monthly or bimonthly mailing program of cards, reprints, or run-on print orders that provides both high-quality visual impact and continuity.
- If your budget is tight, try a quarterly program, which might be as low as $750 to $1,000 per year.
- As the budget expands, some photographers move up to larger and somewhat less frequent poster mailings. The cost differential is, however, quite significant, and the reduced impact from infrequency makes this strategy questionable.
- Some photographers believe a big splash (such as an advertisement in the *Creative Black Book*), though it costs over $4,000, will establish them right away if the photographs displayed are strong enough. Among the beginning photographers who have poured a high percentage of their savings into this approach, at least a few have succeeded, but the risk is substantial.
- Others may well be attracted to the broad marketing program offered by the *Art Directors Index* or the far more modest page rates of the well-established *American Showcase* and the ASMP's new promotional book. Several of the regional promotion books, such as the *L.A. Workbook*, have also produced good results, perhaps because they have fewer advertisers at present, so that each individual ad draws more attention.
- The most expensive media approaches and sophisticated brochure samples are probably best reserved for the more established photographers. You can succeed in achieving visual impact in a format as simple as regular postcard mailings, with some consid-

eration perhaps being given to a promotion book ad which clearly reaches your target audience.

- Before buying any promotion book ad be sure to check with current advertisers about their results, and with art directors about their reference use of the book.
- You can get good exposure from Art Directors and other annual shows. Given the expenses involved, try to get your client to split the cost. Indeed, in some cases they may pick up all the cost.
- If you do an excellent piece or campaign, consider submitting it to the trade magazines in the field for editorial coverage.
- Some photographers don't advertise or engage in promotion at all. The "stars" don't need it, but the rest of the field probably can't live without it.

CHAPTER 4

Agents: Stock Libraries, Reps, and Galleries

General Functions

The *agent*'s primary role is to sell the photographer's work. Some agents go beyond that and provide occasional guidance on the photographer's overall professional progress, much like business managers in other fields.

Stock picture libraries (also referred to as stock picture agents, or picture agents) market the reproduction rights of a photographer's existing file materials. The scope of the photographer-agent relationship here is usually limited to those specific photographs that the library is authorized to deal with. Most stock libraries represent a substantial number of photographers, often hundreds, and in a few cases, several thousand. There are fewer than 100 major stock picture agencies in the United States.

Assignment representatives (often called "reps") generally work much more closely with their photographers, often on an exclusive basis in the cities they cover. These reps continually show their photographers' work to prospective clients and rarely handle more than four to five photographers at one time. The primary center for assignment reps is New York City, although a growing number can be found in Chicago, Los Angeles, and a few other major metropolitan areas.

Gallery representatives exhibit and sell the fine prints of their photographers. This rarely requires frequent contact, although the relationship can become quite intense when planning and executing an exhibit that involves decisions about choices of photographs to hang, framing, matting, advertising, publicity, and the opening party.

Stock Picture Agents

LOCATING AND SELECTING A STOCK PICTURE AGENT

Listings of the major stock picture agents are contained in the following books:

1. *Photography Market Place,* second edition, published by R. R. Bowker, 1180 Avenue of the Americas, New York, New York 10036, telephone (212) 764-5100 ($15.50).
2. *Photographer's Market,* (which has a slightly smaller number of listings than *Photography Market Place*), published by Writer's Digest Books, 9933 Alliance Road, Cincinnati, Ohio 45242 (published annually, $12.95).

Most stock picture agencies welcome good new material because their files must be constantly updated. In deciding on an agency, the most important things to consider are its ability to sell and its overall business reputation. You should never send material to an agency without first making a serious inquiry into these matters.

You should find out what areas the agency specializes in, if any. Are those subjects consistent with what you have shot or will be shooting? Does the agency already have an overabundance of your type of material? Is the agency big enough to do a reasonable job of selling? Is it too big to give you and your photographs some personal attention?

As to business reputation, you should check with other photographers either previously or currently represented by that agency. You may also be able to find additional information at the American Society of Magazine Photographers (ASMP), 205 Lexington Avenue, New York, New York 10016, telephone (212) 889-9144. Does the agency pay on time, and is it reputed to pay on all sales? Equally important, does the agency handle photographs carefully? Does their filing system appear to be neat, orderly, and accessible? (If photographs can't be found, they can't be sold.) Your inquiry is crucial because the agency will probably hold your material for a number of years, and the earnings from your photographs are usually split equally by the agency and you.

Once you have made an arrangement with an agency, don't send them everything you have all at once. It is a difficult, lengthy, and costly process to get one person's photographs out of the complex files of a picture library. The material usually is filed by subject, *not* by the

name of the photographer. Accordingly, it is best to start the agency out with a large enough selection to see whether there is reasonable sales potential, but you should retain enough material for yourself to go elsewhere if the relationship does not work out.

Most importantly, don't send any agency original photographs (negatives or transparencies) that you feel are priceless or irreplaceable. In the normal course of events, a small amount of work is likely to be damaged or lost by the agencies, and they never accept liability. The only recovery occurs when clients lose or damage original material. For your genuinely treasured pieces, then, send only duplicates to your agent. In addition be sure the agency signs a receipt for any and all originals you do submit.

The decision to seek a stock photo agent involves an analysis of the following factors:

- Your own success in marketing your stock files.
- Your efficiency in (or tolerance of) the administrative work involved in selling, making and documenting submissions, and keeping after clients to make decisions and return originals and make payments.
- Your ability to negotiate reasonable fees (it is generally believed that an agency will get a higher fee than an individual in most cases, because of its greater bargaining power).
- Your having a file large enough and updated frequently enough to attract an agency—you probably need 500 to 1,000 potentially saleable images for serious attention, though you might not give all these to the agency at one time. In addition you probably need to create several hundred new photographs of marketable quality each year.
- Your willingness to split the income equally with an agent.

If you have decided to approach an agency, it's best to call first and ask for an appointment, as you would do with a prospective client. You can also mail material to an agency at a distant location, but call first to see whether they are looking for new work of the type in your files. When using the mail, as usual stick to registered mail, enclose a return envelope with enough postage to cover registered mail, and request that the agency use that type of service when the material is returned.

When you and the agency decide to work together, the agency will probably make an offer to you of a contract to sign. Remember that their action is exactly that, *an offer*. Feel free to use their

document simply as the starting point to negotiate the best possible deal you can get, taking account of the discussion that follows.

STOCK PICTURE AGENCY CONTRACTS

Most agencies require written agreements to be signed before they will deal with you. Those contracts will cover some of or all the points below:

- *Exclusivity*. The agency usually requires exclusive authority to license reproduction rights on the material you give them, for the time that the work is in their file. That authority should, however, be carefully restricted to the specific geographic areas and markets in which your agency is active. For example, if they are on the East Coast, make sure they are active in selling on the West Coast. The same holds true for European markets. Alternativity, you may find that you can be more effective than your agency in selling to certain specialized markets such as greeting card and calendar companies. These are all factors to consider before granting your agency worldwide authority on an exclusive basis.

 The agency may also request exclusively on clients they sell your work to, thereby requiring you to pay the agency their regular commission (usually 50 percent) on work you yourself sell to that client directly. Such provisions are only fair in limited situations where the agency is selling your work to such clients on a regular and on-going basis. However, a reduced commission in the range of 25 percent appears to be more valid than 50 percent under the circumstances.

 Finally, some agencies ask for exclusive rights on all future stock output that you produce during the term of the contract. Strike out such a provision whenever possible. Each agency has its strengths and weaknesses; it may be good in some markets (sports and recreation, for example) and poor in others. You simply cannot afford to be tied down regarding all your future stock production.
- *Agency Commission*. The typical split on all reproduction licensing and related fees is 50 percent for the agency and 50 percent for the photographer. On foreign sales, however, in cases where foreign subagents are involved, the typical split is one-third to the foreign subagent, one-third to the photographer's main agency, and one-third to the photographer.
- *Lost and damaged materials*. If photographs are lost or damaged

by the agency's client, the money recovered is split equally by agency and photographer. This is extremely important since agencies are often able to secure settlement amounts close to the $1,500 per transparency figure recommended by the ASMP as a reasonable value for professional materials.

On the other hand, agencies do not accept liability for material they themselves lose or damage. The reason is that the agency's files are so large that the premium needed to insure them would be prohibitive. In effect, those files are uninsurable.

- *Dupes and similars.* Your agency will usually insist that you not give dupes of what you leave with them to other agencies. That is logical, because considerable embarrassment would arise if two agents were showing the same work to one client. Some agents try to extend this to cover "similars." That term is difficult to define, and reasonable judgment must be used in its application. In any event, these provisions should be specifically limited to the geographic area and market specified in the exclusivity provisions referred to above.

- *Return of photographs.* Most agencies need time, after the contract expires, to find and return your materials. This process could take as long as a year. A number of agencies, however, often try to provide for a 3-year period after the contract expires for returning your work. You can often negotiate a shorter time period. In addition, if you agree to pay for the clerical time involved, you can probably get a provision allowing for immediate search of the agency file.

Contracts often state that the agency can't be expected to get black-and-white material back from their clients. If that is true, then the agency should never get museum-quality or master prints.

The agency cannot, of course, be responsible for color material that fades as a result of normal usage. You should, however, insist on getting faded color photographs returned to ensure that they were not simply lost.

Finally, if the agency goes bankrupt or threatens to do so, you should have the immediate right to visit its offices and get all your work back. The agreement should also set forth that you are the owner of the material and that the agency is holding it for consignment purposes only. Otherwise, in the event of bankruptcy you might have to wait for years to secure the return of your material.

- *Copyright.* Any copyright notices on the photographs themselves should be in the photographer's name. If they are left off, the agency should be authorized only to place a notice in the photographer's name.
- *Accounting.* The contract should have a provision requiring that the agency provide you with a monthly, bimonthly or, at worst, quarterly accounting of all sales and a check covering those sales. The statement should provide you with the client's name, the amount paid, and the usage relating to each sale. You should also have the right to inspect the books and records of the agency on reasonable notice. These provisions are customary in all sectors of the publishing business but are relatively new to stock agency agreements.
- *Duration of contract and renewal.* Many agencies try to secure 5-year agreements with their photographers. The argument is that considerable time is needed to recoup their investments in editing, filing, storing, and promoting your material.

 You, of course, do not want to be stuck if the relationship doesn't work out, and should try for a shorter period of time. Many agencies will accept 3 years and, for important work with a ready market, possibly less.

 Renewal is an area you must watch with great care. Many agency contracts are set up with provisions calling for automatic renewal for an additional 3 or 5 years unless you notify the agency by a special date that you don't want such renewal. *If possible, never sign an agreement with that provision.* Photographers almost always forget the dates by which they have to send that notice and they are then stuck with another 5 years in a relationship that may not be working well.

 Instead of automatic renewal, the contract should have a provision stating that renewal will occur only if both parties notify each other that they wish, in fact, to renew. If the relationship is a good one, both sides will indeed want to renew and that will be no problem. In addition, many reputable agencies will be willing to terminate your agreement with them if the deal is not proving to be fruitful and will then try to get your photographs returned to you as soon as possible.
- *Change of ownership.* The photographer-agent relationship is usually quite personal. If the agency sells out to new owners, the photographer should have the opportunity to reassess the situation. Once notified of the change, the photographer might well

want to have a 60- to 90-day period in which to terminate the agreement. Such provisions are, however, not yet commonplace.

- *Arbitration.* It would be wise to include a provision in the contract calling for arbitration of disputes between the photographer and the agency, since that procedure is generally somewhat less costly and less time-consuming than court litigation.

Assignment Representatives (Reps)

LOCATING A REP

Most assignment representatives (reps or representatives) concentrate on securing advertising agency accounts and, to a lesser degree, annual report and other accounts for their photographers.

The photographer-rep relationship requires almost daily contact and considerable rapport between the two. The rep is constantly showing the portfolio, developing estimates, discussing new jobs, and delivering finished jobs.

The number of jobs a rep can bring in will vary widely. Some reps try to keep their photographers working on a new shooting every day and are capable of generating enough work to accomplish that. Some photographers, however, can't handle that level of intensity for an extended period. Accordingly, the rep and photographer must determine an acceptable pace that will allow the photographer to test, experiment, work on personal projects, and fulfill all job obligations arranged by the rep. Obviously there is no set rule here. Every photographer-rep relationship will be different on this score. Equally true, if the rep can't bring in whatever level of jobs both agree is necessary, the relationship will certainly deteriorate, probably ending within a period of 6 months or less.

Good reps are quite scarce, and their total number is probably under 200 in New York City, which is their major media market center. Due to this scarcity, and to general economic pressures, few reps, if any, make a practice of handling new talent (photographers without at least a few regular clients in advertising or corporate fields). In any event, most photographers and reps believe it is preferable, when starting out, to gain as much selling and marketing experience as possible on your own, before even considering association with an assignment representative.

Interestingly, the reps in New York, Chicago, and Los Angeles often represent established photographers from cities other than their own, to execute specialized shootings or distant location shots when travel budgets are limited. For example, many New York reps, in

addition to their New York photographers, show the work of Los Angeles and San Francisco photographers who can handle outdoor location work for winter shootings when those jobs cannot be completed in New York City. Similarly, a number of Chicago reps show the work of leading photographers in New York City who have unique styles that may not be available among the Chicago photographers.

A high percentage of New York representatives are members of the Society of Photographer and Artist Representatives (SPAR). A directory of their members can be obtained from SPAR at Post Office Box 845, F.D.R. Station, New York, New York 10022, telephone (212) 832-3123 (enclose $5 and a self-addressed stamped envelope with 30¢ postage). You will then be able to send each member a card or other sample of your work in the hope that it will generate sufficient interest to warrant an interview. If you are approaching West Coast reps, many are listed in *The L.A. Work Book* ($18 from the publisher, Alexis Scott, 6140 Lindenhurst Avenue, Los Angeles, California 90048, telephone (213) 657-8707).

ASSIGNMENT REPRESENTATIVE CONTRACTS

Once you and a rep have decided to work together, you should enter into some kind of written agreement. Many arrangements are never documented in writing, and that is probably a mistake since a simple exchange of letters will usually cover the major points. Some reps use a standard contract form made available to members of SPAR. That is, of course, only one of a number of possible approaches, and the form should always be modified to reflect your particular circumstances. Whether you use an exchange of letters, the SPAR form, or a new agreement you have drafted, the arrangement should cover the following points:

- *Representative's exclusivity.* Normally, the representative is the photographer's exclusive assignment agent in the market or geographic area covered by their agreement. Accordingly, those areas of work and geographic territory should be carefully specified. Frequently different agents are engaged for the different major markets (New York, Chicago, West Coast, Europe). Similarly, different reps may be engaged for advertising, editorial, and television.
- *Commissions.* The generally accepted commission percentage is 25 percent of the fee. Nonetheless, a few very successful talents have salaried reps who may simply receive a percentage bonus. A

few agreements provide for a 20 percent commission; some also provide an extra 5 percent on out-of-town accounts (due to higher sales costs on those jobs). In television commercials the commission rate is usually 5 to 7 percent of gross billing. Agents who specialize in photojournalism have higher rates.

For photographers working primarily in the commercial fields, the commission on lower-paying accounts such as editorial illustration is often reduced, sometimes to 12.5 percent or 15 percent. The theory here is that the work in these markets is primarily for promotional effect (credit lines) and is not a primary income source for either the representative or the photographer.

- *House accounts.* Accounts that a photographer has been working on prior to forming a relationship with a new representative are referred to as "house accounts." Commissions on these accounts are typically lower than 25 percent (frequently 12.5 percent). Some photographers prefer to pay no commission at all on house accounts. The problem then is that the representative might well ignore the account and it may diminish sharply. Therefore it is usually preferable to pay some commission even on house accounts, and to increase the percentage as overall billing is increased from the new rep's effort.

- *Expenses.* No commissions are paid on expenses normally charged to the client. When jobs are undertaken on a flat-fee basis, the expenses normally billed must be subtracted from the total price before the commission is calculated.

- *Billing for jobs.* Since photographers invest considerable time and often advance expenses to complete the job, they usually handle the billing and pay the rep as soon as money is received. In some cases where the photographer is too inexperienced or just too busy to handle the necessary records, the representative should handle the billing. In any event the photographer and rep should both agree on the wording and amount of all bills.

- *Advertising and promotion.* The costs of promotional expenses (such as mailers and paid advertising) are sometimes split equally, in other cases they are divided 75/25 in accordance with the typical fee/commission split. The ratio invariably depends on the total financial interrelationship between photographer and representative.

- *Termination.* The termination provisions are the areas of greatest sensitivity in the photographer-representative contract situation. In most contracts, either party can terminate on 30 days' notice or less. Generally the representative receives some commission after

the termination based on work the photographer does for those accounts secured by the representative in question. The theory here is that the rep is entitled (for a reasonable period) to compensation for efforts that in fact generate current income for the photographer, even though they are no longer working together.

The usual provision is that the representative receives full commissions for a *maximum* of approximately 6 months on accounts that he or she secured prior to the time of termination. These commissions are called "residuals." During the first year of association, residuals are sometimes limited to approximately a 3- to 4-month period. Thereafter they typically increase to a maximum of 6 months after no more than about 2 years. In many cases the representative will seek to have the 6-month period apply immediately, and the point may require fairly intense negotiation.

Residuals are generally not paid on any of the original house accounts unless the rep took over the responsibility for them. However, if the representational association has lasted for a considerable period of time (perhaps over 2 years), a reduced residual (perhaps 12.5 percent) might be paid for up to 6 months on such house accounts.

- *Following termination.* The contract should provide that all sums owed by either party to the other, on previously billed work or work in process, will be paid promptly upon receipt from the client. In addition, the representative must agree to return the photographer's portfolio immediately upon termination.
- *Arbitration.* It would be wise to include a provision in the contract calling for arbitration of disputes between photographer and representative, since that procedure is generally somewhat less costly and less time-consuming than court litigation.

Contracts with Galleries

Sources of information regarding the names of galleries known for selling photographic prints were provided on page 35. The following points should be covered in writing whenever you become associated with a gallery, whether it is a commercial or cooperative organization.

- *Gallery's territory and exclusivity.* Some galleries may try to secure the exclusive right to represent you in the United States or worldwide. Unless it is an unusually powerful gallery, with vast

connections, that provision should not be accepted. More typically, your gallery will have a local market (its own metropolitan area) or possibly a regional market (such as New England, or the Midwest). You should restrict exclusivity (if any) to the specific geographic area the gallery has handled in the past. Otherwise you may simply lose out on markets that the gallery cannot possibly reach.

• *Duration.* Keep the duration of the contract as short as possible, preferably for 1 or 2 years at most. Remember that the larger the geographic territory you give the gallery, the more important the duration of the contract. A long exclusive contract covering a wide territory can be disastrous if the gallery is unable to sell your work.

• *Type of work involved.* Limit the nature of the work you are providing the gallery. Some agreements include both prints and reproduction rights to those images in other media. That should not be accepted. In fact, most galleries have much less experience than you do in media other than fine prints. There is rarely any reason for your gallery to get a commission on deals you make for reproduction on calendars, greeting cards, magazines, and the like. The one exception may be for limited-edition graphics or posters, which are also sold in a retail gallery setting.

Regarding the type of work involved, you should also specify whether the gallery is handling color photography, black-and-white photography, or both. Your gallery may do a fine job with black-and-white prints, for example, but have no experience in dealing with color photography. Be sure you know what the contract covers in this regard.

• *Commissions.* Gallery commissions are usually 33-1/3 percent to 50 percent for the gallery. The range is a function of gallery overheads, promotional expenses, and the like. Remember that, if the contract is an exclusive one, it will cover sales you make directly in the market specified to be exclusively the purview of your gallery. This means that you will probably owe a commission to the gallery on such sales. Sometimes the commissions on sales that you make directly are at a reduced rate.

• *Exhibits.* Try to secure agreement on the number of one-person and group shows that you will be in over a specified period of time. Establish who has artistic control over those shows, with reference to choice of prints, frames, matting, and placement. Also determine who will be paying for the promotional expenses

of these shows in areas such as advertising, opening party, and catalog.

- *Pricing.* Both you and the gallery may wish to control pricing, and the contract should specify who has the final say here. A good reason for your control is to prevent sales that are artificially low-priced to "insiders" who will help to build the gallery's own inventory for later resale at a higher profit. While this is a most unlikely situation, the possibility of it can never be entirely discounted.

- *Accounting and payments.* You should receive statements of sales indicating the quantity of each print sold, the price, and, where possible, the buyer's name and address. These should be sent quarterly, semiannually, or, alternately, whenever a sale is made. The applicable payment should accompany each statement.

 As a parallel provision you should be accorded the right to inspect the books and records of the gallery with reference to the sales or loans of your work, upon reasonable notice.

- *Copyright.* The contract should specify that the copyright on all works belongs to the photographer and that any buyer will be put on notice that purchase of a print conveys no reproduction rights whatever.

- *Consignments.* If you are leaving prints on consignment with a gallery, establish a procedure whereby each piece that you leave is signed for, with an acknowledgement that you are the owner of all rights and title to the print until it is sold. This may protect your right to get the print back in the event the gallery goes bankrupt. A few states, including New York and California, have statutes that provide for this safeguard.

 As another protection in this area, provide that in the event of any bankruptcy or act that can be reasonably deemed to indicate insolvency or threatened bankruptcy, the contract is automatically terminated, and you have the immediate right to enter the premises and obtain your prints.

- *Damage or loss.* Try to require the gallery to insure your prints against damage, loss, or theft, at least up to the amount you would receive if they were sold (in effect, the wholesale rather than the retail value). It is especially important that the work be insured while in transit to a museum or buyer, when risks of loss or damage are greatest.

- *Change of ownership.* The gallery business is highly personal and

you should have the right to terminate the agreement if the business changes hands.

- *Arbitration.* You should include a provision in the contract calling for arbitration of disputes between yourself and the gallery, since that procedure is generally somewhat less costly and less time-consuming than court litigation.

PART II

Business Guide

CHAPTER 5

Pricing Photography and Billing Expenses

The Pricing Dilemma

Pricing is the end product of time, talent, costs, and competition. You will *want* your time to be adequately compensated. In addition, you *must* recover your costs and simultaneously remain competitive.

As to competition, the tables in this chapter (pages 83-89) provide a sampling of typical going rates for most of the photographic markets. These prices, however, always vary somewhat from one community or region to another. The tables thus should be seen as useful starting points. They do show clearly the relationships between one type of photography and another, and the range of pricing for each specific market. With those tools you can refine the information as it applies to your geographic area and photographic specialty.

Photographers frequently discuss these matters with one another, especially when they are just getting started. You should make it a point to be in touch with others at your level of experience. In addition, personal friends who are art directors, art buyers, or editors may also provide helpful guidance on pricing matters. Consult them from time to time when their own interests are not affected.

For studio work such as local commercial assignments, weddings, and portraits, many photographers have printed price lists reflecting common situations. You should try to secure as many of these as possible in your community. You can then price your own work, basing your prices in part on existing standards and client expectations.

If you are starting out you may not have all the extensive studio facilities or equipment available to some of your competition, and your prices may reflect this, unless of course your talent and skill can overcome those drawbacks.

Few photographers, however, want to be known as the cheapest in town. This reflects both ego and good business judgment. Most professionals believe that the majority of clients are looking for a reasonable combination of acceptable price and quality. Many clients undoubtedly fear that the absolutely lowest price necessarily means a large compromise in quality.

It is an equally perverse truth that some clients will seek out only the most expensive professionals in certain fields (certainly including photography), provided those professionals have established a suitable image of outstanding reputation or quality.

However, for the bulk of professionals—full-time, part-time, or just beginning—pricing requires the good sense to charge approximately the "going rate" for similar services, taking account of the overall experience, talent, and reputation a photographer brings to the situation.

The discussion and tables of going rates for assignments and stock photography follow two sections covering cost recovery and the billing of expenses, and negotiation tactics.

Cost Recovery and Billing of Expenses

Your pricing for a job must result in a complete recovery of all direct costs of that job, plus additional revenue to offset a fair portion of your general overhead. If the competitive price structure does not permit this to occur, you will be out of business unless you can reduce your costs in some manner.

Assignments in advertising, corporate-industrial, editorial-journalism, and other media-related fields usually permit the photographer to bill the client for all direct out-of-pocket expenses associated with the job. Many commercial assignments for brochures, catalogs, and so on are done on a similar fee-plus-expenses basis. Virtually all portrait and wedding work and some commercial studio work is done on an all-inclusive basis wherein the flat fee and/or per-print fee includes all expenses.

For work done on a fee-plus-expenses basis it is, of course, crucial to bill *all* expenses. A complete list can be found in the contracts chapter, on the assignment agreement form (page 95). That form reminds you to bill for photo assistants, casting, stylists,

hairdressers, location finders, and other personnel, as well as for all film and processing, transportation, sets, props, wardrobe, and travel.

Items that are easily overlooked include Polaroid film; assistants' lab time and printing paper (for in-house processing); assistants' time required to strike a set; telephone toll charges; gratuities and in-house lunches (where necessary) for the crew, client, and models; and a pro rata portion of your liability insurance coverage (since that may protect the client as well as yourself).

These seemingly minor items can mount to a significant portion of the photographer's fee and should be billed. For example, one box of Polaroid color film, 10 sheets of paper, a few lunches and telephone toll charges can easily amount to $25 or $30. On 100 jobs per year that's $2,500 to $3,000. Add a pro rata $25 service charge per job for liability coverage (assuming you have it), and that's another $2,500 per year. These simple adjustments in billing can thus yield over $5,000 per year on a relatively modest number of jobs.

You must, however, avoid surprises for your client. Make sure the client understands, in advance, what charges are going to be made. You should provide a detailed estimate of expenses wherever possible. It will protect both you and your client. Thereafter scrupulously document all items of expenditure for each job.

In many major markets, photographers do not charge a mark-up on their expenses (especially in the media-related fields). As a consequence, photographers often have little leeway for error. If they forget to bill some item, they will not be protected by mark-ups on other items. As a result, there's a premium on excellent record keeping.

When you work on a flat-fee basis, the situation actually does not change much. In almost all cases today, you have to know what your expenses are going to be in advance. On the fee-plus-expenses basis, you will probably supply the client with a written estimate in advance. You need that same information to set a flat fee on any job, including establishing rates for weddings and portraits.

In addition to recovering all your direct expenses, you must recover a fair portion of general overhead on each job. Those are the items that are never billed to clients and include such expenses as commissions, equipment amortization, fixtures, legal and accounting services, office salaries, rent, sales and promotional expense, telephone charges, unbillable general insurance, and utilities.

You or your accountant should approximate as closely as possible the number of jobs you are likely to complete over a given period and divide that number into the total of your overhead expenses. The

result is the amount of money you must build into every photo fee before there is a profit (salary) left over for you.

Consider the following modest operation (beginners may well have even lower expenses, and studios with several employees could be much higher).

Overhead Charge	*Annual Cost ($)*	
Rent	$ 4,800	($400 per month)
Equipment	2,000	(14,000 to last 7 years)
Utilities and phone	1,800	(150 per month)
Promotion	1,000	
Insurance	700	(not directly billable)
Accounting and legal	1,500	
Salary	5,200	(part-time bookkeeper/ secretary @ 100 per week)
Miscellaneous	1,000	
Total overhead	$18,000	

At 150 jobs per year, the pro rata portion of this overhead total is $120 per job. Thus, even at this relatively modest level, the photographer needs to charge over $120 per job, plus all direct job expenses, in order to simply break even. In addition, that same photographer must charge $220 per job to net $15,000 per year ($100 profit for 150 jobs).

Alternatively, if the number of jobs goes up to 200 without significant additional overhead, the break-even drops to about $90 per job. However, if the number of jobs drops to 100, the break-even rapidly escalates to $180 per job. (Again, the break-even does not include any allowance for net profit to the photographer. That is merely the point at which all costs are covered.)

The following table summarizes the situation for a variety of different activity levels, assuming constant overhead (usually, however, overhead increases with a substantial increase in the number of jobs).

Break-Even Points and Profitability

Total Number of Jobs per Year		50	100	150	200
Annual Overhead ($)		18,000	18,000	18,000	18,000
Break-even per Job ($) Overhead divided by number of jobs; assumes all direct costs billed or included in fee		360	180	120	90
	Annual Inc.	Charge Per Job			
Total Charge per Job* Needed to net annual income from $10,000 to $30,000	10,000	560	280	187	140
	15,000	660	330	220	165
	20,000	760	380	253	190
	25,000	860	430	287	215
	30,000	960	480	320	240

*Break-even, plus net income divided by total number of jobs per year. Thus, if you do 50 jobs per year, your break-even is $360 per job and you need to charge an average of $760 per job to net $20,000 for the year.

It is no surprise that the table shows that the higher your fees, the fewer the jobs you need for a specified level of net income. For example, to net $20,000 per year you can do 50 jobs for $760 each or 200 jobs for $190 each. Of course, the higher-paying jobs may also be the most complex, so the trade-off in work effort is never clear-cut.

The main point is that you should see where you fit in the above pattern. Are you charging enough above your break-even to ensure a reasonable income level, given the number of jobs you do? Are you better off modifying your fee structure or securing more work? With the above analytic tools you can begin to develop answers to some of these questions.

Negotiation Tactics

Many highly skilled photographers pale at the thought of negotiating their fees and expenses on each job. This is unfortunate because mastery of a few basic principles in negotiations would drastically alter those attitudes. While we cannot cover all aspects of the subtle interaction involved in active negotiation, the guidelines below may help you to see the situation in a less threatening light.

- If you want something, ask for it. Virtually no one makes concessions that aren't requested.
- The more information you have about the concessions someone usually gives, and the less you reveal about that, the better off you are.
- Often, the greater your demands the better your treatment. If you do not demand professional treatment, you will not receive it.
- Add something sensible to your demands that you know in advance you're willing to surrender. The other side also needs to feel it has won concessions.
- If you can't afford to say no, you can't afford to negotiate. In other words, you'll never know what your "going rate" could be unless you're willing to risk losing a few deals.
- If a client can't afford an advance or a deposit now, you're going to be in trouble later.
- The key to negotiating clout in photography is the quality of the samples you show and your sense of security (or insecurity) about them.

The Going Rates

The rates below provide a fairly wide range of prices within various job and stock photo categories. This reflects the fact that each photographer's overhead, cost structure, and income requirement is unique. In addition, the desire to do a particular job, to get a particular tear sheet or sample, can be a factor, especially for beginners. The tables on pages 83-89 are designed as aids both in pricing and in marketing. They group different media and uses according to their price levels per job. You can thereby clearly see which are the highest-, average-, and lowest-paying market clusters. Those groupings provide some clues as to where you can most effectively direct your personal promotional efforts.

From another perspective, if you are known as someone who earns a certain amount per day (or per job), the assignment pricing table also gives a clear picture of which markets exist at that pricing level. You probably can't economically afford to work in lower-paying markets, and you may not yet be ready for the higher-paying realms. Again, the tables show what's available in the market at your going rate.

The following tables do not, however, tell the whole story. There are special situations whose scale bears no relation whatever to the usual going rates. A few examples will suffice:

1. Several years ago the producers of a $20 million motion picture determined that they had to have a photographer's prize portfolio piece as the logo image for their film. In the film industry designers are customarily paid $12,000 to $20,000 for creating such images from scratch. The photographer was paid $14,000 for three years' exclusive use (and additional nonexclusive use) of the image in question. The producers actually saved money because they didn't have to commission several different artists to create competing logo images.
2. A professional photographer was recently among a group of people (including several celebrities) who were involved in a bizarre kidnaping. He was allowed to photograph the incident, and when everyone was released he had the only inside photos and made the following sales:
 - A first rights' exclusive (to last only 24 hours) to a daily newspaper for $1,000 (the paper ran a front-page photo and centerfold spread).
 - First United States magazine rights to a leading United States pictorial magazine for a minimum guarantee of $3,000, plus $1,500 per page if usage ran more than two pages (it didn't).
 - First German magazine rights: $3,000.
 - First French magazine rights:$1,000.
 - First English magazine rights: $1,000.

 All those sales were made in New York City by the photographer himself, visiting the offices of the magazines involved within a 36-hour period after the release of the victims was first reported on television.
3. The most dramatic coup of all probably belongs to the photographer who managed to take an apparently unauthorized photo of a major rock star in his coffin. The photographer was reportedly paid $75,000 for all rights to the photo by one of the major United States "personality" weeklies, an investment that was quickly recovered. That publication boosted its own United States newsstand sales by some 250,000 copies and also sold the German rights to that photo for $37,500.

These examples also indicate one other crucial factor about the tables below. The prices they provide are in accordance with certain specified uses. If greater uses are made, you should seek additional compensation whenever possible. Your agreements with clients should reflect that, as discussed in the chapter on contracts (see page 90).

Particularly in regard to stock photographs, those photographs that you already own, the norm in the industry is almost universal in its application. The basic transaction is that the client acquires one-time (usually North American) rights to the photo for the specified usage. Any other uses require additional compensation. One time in a magazine advertisement, for example, usually means usage in a single advertising layout wherever that may be run (usually involving multiple insertions, unless a single insertion rate has been bargained for). Similarly, one time in the hardcover edition of a certain book does not include foreign editions or the soft-cover edition unless specifically authorized. These points will be developed in greater detail in the contracts chapter; nonetheless, they should be kept in mind when referring to the going rates that follow.

Finally, for additional information, there are two sources that you may find useful. The American Society of Magazine Photographers (ASMP) publishes a guide best known for its detailed pricing information in the media fields, that is, those fields outside weddings and portraits. The title is *ASMP Guide to Professional Business Practices in Photography,* edited by Arie Kopelman ($12.50 plus postage from ASMP, 205 Lexington Avenue, New York, New York 10016, telephone (212) 889-9144). It is generally felt that this book is geared to professionals who are at least reasonably well established. For pricing information, particularly as it relates to weddings and portraits, you may find some help in *The Blue Book of Photography Prices,* by Thomas I. Perrett ($65 from Photography Research Institute Carson Endowment, 21237 South Moneta Avenue, Carson, California 10745, telephone (213) 328-9272).

The Going Rates: Assignments

Whole-day rates or assignment (per job) rates, as applicable

Media Advertising

	Local	Regional (or 1 major metro area)	National (or several major metro area)
Billboards	Products and packaging		
Catalogs and sales brochures (day rates; for covers and shot rates, see below)	Stills for television commercials (at lowest end of range)	$600–1,000	$1,250–2,500 +
Consumer magazines	(25 percent less for newspaper)		
	Trade magazines (see below)		
Newspaper campaigns			

Promotion and Corporate/Industrial

Scale of Distribution or Production

	Minor	Average	Major
	(smallest companies, limited print runs, local distribution insert shots, and so on)		(largest companies or print runs, widespread distribution and so on)
GROUP 1			
Album covers			
Annual reports (day rate)			
Brochure and catalog covers			
Point of purchase			
Posters (promotional)			
Trade magazine ads	$300–600	$600–750	$750–1,500
Senior executive portraits			
Calendars (promotional)			
Motion picture (special stills)			

GROUP 2

Brochures (nonsales)			
Nonprofit Organizations			
Film strips (educational, at low end of range)	$250–350	$350–500	$500–850
Promotion (press kits and general public relations)			
House organs			
Slide shows (trade shows)			

GROUP 3

Brochure and catalog per-shot rates			
Fashion (single full figure) and Still life (single product/item) (see above for covers and day rates)	$ 50–100	$125–250	$300–400 +

Editorial and Journalism

	Minor (Limited-run publications, smaller trade magazines, insert shots)	Average (Medium-run publications and larger trade magazines)	Major (Those with national distribution or circulation)
Book and magazine covers	$250-350	$400-600	$750-1,500
Editorial illustration day rates[1] (fashion, home product, & general documentary magazines)	$200-250	$300-500	$600-1,000
Photojournalism (magazine and newspaper hard news) day rates[1]	$150-200	$250	$250-400+

[1]Usually day rate is a minimum guarantee against space rate.

The Going Rates: Stock Photos

Editorial and Related Media

Magazines	*Other Media*	*Usage[1]*	
(Consumer, trade, corporate [house organs] and Sunday supplement magazines)	(Annual reports, books calendars, filmstrips, greeting cards, posters television programs, trade slide shows)	(Half page to three-quarter page[1] in print media, one shot in other media)	
Consumer magazines below 200,000 circulation, smallest trade publications, and house organs[2]	Specially limited book print runs only, local television, film strips[3]	color $75–100	black-and-white $50–75
Consumer magazines between 200,000 and 500,000 circulation, typical trade magazines, and house organs	Trade books and text books (additional 25 percent for encyclopedias), metropolitan area television, trade slide shows[3]	$150–200	$100
Consumer magazines between 500,000 and 1 million circulation, major trade magazines and house organs, major Sunday supplements	Greeting cards (advance against royalty),[4] annual reports of smallest companies	$250–300	$150
Consumer magazines between 1 and 3 million circulation	Typical annual reports	$400	$225
Consumer magazines over 3 million circulation	Major annual reports, retail posters, and calendars (advance against royalty on later two)[4]	$500	$300

(Footnotes on page 88)

[1] Quarter page: subtract 25 percent; full page or back and flap of book jacket: add 25 percent. Covers: One and a half to three times full-page rate (may be higher for certain mass-market paperback books).

[2] Publications outside the reasonably professional markets may be a bit lower but are often not profitable to serve on a regular basis.

[3] Discounts for large quantities may be 15 to 20 percent for over five images and 25 to 35 percent for 100 or more.

[4] Royalty is normally 5 to 10 percent of publisher's receipts (depending on volume; see contracts chapter, page 109).

Advertising and Promotional Media

Per-shot fee is same as single assignment rate for items not shown on above stock photo rates: (For example: 1 shot for regional billboard is $600–1000; for major catalog or annual report cover it would be $750–1,500).

The Going Rates: Portraits and Weddings
Portraits

	SITTING FEES[1]	
Economy[2]	*Standard*[2]	*Custom*[2]
One or two changes; six to eight poses; head and shoulders only.	Two or three changes; 10–15 poses; head and shoulders only (possibly half or three-quarter view) some negative retouching.	Three or four changes; 15–20 poses; possible changes in lighting or background; extensive negative retouching, up to full-length views.
$15–40	$30–65	$50–85

	TYPICAL PRINT FEES (color)			
Size	5 x 7	8 x 10	11 x 14	16 x 20
First Print	$20–55	$30–85	$55–175	$120–250
Duplicate	$15–35	$15–45	$35–110	$ 60–140

Weddings

PACKAGE BASIS: Varied groupings of standard machine prints, such as:

4 x 5s or (5 x 5s)	$5– 8 each
plus 5 x 7s	$7– 9 each
plus 8 x 10s	$9–14 each

Adding up to minimum fees of $400 to $700
for usual choice of economy,[2] standard,[2] and custom.[2]

FEE-PLUS-PER-PRINT BASIS: Sitting fee of $20 to $40 per hour (for 3 to 4 hour minimum). Plus per-print fees for each print (high end of above wedding scale on first prints, reduced thereafter). Minimum total, as required by photographer, is also common.

[1] Sitting fee is usually charged *plus* all print fees. This range does not include a limited number of well-known celebrity or "star" photographers whose sitting fees can range from $1,000 to $2,5000 (plus expenses). See also the range for senior executive portraits referred to in the assignments pricing table above.

[2] Most photographers have a range of services and prices. They will normally have a price sheet listing at least three (and possibly more) categories. This necessarily means the least and most expensive, and one or two in between. The names used to descibe the categories differ from studio to studio. "Economy" might be described as "popular." "Standard" as "regular" or "general." And "custom" as "prestige."

CHAPTER 6

Contracts

A CONTRACT describes the working relationship between two or more parties. The best time to get a contract in writing is when everybody is getting along fine, and you don't need it. It's easy to work out the details then and you're protected if something goes wrong later. Some agreements are oral and therefore difficult (but not impossible) to enforce. Others are wisely set down in writing.

If you get a contract from a client, read it with great care. Remember, it's not drafted for your benefit. If you don't understand it, get expert help. There's usually a good reason for your confusion. Also, remember that, just because something is printed on a form, that doesn't mean it can't be changed by crossing out some words or adding others.

A written agreement can be incredibly short—even a few words. For example, suppose in a note to a client you say,

> I look forward to shooting for you on November 1, for $500, photography to be used solely for brochures.

If accepted, that's an agreement, a contract. It sets forth the fee, duration of performance (one day), and usage limitations (brochures only). It doesn't cover everything but it's far better than nothing.

Contracts come in many forms. Letter agreements are one. Standard purchase orders from clients and standard assignment agreement forms from photographers, if accepted, are other forms of contracts. A simple statement on an invoice may also form a contractual relationship. For example, suppose you state the following on your bill: "For annual report use only," and you previously had an oral understanding with the client accepting that limitation. Assuming the bill was paid without argument, the client would clearly be limited to annual report use only.

For more complex situations such as long-term assignments, with

vast expenses and sophisticated multiple uses, specialized documents drafted by an attorney may be required. That is the exception. Simple forms and short letters will cover most situations.

The discussion below describes the points you should cover in most common agreements for assignment work and stock sales. For these situations, sample contract forms are also provided. The discussion concludes with checklists of items to consider when contracting to do a book or when selling original prints. The specialized topic of contracts with agents (stock, assignment, and gallery representatives) is covered in the chapter on agents (page 60).

Commercial and Publishing Assignments

The following points can be covered in a letter or in some cases with a simple note on an invoice. Also consider using the assignment agreement form at the end of the discussion on this subject (page 95).

1. *BASIC FEE:* Specify the amount per day (if it's a day rate) and the guaranteed number of days, if any, or, if applicable, the amount per photograph (if it's an assignment rate).
2. *MISCELLANEOUS FEES:* Try to cover as many of the following items as possible:
 Overtime: Occasionally the photographer will be able to secure an hourly charge after a certain time of day (say, 6:30 P.M.) or whatever you might consider a reasonable hour. Some others specify overtime after a stipulated number of hours (say, 8 or 9 hours). The probability of securing overtime is likely to depend on the size of the basic fee. The more modest the basic fee, the more acceptable a charge for overtime.

 Space or use rate: Magazines have preestablished space rates, but these are occasionally negotiable. You may be able to get a better deal with special material. The day rate in that field is usually an advance against the space rate. In the advertising field some fees are based on a day rate plus a usage fee if any of the material shot is utilized (or if more than a certain number of shots are used).

 Travel, preparation and weather days: Travel time is often compensated at half-fee. If the overall deal is good enough, you may decide to accept less. The same applies to half-fees for

weather cancellations. Both are negotiable. In addition, a big shooting that can tie you up for days beforehand may have a budget for preparation days at half-fee. This is not common, but it is worth talking about in your discussions with the client.

Cancellations and postponements: Try to provide for at least a half-fee if you don't get reasonable notice. Some photographers consider 48 hours reasonable. Others need a longer period of time and some will accept less. Frankly, these are very touchy points with clients. You might consider waiving a postponement fee if the reshoot takes place within a reasonably close period of time (for example, 30 days).

Reshoot fees: This is another difficult area. The usual rule is that the client pays an additional half-fee plus expenses where the client desires a reshoot because of a need to change from the original layout or concept. Naturally, some clients will balk at this. In any event, you should have the first right to do a reshoot, before the client takes the job elsewhere. That is a customary arrangement.

Secondary photographs: Many agreements provide for a special rate for small inserts, which is often lower than the rate for the principal photography. Regardless of the size of the job, such work should definitely not go unbilled.

3. *EXPENSES:* If you are working for a fee plus expenses, it is safest for everyone if you provide a written estimate, if expenses are at all substantial. Indicate that, per normal industry practice, expenses on approved items may if necessary exceed the budget by 10 percent without requiring further approval. Be sure to include all categories of applicable expenses on your estimate per the form that follows the discussion in this section, on page 000.

4. *ADVANCES AND PAYMENTS:* Many clients will at least advance out-of-pocket expenses if they are going to be quite large on a given job. On a job that will extend over a considerable period of time, some clients will accept a schedule of partial payments (for example, one-third up front, one-third upon partial completion, and one-third on final billing). You should indicate that all bills rendered must be paid within 30 days, with a service charge (often stated at 1.5 percent per month) for late payment. Service charges are in fact rarely, if ever, collected. Stating them on an invoice may, however, lead to quicker payment.

5. *USAGE:* You *must* be specific about usage. Whenever possible, indicate the general category of usage, the media it is slated for, and the title if it is a publication or the name if it is a product. For example, "Advertising in trade magazines for product X only." That would entitle you to additional compensation for uses such as on television, in consumer magazines, in brochures, or in any connection associated with product Y. The more specific you are, the better. You should also become totally familiar with the different categories of photographic uses provided in the pricing charts on pages 83-89. These are primarily advertising, corporate, promotional, editorial, and journalism. Those same pricing charts will also familiarize you with virtually all the relevant media such as books, magazines, (trade, consumer, and corporate) television, posters, billboards and so on. If you then insert the publication name or product name you will have a complete description of the usage.

The word "only" can also be very important. It establishes with certainty that no other use is permitted. If you think the word "only" will frighten your client, try an expression like "other rights reserved to photographer."

There is, by the way, nothing unacceptable about selling multiple rights or even all rights, provided you are properly compensated for such extensive usage. Some of the highest-paid work indicated in the pricing tables on pages 83-89 has traditionally involved grants of rather extensive use for clients. Many clients who pay the going rate for advertising that will run in consumer magazines try to specify that they are acquiring all advertising rights. The issue is negotiable, but that is their starting point in some cases. Similarly, some clients who pay the top rate for annual report usage take the position that this may include some minor brochure usage. A certain amount of give and take is bound to be involved in these situations. It is not unreasonable to suppose that a client paying $1,500 to $2,000 per day for annual report covers or consumer magazine advertising rights might seek more leeway than the client paying $350 a day for corporate recruitment brochure work.

Finally, even if you use no other documentation, be sure to include a statement about usage in your invoice. A simple statement or brief sentence may save you a lot of aggravation later.

6. *RETURN OF PHOTOGRAPHS:* Commercial outtakes are the cornerstones of a number of stock picture files that earn considerable income for photographers. This is a growing

practice in the industry. Accordingly, state that all originals are to be returned unless "all rights" are purchased (clients purchasing all rights usually expect to keep originals). Some commercial clients expect to keep at least the image(s) they use, and this point may have to be separately negotiated. The outcome could depend on the size of the fee.

Most assignments in publishing are done on a one-time-use basis—one time in a magazine, on a book jacket, or elsewhere. Here you must be sure to specify the return of all originals, in order to develop your editorial and journalistic stock file.

In either commercial or editorial assignments, set a time limit for those originals that are to be returned (typically 30 to 60 days after first use).

7. *CREDIT LINE:* Credit lines are customary in all publishing uses but not in commercial work. In any event, if you have any doubts, specify your requirements in your letter or assignment agreement form.

Some publications do not place the credit adjacent to the photograph. You should not accept that practice. Specify that the credit *must* be adjacent to the photograph. If you want the credit in the form of a copyright notice you must specify that as well.

Of course, there is great value in getting a credit line on a commercial job, especially if the result is excellent. It is certainly worth negotiating for. Some clients occasionally seek a reduced fee in exchange for a credit line, and that may be acceptable in certain cases.

Finally, some photographers seek to enforce the credit line requirement by stipulating that the fee will be doubled if the credit is missing or misplaced.

8. *RELEASES:* You should not risk being responsible for the way your client uses your photographs, since you have no control over that usage. For that reason you should state that the client must notify you when releases are required and must absorb all liability for uses that exceed the authority of the releases, if any.

When you are working on assignment, the form that follows can be used in three ways: (1) as an estimate, (2) to accept an assignment, and (3) as an invoice. It is not, however, chiseled in stone. Use as much of it as you feel comfortable with. The more the better, of course, from the standpoint of your own protection.

ASSIGNMENT AGREEMENT FORM

(Your letterhead) Client's name Client's address	ESTIMATE ☐ CONFIRMATION ☐ INVOICE ☐ Date: P.O./Job #

Job description

Usage: Category _____ Media _____ Title _____

Adjacent credit required: yes _____ no _____

BASIC FEE (Mininum guarantee and day or picture
rate, assignment rate, or other) $ _____

OTHER FEES AS APPLICABLE
 (Travel time, weather days, cancellation, or postponements within 48
 hours of shooting and reshoots due to client change, all are 50 percent of
 basic fee unless specified otherwise.)

SPACE OR USE RATE (if
applicable) _____

EXPENSES
 Assistants _____
 Film and processing (black-and-
 white, color, Polaroid) _____
 Liability insurance _____
 Location/studio rental _____
 Messengers and trucking _____
 Models _____
 Props _____
 Sets (materials and labor) _____
 Special equipment _____
 Special services
 Casting _____
 Hair and makeup _____
 Home economist _____

(Chart continues on next page)

Location search _____
Styling _____
Other _____
Transportation and travel
 Air and ground _____
 Hotels and meals _____
 Gratuities and miscellaneous _____
Miscellaneous _____

EXPENSE TOTALS $ _____ $ _____
 Subtotal _____
 Sales tax (if applicable) _____
 TOTAL _____
 Advance _____ *
 AMOUNT DUE $ _____

(*Due within 30 days or subject to 1.5 percent per month service charge.)
SUBJECT TO ALL TERMS AND CONDITIONS ABOVE AND ON REVERSE SIDE
UNLESS OBJECTED TO IN WRITING BEFORE SHOOTING BEGINS.

(Assignment Agreement Form—reverse side)

Terms and Conditions

1. *USAGE:* Rights granted depend upon payment and are limited solely to those stated under "usage." Editorial reproduction is limited to one-time North American use unless stated otherwise. All other rights reserved to photographer. "Category" of use means advertising, corporate, or editorial, etc.; "media" means album, brochure, billboard, book (hard or soft cover), magazine (consumer, corporate, or trade), point of purchase, poster slide show; "title" means product or publicaton NAME.
2. *RETURN OF PHOTOGRAPHS:* Unless all rights are granted, client agrees to return photographs safely and undamaged within 30 days of publication, by bonded messenger, air freight, or registered mail.
3. *CREDIT LINE AND COPYRIGHT:* Adjacent credit line must accompany editorial use or fee is doubled.
4. *RELEASES:* Client will indemnify photographer against all claims and expenses due to uses for which no release was requested in writing or for uses that exceed authority granted by a release.
5. *EXPENSES:* Expense estimate is subject to normal trade variance of 10 percent and clients' oral authorizations for additional items.
6. *ARBITRATION:* Client and photographer agree to submit any disputes hereunder involving more than ($_____*) to arbitration in *(your city and state)* under rules of the American Arbitration Association. An award therefrom may be entered for judgment in any Court having jurisdiction thereof.

Signed: _____ _____
 (client) (photographer)

*Maximum amount you can sue on in small claims court (usually your quickest remedy).

Portrait and Wedding Assignments

The basic contract in portrait and wedding work is usually an order form that the client or customer should sign covering the following points:

1. SITTING FEE OR MINIMUM PACKAGE PRICE: You should require a minimum fee for a specified number of either poses or prints. This should incorporate your own sales brochure

or price sheet by indicating that the minimum fee is in accordance with the information in those printed pieces. That will automatically establish the amount of the fee, the number of previews (proofs), and the number of poses if it's a portrait sitting, as well as the number of finished prints you will deliver.

2. *PRINT CHARGES:* Allow space on the order form for each size print you make available, for orders over and above the prints included in the minimum package price.

3. *TRIP CHARGES:* For travel in excess of a specified number of miles or specified amount of time (for example, half an hour) you should impose either a mileage charge or, more likely, a time charge.

4. *DEPOSIT AND PAYMENTS SCHEDULE:* You should require a substantial deposit on all work. Deposits often range up to 50 percent of the basic fee, with half the balance due on delivery of previews and the remainder on delivery of finished prints. Consider charging 1.5 percent per month when finished prints aren't picked up within 30 days.

5. *ADDITIONAL CHARGES:* You'll need to leave room on the order form for such additional items as special retouching and finishes, resitting fees (some photographers charge 50 percent for additional poses caused by the client's change of mind), rush services (sooner than 5 to 7 days on previews or 15 days on finishes), and sales taxes (where applicable).

6. *CANCELLATIONS:* You should provide that cancellations within a limited number of weeks prior to a wedding will result in the client's loss of deposit, provided that another engagement is not secured for the same time period. Obviously, in a relatively small community, there are public relations and goodwill issues that arise in connection with charging cancellation fees, and these should be considered most carefully.

7. *PROPERTY OF PHOTOGRAPHER:* Previews and negatives should remain the exclusive property of the photographer. Unreturned previews should be billed at the same rate as finished prints to encourage their return. Negatives must remain the photographer's property so that income from supplying prints is not jeopardized.

8. *REPRODUCTION:* Photographer and client should both agree not to allow reproduction for commercial purposes without permission of the other. This protects the client's privacy and the photographer's potential income in the event of the possibility of commercial sales. For the photographer's

reasonable business interests, however, it would be useful to secure permission to display prints inside or outside the studio, and to reproduce them in limited-circulation brochures.

9. *LIABILITY:* The photographer should be careful to give notice that the photographer shall not be liable for nondelivery or nonperformance of any kind except for returning the client's deposit, and that dyes used in color work, like all color dyes, may fade over time, and the photographer cannot be liable for such occurrences.

10. *EXCLUSIVITY:* The photographer should advise wedding clients that the photographer must be the only party permitted to take photographs at the event, apart from family and friends who are guests of the client at the wedding. Such guests will be permitted to take only snapshots and, in any event, will not be permitted to photograph any formal poses arranged by the photographer. This provision is necessary to reasonably protect the photographer's ability to sell prints.

The form that follows covers the above points.

Order Form

(Your letterhead)	Date: Client's name address telephone Order #:

GENERAL JOB DESCRIPTION AND SPECIAL INSTRUCTIONS:

SITTING FEE OR PACKAGE FEE $ _____
(plan number/type_____, as per studio price list):

SPECIAL ORDER PRINT CHARGES

QUANTITY	SIZE	COST ($)	QUANTITY	SIZE	COST ($)
_____	Passport/ID	_____	_____	11 x 14	_____
_____	3½ x 5	_____	_____	16 x 20	_____
_____	4 x 5	_____	_____	20 x 24	_____
_____	5 x 5	_____	_____	24 x 30	_____
_____	5 x 7	_____	_____	30 x 40	_____
_____	8 x 10	_____	_____	40 x 60	_____
	Subtotal $			Subtotal $	

ADDITIONAL CHARGES

Trip charges	_____	Rush service	_____	
Special retouching	_____	Unreturned previews	_____	
Special finishes	_____	Other (specify)	_____	
Resitting	_____			
		Subtotal	_____	

SUBTOTAL (sitting/package
 fee and above subtotals) _____
SALES TAX (where applicable) _____
TOTAL _____
DEPOSIT _____
BALANCE (due upon delivery of previews) _____
FINAL BALANCE * (due on delivery
 of finished prints) _____

*1.5 percent month service charge on work not picked up in 30 days.

(Order Form—reverse side)

Terms and Conditions*

1. *CANCELLATIONS:* Cancellation of any wedding order within _____ days of wedding requires forfeiture of entire deposit, and within _____ weeks, of 50 percent of deposit, in the event that photographer is unable to secure another engagement for the same date.

2. *PREVIEWS AND NEGATIVES:* All previews and negatives are the exclusive property of photographer. Client agrees to pay for all unreturned previews at the same rate as equal-size finished prints.

3. *REPRODUCTION:* Photographer and client agree that neither will permit reproduction of any photographs for purposes of advertising or trade without the express written permission of the other. Photographer may, however, display prints on the exterior or interior of photographer's studio and reproduce photographs in photographer's own brochures or portfolios.

4. *LIABILITY:* Photographer agrees to return deposit to client in the event of nonperformance or nondelivery caused by photographer. Client acknowledges that the dyes used in color photography, like all other dyes, may fade or discolor in time, and, accordingly, client waives any and all claims resulting from such occurrences.

5. *EXCLUSIVITY:* In cases of wedding photography, photographer shall be the only person permitted to photograph said wedding, except for family and friends of client who may be guests of client, provided said guests do not interfere with the photographer's execution of normal duties and provided further that said guests do not photograph formal poses arranged by photographer.

Signed: _____ _____
 (client) (photographer)

*May be used as separate information sheet for each client instead of as part of ordering contract.

Stock Photographs

A high percentage of all stock photographs circulate from some 40 to 50 stock picture agencies. Many of these firms use similar contract forms covering such items as fees, limitations on usage, return of photographs, releases, credit lines, timely payment, and arbitration of disputes. As a result, most clients in publishing, advertising, and industry who frequently use stock photographs know how to handle those terms as they are discussed below. In addition, the novelty or paper products industry (which covers posters, graphics, greeting cards, T-shirts, calendars, and the like) has other well-accepted standards, as discussed below.

SUBMISSIONS—LOST OR DAMAGED PHOTOGRAPHS

No contract form can assure you of protection if you send out unsolicited photographs. If unsolicited originals are lost, you probably can't collect damages. Therefore, if you must circulate unsolicited material, send duplicates or prints, never original negatives or transparencies.

When you make a solicited submission, you will usually need a contract form indicating that (a) no reproduction rights are granted until a fee is agreed on, (b) the client will be liable for any photographs that are damaged or unreturned, (c) a "holding fee" can be charged for photographs kept beyond a minimum period, and (d) disputes will be settled by arbitration.

These provisions are essential. If you submit a large number of photographs for several possible uses, you don't know which will be used and for what purpose until a selection is made by the client. Therefore you must prohibit reproduction until a fee is agreed upon.

A client's liability to return all material undamaged is critical because the photographs are inventory that is often irreplaceable. Many photographers place a value of $1,500 on each negative and transparency because of the potential earning power it represents. While your own value may differ, that figure is currently in use by the American Society of Magazine Photographers (ASMP), a leading group of professionals.

In the event, however, of actual loss or damage, it is likely that you will establish some measure of expected earning power for your work to show that the value you placed on each negative or transparency was within the bounds of reasonableness. This can be done most readily through a showing of the record of prior sales of this or related work. In some cases, value may also be measured by the cost, including the photographer's time, required to replace the lost or damaged photographs.

The holding fees current in the industry (weekly charges of $5 per transparency and $1 per print) are designed primarily to ensure early return of the materials, so that they may be circulated to other clients. Holding fees, in fact, are rarely collected though they may in some cases be applied against usage fees. The arbitration provision is seen as beneficial because it may limit some costs and delays associated with Court procedures.

A form that you can use for submission is provided on page 104, immediately following the discussion of billing and invoicing for stock photographs.

BILLING AND INVOICING

Stock picture billing involves three aspects. First, it sets forth the usage requirements in clear language, while reserving all other rights to the photographer. It is essential that the precise usage be known and set forth to avoid later disputes. Very few stock photographs are sold on an all-rights basis. The psychology of the situation is somewhat the reverse of that of the world of assignment photography. With stock pictures you own the photograph at the outset; the client wants it and needs it, and you know that. Accordingly, you are in a stronger position to set reasonable terms.

Second, the invoice establishes the fee and credit requirements. Third, it repeats the protections for return of material, holding fees, and settlement of disputes by arbitration that were referred to above in the discussion of submissions. These provisions are needed again because the client is probably still holding the photographer's materials at this point in the transaction.

In some cases you may be asked to submit a specific photo already selected by the client for a specific use. In that situation you will probably have agreed to a set fee with the client on the telephone or by mail. This will allow you to use one form, the invoice form below, to cover the entire transaction, since it already incorporates all the protections you need for both submission and invoicing where the fee is known.

The forms that follow for submission and invoicing are not, of course, the only possible formats you can use. You may, for example, prefer to type a letter with each transaction, utilizing the language provided on those forms. Nonetheless, it is far more efficient to preprint the forms with your letterhead at the top of the page. This will simplify your office procedure, and the likelihood of adverse client reaction is low since clients have become accustomed to the use of these forms by working with other photographers and stock picture agencies.

STOCK PHOTO SUBMISSION AGREEMENT

(Your letterhead) Request date:

 Subject:

Client's name Job #
 address

PHOTOGRAPHY
ENCLOSED:
Types and subject *Size and Number*

TRANSPARENCIES 35MM 2¼ 4x5 8x10 Other

PRINTS

OTHER

Subject to all terms and conditions on reverse side.

(Stock Photo Submission Agreement—reverse side)

Terms and Conditions

1. *Contents and acceptance:* Count is deemed accurate if not objected to in writing by immediate return mail. Terms not objected to in writing within 10 days deemed accepted.

2. *Reproduction:* No reproduction whatsoever is permitted without photographer's written permission specifying usage and fee(s).

3. *Return of photographs:* Client agrees to return all photographs safe and undamaged by bonded messenger, air freight, or registered mail. The reasonable value of each lost or damaged transparency or negative is $ _____ , and for each lost or damaged print $ _____.

4. *Holding fees:* Material held beyond _____ days incurs the following daily holding fees: $ _____ per transparency or negative, and $ _____ per print.

5. *Arbitration:* Client and photographer agree to submit any dispute hereunder involving more than $ _____* to arbitration in *(your city and state)* under rules of the American Arbitration Association. An award therefrom may be entered for judgment in any court having jurisdiction thereof.

Agreed and Accepted

(client's signature)

*Maximum amount you can sue on in Small Claims Court (usually your quickest remedy).

STOCK PHOTO USAGE AGREEMENT

INVOICE □
SUBMISSION □

(Your letterhead)

Date:

Request date:

P.O./Job#.:

Client's name
address

Subject:

PHOTOGRAPHS BILLED (and ENCLOSED IF SUBMISSION)

TYPE and SUBJECT	*SIZE and NUMBER*					*USAGE**				*FEE*
TRANSPARENCIES	35MM	2¼	4X5	8X10	OTHER	CATEGORY	MEDIA	TITLE		$

PRINTS

SERVICE/RESEARCH FEE(S)
(describe) $ _____

OTHER
(describe)

SUBTOTAL $ _____
SALES TAX (if applicable)
TOTAL
DEPOSIT/ADVANCE
BALANCE DUE** $ _____ **

* Other limitations (if applicable): _____ Geographic region _____ .
Time period _____
** Due within 30 days or subject to 1.5 percent per month service charge.
SUBJECT TO ALL TERMS AND CONDITIONS ABOVE AND ON REVERSE SIDE UNLESS OBJECTED TO IN WRITING BEFORE USAGE.

(Stock Photo Usage Agreement—reverse side)

TERMS AND CONDITIONS

1. *CONTENTS:* If submission, count is deemed accurate if not objected to in writing by immediate return mail.
2. *USAGE:* The grant of rights is conditioned on receipt of payment in full and is limited solely to that stated under usage. Editorial reproduction is limited to one-time North American use unless stated otherwise. All other rights reserved to photographer. "Category" of use means advertising, corporate, editorial etc.; "Media" means album, brochure, billboard, book (hard or soft cover), magazine (consumer, corporate or trade) point of purchase, poster, slide show or television, etc. "Title" means product or publication name.
3. *RETURN OF PHOTOGRAPHS:* Client agrees to return all photography safe and undamaged by bonded messenger, air freight, or registered mail. The reasonable value of each lost or damaged transparency shall be $_____, and of each lost or damaged print, $_____.
4. *HOLDING FEES:* Material held beyond _____ days incurs the following daily fees: $_____ per transparency and $_____ per print.
5. *CREDIT LINE:* Adjacent credit line must accompany editorial use or fee is doubled.
6. *RELEASES:* Client will indemnify photographer against all claims and expenses due to uses for which no release was requested in writing or for uses that exceed authority granted by a release.
7. *ARBITRATION:* Client and photographer agree to submit any disputes hereunder involving more than $_____* to arbitration in *(your city and state)* under rules of the American Arbitration Association. An award therefrom may be entered for judgment in any Court having jurisdiction thereof.

*The maximum you can sue on in Small Claims Court (usually your quickest remedy).

Signed: _____ _____
 (client) (photographer)

Royalty Agreements for Novelty and Paper Products

Uses of photographs on greeting cards, calendars, posters, T-shirts, and the like often involve royalty payments to photographers, based on sales of the products. In these novelty or paper products fields, the royalties are usually in the range of 5 percent to 10 percent of the manufacturer's or publisher's receipts. For limited-edition graphics, especially for signed fine prints, the royalty may be substantially higher (and the deal frequently includes retention by the photographer of a small percentage of the edition printed, as artist's proofs). Advance payments against future expected royalties are also

common in the field (see the chart of going rates on page 83-89 above).

The contractual terms associated with royalty transactions are most important. The following checklist should help guide you in handling such transactions.

1. *GENERAL PROVISIONS.* All the protections indicated in the stock picture invoice form (see pages 106-108) covering submissions, limited reproduction, return of photographs, holding fee, releases, and arbitration should be included in the royalty agreement in addition to the special provisions applicable to this field that follow.
2. *CREDIT AND COPYRIGHT.* The credit line requirement should, and usually does, read as follows: "Copyright credit for photographer required as follows: Copyright or ©, photographer's name, year date."
3. *USAGE.* The client's usage should be limited to one specific product (such as cards). Many clients publish in several of the paper products fields simultaneously and may want calendar, poster, and card rights as part of a single deal. If you cannot segregate the rights into separate transactions, you should at least try to insist on a separate advance for each such usage. In addition, try to prevent the client from having the payment of a royalty owed to you on one product count as an advance that may be due to you on a second product.
4. *ADVANCES.* Try to provide that any advance will be nonreturnable even if the client eventually changes his or her mind about publishing your work.
5. *ROYALTIES.* Often royalties are increased as the volume of sales increases. This is reasonable because at the higher volumes a publisher's fixed cost (for example, for plates) have been entirely absorbed, leaving a greater profit margin available. A reasonable scale for greeting cards might, for example, be 5 percent on the first 10,000 units, 7.5 percent on the next 20,000, and 10 percent thereafter. Some card deals may be lower, of course, and others higher.
6. *ACCOUNTING.* You should be assured of receiving regular statements of sales and royalties (for each item separately). Statements and payments are usually quarterly in this industry, though some contracts call for monthly reporting and others for semiannual reporting. You should also have the right to inspect the books and records of the publisher upon reasonable notice.

7. *EXCLUSIVITY*. Many publishers in this field try to tie up talent under an exclusive contract, on the theory that they need a long period of time in which to promote the talent and they want to be assured of a reasonable return on that effort. You, on the other hand, will have an interest in keeping the period of exclusivity as short as possible. The publisher may not do well with your work and you would then want to be able to sell to others. If you cannot keep the period quite short (1 to 2 years for example), at least get a financial guarantee, allowing you to terminate in the event that certain sales or royalty goals are not met.

In addition, you might try to limit the client's exclusivity to a specific product. From the photographer's point of view, the best solution is to limit the client's exclusivity to the single image or images being published, while those images are in print (that is, offered for sale). Many publishers will accept this limited exclusivity if they are pushed hard enough.

8. *RETURN OF RIGHTS*. If the publisher takes the product with your image off the market, you should be able to secure a return of the rights granted, so that you can offer them to someone else.

Books

Book contracts affect only a handful of photographers: those doing their own books and those collaborating with others on a book. Book contracts and collaboration agreements are treated separately below.

BOOK CONTRACTS

Book contracts usually appear as publishers' form agreements. You should never sign one without consulting an expert. These form agreements are simply offers. Publishers expect a certain amount of bargaining on many points, provided your demands are within the realm of normal industry practice. With a reasonable amount of guidance, you should be able to handle much of the negotiating yourself.

The checklist that follows is for general reference only. The subject is treated in much greater depth in *The Writer's Legal Guide*, by Tad Crawford (New York, New York: Hawthorn Books, 1977; hardcover $10.95, paperback $5.95). See pages 98–123.

1. *BASIC GRANT OF RIGHTS.* The publisher should be re-
 stricted to publishing the work in *book* form in the English
 language.
2. *SUBSIDIARY RIGHTS.* Subsidiary rights are often critical to
 photographers. They involve secondary markets such as maga-
 zines, audiovisuals, retail calendars, posters, and more. The
 original book publisher rarely develops these markets but may,
 through lack of careful bargaining on the photographer's part,
 retain a major financial interest in such uses. Many subsidiary
 rights clauses provide for an equal split between author and
 publisher. You should restrict such splits to subsidiary rights in
 the book field (for example, a soft-cover edition) and reduce
 the publisher's share to a maximum of 10 to 25 percent outside
 the book field.

 When the publisher acts as agent and secures foreign or
 magazine sales of subsidiary rights, the proceeds are typically
 divided as follows: on foreign rights—75 percent to the author
 and 25 percent to the publisher (though some leading authors
 have won 90/10 deals); on magazine rights—90 percent to the
 author and 10 percent to the publisher on the first serialization
 and an equal split on subsequent serializations. Nonetheless, on
 incidental stock sales of individual photographs by the pho-
 tographer where a serialization of the book is not involved, the
 photographer should retain 100 percent of the proceeds.
3. *RESERVATION OF RIGHTS.* To protect new markets and
 evolving media, you should be sure a contract says that all
 rights not otherwise granted to the publisher are reserved to the
 photographer.
4. *ROYALTIES.* Royalties on bookstore sales (for trade books)
 are generally based on the retail selling price of the book.
 Basing royalties for those sales on the publisher's receipts
 (usually referred to as the "net price") will reduce your royalty
 by almost 50 percent.

 The normal discount given by publishers to bookstores on
 trade books is 40 percent to 48 percent. If a publisher has to
 give a higher discount he will want you to share that burden
 with a reduced royalty. Some publishers try to reduce the
 royalty by the same percentage that the discount exceeds a
 normal discount. They are, however, usually willing to accept a
 royalty reduction of half that amount if you're willing to press
 the point hard. In any event, never accept a royalty of less than

half your normal royalty. Other sales that may involve a reduced royalty include direct-mail and coupon ad sales.

A commonly cited hardcover royalty deal is 10 percent of the book's retail price on the first 5,000 copies, 12.5 percent on the next 5,000 copies, and 15 percent thereafter. These amounts are, of course, subject to negotiation and may not be in the publisher's first offer. For quality paperbacks a common scale is 6.5 percent to 7 percent on the first 50,000 copies, increasing in steps to 10 percent after 100,000 to 150,000 copies. You should note carefully which sales are counted (and which are not) in determining these escalations.

5. *ADVANCES*. An advance is a payment from the publisher made before any royalty is earned. It is intended to make it possible for you to produce the book and is subtracted later from actual royalty payments. Publishers' advances tend to equal about 75 percent to 100 percent of the first year's projected royalty. Ask your editor what the sales projections are for the first year, and what the likely selling price will be. Assuming a normal royalty, you will have a pretty good idea of how hard you can push in negotiating for your advance.

6. *STATEMENTS AND PAYMENTS*. Most book contracts call for semiannual accounting and payments and give authors the right to inspect the publisher's books upon reasonable notice.

7. *COPYRIGHT*. The standard practice is for copyright to be in the author's name, not the publisher's name.

8. *RETURN OF RIGHTS*. Book contracts should require the publisher to have the work in print within a reasonable period (typically 18 months). Most contracts provide for a reversion of all publishing rights to the author in the event that the publisher fails to keep the book in print.

9. *ARTISTIC CONTROL*. Book contracts usually place artistic control solely in the hands of the publisher. Even if you want consultation rights, you must negotiate for them. Obviously then, if you want control or veto power over who designs the book, or what the quality of the paper will be, you must negotiate for that separately.

10. *CREDIT*. If you have any special credit requirements, get them in the agreement. This is particularly important in the case of collaborations (see collaboration agreements in the section immediately following).

11. *OPTIONS*. Most publishing contracts give the publisher an option on the author's next book. This provision is invariably deleted if the author insists.

There are also provisions covering noncompetition and various warranties. Noncompetition requires you not to do work that directly competes with sales of the book in question. In the warranties you promise that the work is original, not obscene, and not libelous. Publishers are loath to modify these provisions. You should make sure they are not overly broad.

COLLABORATION AGREEMENTS

Collaboration involved in book publishing is usually between a photographer and a writer. In some cases the two simply sign separate agreements with the publisher, stipulate what work they will provide to that publisher, and have no relationship with each other. In other cases they work closely together, and an agreement between them is essential. Such an agreement should cover the following:

1. *MONEY.* Is it 50/50? Or is the book principally the work of one or the other? It's rare for anyone to get less than one-third in a collaboration. This refers to both royalties and advances. However, even in a 50/50 deal, if the photographer's expenses are higher than the writer's, these may be reimbursed before the 50/50 split takes effect.
2. *CREDIT.* Whose name goes first? Are both considered the author? Does the credit say "by J. Writer, photographs by L. Photographer," or are the two to be treated equally, with the credit simply stating that the book is by both of them? Obviously, it is better for the photographer if the credit reads "by L. Photographer, text by J. Writer." Sometimes the issue is determined by looking at who came up with the original idea for the project or book.
3. *COPYRIGHT.* Usually a contract calls for the photographs to be copyrighted in the photographer's name and the text to be copyrighted in the writer's name. This protects both with respect to the work that they originate.
4. *SUBSIDIARY RIGHTS.* Often subsidiary income derived exclusively from the photographs remains solely the photographer's property, although in some deals it's just a 50/50 split on everything.

Other issues to be considered are: Whose agent handles the book? What happens if one party dies during the course of the project? Who exercises artistic control (if any)? Should disputes be resolved through arbitration?

Sales of Original Prints

Most sales of original art in photography involve original prints singly or as portfolios. These are usually sold pursuant to a bill of sale, which should provide the following:

- Names and addresses of the parties.
- Date.
- Price of the print or portfolio and terms for payment.
- Description of the item(s) transferred, including size, subjects, medium (black-and-white or color), whether framed or matted, and whether signed or unsigned.
- A statement that all reproduction rights and copyright are reserved and owned solely by the photographer.
- A statement, if applicable, by the photographer warranting that the photograph or portfolio is "one of a limited edition of ＿＿＿＿ copies, numbered as follows ＿＿＿＿ ."

In very special cases the photographer might consider trying to secure additional rights, such as these:

- A royalty on any profits derived from retransfer of the photograph(s) or portfolio(s).
- A share of rental income or a limitation on exhibiting the print(s) generally.
- Permission to reacquire possession of the print for brief periods for exhibition purposes.
- A prohibition against destroying or modifying the print(s).

Such additional provisions, often loosely referred to as "moral rights," have rarely, if ever, been imposed in a sale of photographic prints.

CHAPTER 7

The Going Concern

MOST PEOPLE don't leap into a profession. They test and explore it first and gradually intensify their commitment. This is as true of photography as it is of any other entrepreneurial activity. Many photographers start part time while going to school or working at another job. For some it is a dream they work toward, even when supporting themselves with other work, and for others it is the extension of a beloved hobby. But once the photographer begins to effectively market his or her work, questions inevitably arise as to the basics of operating a business. Should it be incorporated? Where can it be located? What kind of records do you need? What taxes will you have to pay?

Making decisions about these kinds of questions requires knowledge. Your knowledge can be gleaned from experience or from advisors with expertise in accounting, law, and business. The most important skill that you must have is that of problem recognition. Once you're aware that you face a problem, you can solve it—by yourself or with expert help.

Form of Doing Business

You will probably start out in the world of business as a *sole proprietor*. That means that you own your business, are responsible for all its debts, and reap the rewards of all its profits. You file Schedule C, "Profit or (Loss) From Business or Profession," with your Federal Tax Form 1040 each year and keep the records described in the next chapter. The advantages of being a sole proprietor are simplicity and a lack of expense in starting out.

However, you have to consider other possible forms in which your photography business can be conducted. Your expert advisors may decide that being a corporation or partnership will be better for you than being a sole proprietor. Naturally you want to understand

what each of these different choices would mean. One of the most important considerations in choosing between a sole proprietorship, partnership, and corporation is taxation. Another significant consideration is personal liability—whether you will personally have to pay for the debts of the business if it goes bankrupt.

As sole proprietor *you* are the business. Its income and expenses are your income and expenses. Its assets and liabilities are your assets and liabilities. If the business owns a Hasselblad and has taken a $1,000 loan from a bank, you owe the bank $1,000 and have a great camera. The business is you, because you have not created any other legal entity.

Why consider a *partnership?* Perhaps because it would be advantageous for you to join with other photographers so you can share certain expenses, facilities, and possibly clients. Sometimes two or more heads really are wiser than one. If you join a partnership, you'll want to protect yourself by having a partnership agreement drawn up before starting the business. As a partner you are liable for the debts of the partnership, even if one of the other partners incurs the debts. And creditors of the partnership can recover from you personally if the partnership doesn't have enough assets to pay the debts that it owes. So you want to make sure that none of your partners is going to run up big debts that you end up paying for from your own pocket. The profits and losses going to each partner are worked out in the partnership agreement. Your share of the profits and losses is taxed directly to you as an individual. In other words, the partnership files a tax return but does not pay a tax. Only the partners pay taxes based on their share of profit or loss.

A variation of the partnership is the *limited partnership*. If you have a lot of talent and no money, you may want to team up with someone who can bankroll the business. This investor would not take an active role in the business, so he or she could be a limited partner who would not have personal liability for the debts of the partnership. You, as photographer, would take an active role and be the general partner. You would have personal liability for the partnership's debts. You and the investor could agree to allocate the profits equally but to give a disproportionate share of any tax losses to the investor (such as 90 percent). This hedges the investor's risk, since the investor is presumably in a much higher tax bracket than you are and will benefit by having losses (although profits are naturally better than losses, no matter how much income the investor has).

The next avenue to consider is that of a *Subchapter S corporation*. This is a special type of corporation. It does provide limited

liability for its shareholders, which is what you would be. However, there is basically no tax on corporate income. Instead, the profit or loss received by the corporation is divided among the shareholders who are taxed individually as partners would be. An advantage of incorporation is the business deductions the Subchapter S corporation can take that would be denied to a sole proprietor. The corporation will be more able to deduct premiums for medical insurance and, in special cases, life insurance. It can also make the same tax-deductible contributions to a retirement plan for you that you would be able to make as a sole proprietor. The disadvantage of incorporating is the added expense and extra paperwork.

What you normally think of as a corporation is not the Subchapter S corporation, but what we'll call the *regular corporation*. The regular corporation provides limited liability for its shareholders. Only the corporation is liable for its debts, not the shareholders. You should keep in mind, however, that many lenders will require shareholders to personally sign on a loan to the corporation. In such cases you do have personal liability, but it's probably the only way the corporation will be able to get a loan.

The key difference in creating a regular corporation is that it is taxed on its own taxable income. There is a federal corporate income tax with increasing rates as follows:

- 17 percent on taxable income up to $25,000
- 20 percent on taxable income from $25,000 to $50,000
- 30 percent on taxable income from $50,000 to $75,000
- 40 percent on taxable income from $75,000 to $100,000
- 46 percent on all taxable income over $100,000

In addition, there may be state and local corporate income tax to pay. By paying yourself a salary, of course, you create a deduction for the corporation that lowers its taxable income. You would then pay tax on your salary as would any other employee. If, however, the corporation were to pay you dividends as a shareholder, two taxes would be paid on the same income. First, the corporation would pay tax on its taxable income, then it would distribute dividends and you would have to pay tax on the dividends.

The advantages of the regular corporation include the ability to deduct as a business expense the cost of premiums for your medical insurance and $50,000 worth of life insurance. Also, the corporation can make greater tax-deductible contributions to your retirement plan than you would be able to make as an individual. The disadvantages

include again extra paperwork and the need for meetings, as well as the expenses of creating and, if necessary, dissolving the corporation.

From this brief discussion, you can see why expert advice is a necessity if you're considering forming a partnership or a corporation. Such advice may seem costly in the short run, but in the long run it may not only save you money but also give you peace of mind.

Business Location

The location of your business is extremely significant. If you run a photographic studio catering to the public, then you must be conveniently located for the public to come to your premises. The area must have a healthy economy with good prospects for the future, so you can count on a continuing flow of clients who are able to afford your services. If you work on assignment, then you must be able to reach the buyers with whom you'll be transacting business. You must consider the location not only from the marketing viewpoint, but also with respect to rent, amounts of available space (compared to your needs), competition, accessibility of facilities that you need (such as labs), and the terms under which you can obtain the space. Speak to other photographers and business people in the area to find out all you can.

Since many photographers have their studios in their homes, it's worth considering this as the first option. You'll save on rent and gain in convenience. However, you may not be near your market and you may also have trouble taking the fullest possible tax deductions for space that you use. The deduction of a studio at home is discussed on pages 141-143.

Another potential problem with having a studio at home is zoning. In many localities the zoning regulations will not permit commercial activity in districts zoned for residential use. If you didn't realize this, you could invest a great deal of money setting up a photographic studio, only to find you could not legally use it. But even when the zoning law says a home may not be used for commercial purposes, it is unlikely that you'll be prevented from conducting certain aspects of your photographic business, such as shooting and printing. Problems usually arise when your business requires a flow of people to and from the premises, whether they are clients or people making deliveries. The more visibly you do business, the more likely you are to face zoning difficulties. If you are considering setting up your studio in a residentially zoned area, you should definitely consult a local attorney for advice.

What happens if you rent a commercial space for your studio and decide to live there? This has become more and more common in urban centers where rents are high. You run the risk of eviction, since living in the studio will probably violate your lease as well as the zoning law. Some localities don't enforce commercial zoning regulations, but you must be wary if you are planning to sink a great deal of your resources and time into fixing a commercial space with the plan of living there. Especially in this situation, you should ask advice from an attorney who can then also advise you how to negotiate your lease.

Negotiating Your Lease

It's worth saying a few words of warning here about the risks involved in fixing your studio. You can lay out thousands of dollars (many photographers have) to put up walls for your darkroom, reception area, and model's dressing room; to put in wiring and special plumbing for your darkroom; and to redecorate and refurbish your space in every way so that it's suitable for your special needs. What protects you when you do this?

If you're renting, your protection is your lease. The more you plan to invest in your space, the more protection you need under your lease. There are several crucial points to consider:

- length of the lease
- option to renew
- right to sublet
- ownership of fixtures
- right to terminate
- hidden lease costs

You have to know that you are going to be able to use your fixed-up space long enough to justify having spent so much money on it. A long lease term guarantees this for you. But what if you want to keep your options open? A more flexible device is an option to renew. For example, instead of taking a 10-year lease, you could take a 5-year lease with a 5-year option to renew. But you want to guarantee not only that you'll be able to stay in the space, but also that you can sell your fixtures when you leave. In most leases, the landlord owns all the fixtures when you leave, regardless of who put them in the space. If you want to own your fixtures and be able to resell them, a specific clause in the lease would be helpful.

The right to sublet your space—that is, to rent to someone else

who pays rent to you—is also important. Most leases forbid this, but if you are selling fixtures it can be important who the new tenant is. Your power to sublet means you can choose the new tenant (who can then stay there for as much of your lease term as you want to allow). On the other hand, you may not be able to find a subtenant. If your business and the rental market are bad, you may simply want to get out of your lease regardless of the value of the fixtures you've put into the space. In this situation, the right to terminate your lease will enable you to end your obligations under the lease and leave whenever you want to. Remember that without a right of termination, your obligation to pay rent to the landlord will continue to the end of the lease term, even if you vacate the premises (unless the landlord is able to find a new tenant).

In every lease you should look for hidden lease costs. These are likely to be escalators—automatic increases in your rent based on various increasing costs. Many leases provide for increased rent if fuel prices increase. Others require you to pay a higher rent each year based on increases in the consumer price index. Of course, you want to know about all these hidden costs—whether to include them in your budget or to try to negotiate them out of the lease.

This is a very brief discussion of the negotiation of your lease. Your attorney can aid you with the ins and outs of negotiating a lease.

Business Licensing and Registration

Photography is considered innocuous and not a danger to the public welfare. For this reason, state statutes requiring the licensing of photographers have generally been held unconstitutional (although in North Carolina a court divided 3-2 held a photography licensing statute constitutional). However, a number of states do require that a fee be paid in order to practice photography professionally. There is no examination, however, to determine your proficiency as a photographer. Of course, states and localities can regulate photographers who sell their services from door-to-door or in public places. And if you're going to be shooting in a way that may disrupt public activities, you should certainly consider whether you need a permit from the local government. A local attorney or photographer's society is obviously the best place to find out exactly which regulations apply in your area.

The registration of your business—or the name of your business—is also important. This is usually done with the county clerk in the county in which you have your studio. The purpose of this

registration is to ensure that the public knows who is transacting business. Thus partnerships must file and disclose the names of the partners. Individuals doing business under an assumed name must disclose their true identity. But an individual photographer doing business under his or her own name might very well not be obligated to file with the county clerk. In any case, you should call the county clerk to find out whether you must comply with such requirements. The fee is usually not high.

Your Budget

Starting a business requires planning. You have to estimate your expenses and your income, not just for the first year, but for as many years into the future as you can reasonably project. Some expenses only happen once, while others recur each year. You have to take both kinds into account and should refer to the example given on page 79.

For starting costs you may only have to pay once, consider the following list:

- fixtures and equipment
- installation of fixtures and equipment
- decorating and remodeling
- legal and other professional fees
- advertising and promotion for opening

Of course you must realistically think through the outlays you are going to have to make. Daydreaming can be pleasant, but in business it can easily become a nightmare.

What about the outlays that you'll have to make every month? Here's a partial list:

- your own salary
- any other salaries
- rent
- advertising
- materials and supplies
- insurance premiums
- maintenance
- legal and other professional fees
- taxes (usually paid in four installments during the year)
- miscellaneous

Maybe the last category is the most important, because it's the unexpected need for cash that leads to trouble for most photographers. If you can plan properly, you will ensure that you can meet all your needed outlays. And don't leave out your own salary. Martyrs don't make the most successful business owners. If you worked for someone else, you'd get a salary. To see realistically whether your business is making a profit, you must compute a salary for yourself. If you can't pay yourself a salary, you have to consider whether you'd be doing better working for someone else.

Your income is the next consideration. What sort of track record do you have? Are you easing from one field of photography into another field in which you're likely to have success? Or are you striking out toward an unknown horizon, a brave new world? You have to assess, in a fairly conservative way, how much income you're likely to have. If you just don't know, an assessment of zero is certainly safe.

What we're talking about is *cash flow*. It should probably be the most important word in the photographer's business lexicon, although *bottom line* is also very popular these days. *Cash flow* is the relationship between the influx of cash into your business and the outflow of cash from your business. If you don't plan to invest enough money in your business initially, you are likely to be *undercapitalized*. This simply means that you don't have enough money. Each month you find yourself falling a little further behind in paying your bills.

Maybe this means your business is going to fail. But it may mean that you just didn't plan very well. You have to realize that almost all businesses go through an initial start-up period during which they lose money. Even the Internal Revenue Service recognizes this. So after you plan for your start-up expenses and your monthly expenses (with an extra amount added in to cover contingencies you can't think of at the moment), you can see how much cash you're going to need to carry the business until it becomes profitable. Your investment should be enough to carry the business through at least one year without cash flow problems. If possible, you should plan to make a cash investment that will carry the business even beyond one year. Be realistic. If you know that you're going to have a profit in the first year, that's wonderful. But if it may take you a year or two before you have a profit, plan for it. It's easy to work out the numbers so you'll be a millionaire overnight, but it's not realistic. In fact, it's a direct path to bankruptcy. But once you realize you need money to avoid being

undercapitalized when you start or expand your business, where are you going to be able to find the amount you need?

Sources of Funds

The most obvious source of funds is your own savings. You don't have to pay interest on it and there's no due date when you'll have to give it back. But don't think it isn't costing you anything, because it is. Just calculate the current interest rate—for example, the rate on short-term United States Treasury notes—on what you've invested in your business. That's the amount you could have by sitting back and sipping iced tea—without spending all those hours in the darkroom.

What if you don't have any savings and your spouse isn't keen on donating half of his or her salary to support your studio? Of course you can look for investors among family, friends, or people who simply believe you're going to create a profitable business. One problem with investors is that they're hard to find. Another problem is that they share in your profits if you succeed. And after all, isn't it your talent that's making the business a success? But if you're going to have cash flow problems and are fortunate enough to find a willing investor, you'll be wise to take advantage of this source of funds.

The next source is your friendly banker. Banks are in the business of making money by lending money, so you'd think they'd be happy to have you as a client. You may be the lucky photographer who finds such a bank, but most loan officers know that the photography business carries high risks and is unpredictable. Conservatism is ingrained in their natures (otherwise they'd be opening their own photographic studios). So if you're going to have any chance of convincing the bank to make a loan, you must take the right approach. You should dress in a way that a banker can understand. You should know exactly how much money you want, because saying, "I need a loan," or asking for too much or too little money is going to create a bad impression. It will show that you haven't done the planning necessary to succeed. You should be able to detail precisely how the money will be used. You should provide a history of your business—from a financial standpoint, since the loan officer may not have an intense interest in your sense of the esthetic—and also give a forecast.

One prediction you had better make when you gaze into your crystal ball is that your business is going to generate the funds necessary to repay the loan. And you must have good business records, as discussed in the next chapter, in order to make an effective

presentation to the bank. The loan officer must believe in the quality of management that you offer to your business. One other point to keep in mind is the importance of building a relationship with your banker. If he or she comes to know and trust you, you're going to have a much better chance of getting a loan.

But, frankly, bank loans are going to be very difficult for many photographic businesses to obtain. Where can you turn next? The most likely source is borrowing from family and friends at a reasonable interest rate. Of course you have to pay back these loans whether or not your business succeeds (if you didn't have to pay back the money, you'd be dealing with investors rather than lenders). Another possibility is borrowing against your whole life insurance policy, if you have one. You can borrow up to the cash value, and the interest rate is usually far below the current rate at which you would be borrowing from a bank. And, if you have been able to obtain credit cards that have a line of credit (that is, that permit you to borrow up to $250, $500, or more on each card), you can exercise your right to borrow. Depending on the number of cards you have and the amounts of the credit lines, you may be able to borrow several thousand dollars in this way. You should plan to repay credit-card cash advances promptly to avoid the high interest rates imposed on money borrowed in this way.

Trade credit will undoubtedly be an important source of funds for you. It's invisible, but it greatly improves your cash flow. Trade credit is simply your right to be billed by your suppliers. The best way to build up trade credit is to be absolutely reliable. In this way, your suppliers come to trust you and are willing to let you owe greater and greater amounts. Of course you must pay promptly, but you are paying roughly 30 days later than you would pay on a cash transaction.

The other side of the coin is your own extension of credit to your clients. This creates accounts receivable. Now accounts receivable are an asset of your business, the same way that your cameras and your cash are assets of the business. But what is the magic formula by which you convert accounts receivable into cash when you desperately need it? You can *factor* your accounts receivable. This means that you sell your accounts receivable to another company—the factor—that collects the accounts receivable for you. What does the factor pay for the accounts receivable? The factor gives you the full amount of the accounts receivable, less a service charge. The effect of the service charge can be an annual interest rate of 30 to 50 percent for a small business. Incredible? Yes, and take warning. Using factors isn't the

magic trick it appears at first. In fact, it's inviting disaster. If your cash flow is bad, factoring is likely to make it much worse in the long run.

But as the famed economist Lord Keynes said, none of us will be around in the long run. So let's put it another way—the long run may be in the immediate future if you factor. And the reason you would have to factor is poor planning in the first place. You were undercapitalized.

Another possible source of funds is the Small Business Administration (SBA). It's mentioned in passing here because it has not looked too favorably on loans to photographers over the years. But it's certainly worth an exploratory telephone call to see whether your local SBA office might be atypical.

The true message is *not* to borrow unless you know you're going to be able to repay the money from your business. There's no point in borrowing from one source after another as your business slides closer toward bankruptcy. Not only should you *not* factor your accounts receivable, but you should not borrow against your life insurance cash value or draw on your credit lines unless you definitely know that you will be doing the business necessary to pay back that money. Being adequately capitalized is a necessity if you are to have that wonderful feeling of confidence that comes from knowing that your business has the stamina to survive early losses and succeed.

Expansion

Expanding is much like starting a business. You must be adequately capitalized for the expansion to be successful. This means reviewing your expenses and your income so you can calculate exactly how the expansion will affect your overall business. Then you have to decide whether you have the cash flow to finance the expansion from the income of the business. If you don't, once again you must consider sources of financing. If you're buying equipment, keep equipment financing companies in mind as a potential credit source.

One of the most important reasons to expand is an economic one—the economies derived from larger-scale operations. For example, pooling with a number of photographers may enable you to purchase equipment you couldn't otherwise afford, hire a receptionist that your business alone couldn't fully utilize, or purchase film and other supplies in quantities sufficient to justify a discount. If you can hire an assistant who earns you enough money or saves you enough time to make more than the assistant's salary (and related overhead expenses), the hiring of the assistant may very well be justified.

On the other hand, expansion is hardly a panacea. In the first place, you'll probably have difficulty financing any major expansion from the cash flow of the business. Beyond this, expansion ties you into certain expenses. Suddenly you have an assistant, a secretary, a bookkeeper, a stylist. You need more space and your rent goes higher. You're shooting more jobs, so your expenses increase for all your materials. You find that you must take more and more work in order to meet your overhead. You may even consider a rep, if you can get one, because you need to do a greater volume of business. But the rep will take 25 percent in commissions, so that's hardly going to solve your need for more productive jobs.

Suddenly you realize that you've reached a very dangerous plateau, and that you're faced with a choice that will have lasting consequences for your career. You expanded because you wanted to earn more. But the more resources that you brought under your control—whether equipment, personnel, or studio space—the more time you had to spend managing these resources to make them productive. Now you must decide whether you are going to become a manager of a successful photographic business or cut back and become primarily a photographer. If you choose to be a manager, you had better be a very good one. If you go the expansion route, it's very painful to have to cut back if the business temporarily hits hard times—firing employees, giving up space you've labored to fix up, and so on. The alternative to being a manager is to aim for building a small business with highly productive accounts. You can be a photographer again without worrying so much about the overhead and the volume you're going to have to generate in order to meet it. Of course, you'll make your own decisions, but be certain that you're keeping the business headed in the direction that *you* want it to take.

Extending Credit

It's worth discussing your credit policies, since cash flow is at the core of so many photographers' business problems. If you do assignment photography, it may seem that you're locked into industry practice with respect to billing and being paid after completion of an assignment. But many professionals are now requesting advances, especially against expenses, so that they don't have to finance clients for months at a time. Photographers who take portraits for sale to clients should insist on payment when the sitting is completed—whether by cash, check, or credit card—or at least demand a deposit against final payment upon delivery of finished prints. Yes, credit

cards are a great way to encourage purchases. The cost to you will be several percentage points (varying from card to card), but this may be more than offset by increased sales.

But if you're forced to extend credit (as in the case of ad agencies) or do so as a convenience for your customers (as you might with portraits or the last of the three installment payments you would normally get for a wedding), what will this mean for your business? The longer an amount owed to you is overdue, the less likely you are to collect it. The following approximations are a good guide:

- If a debt is overdue 60 to 90 days, you have a 90 percent chance of collecting it.
- If a debt is overdue 3 to 6 months, you have a 70 percent chance of collecting it.
- If a debt is overdue 6 months to 1 year, you have a 60 percent chance of collecting it.
- If a debt is overdue 1 to 2 years, you have a 40 percent chance of collecting it.
- If the debt is overdue more than 2 years, the percentage you're likely to recover drops until the fifth year when it becomes unlikely you'll ever collect.

What does all this mean? That you must have a firm policy about extending credit and pursuing collections. You should grant credit only to clients who have a good reputation (based on occupation, address and length of residence, bank references, professional credit rating agencies, and personal references), a sound financial position, and measurable success in their own business (especially if the client is an agency or a corporate client that will expect to be billed as a matter of course), and who are willing to accept conditions that you may place on the extension of credit (such as maximum amounts of credit you extend, maximum amounts of time for payment, and similar provisions). By the way, if you feel you don't want to extend credit to a client who absolutely expects it, you should not do business with that client. You must constantly check your credit system to make sure it's functioning properly (more than half your accounts should pay in full on receipt of your statement).

If you have a client who won't pay, you have to initiate collection procedures. You start with a reminder that the account has not been paid. This can simply be the sending of your invoice stamped "Past Due." Or you might use a pleasant form letter to bring the debt to the attention of the client. If this fails, you should make a request to your

client for an explanation. Obviously it isn't an oversight that the client has failed to pay. There may be a valid explanation for not paying. In any case, you must find out—usually by sending a letter requesting the necessary information. If the client still does not pay, you can assume that you're not going to collect without applying pressure. What kind of pressure? Whatever kind—within the bounds of the law—that you judge will get your money without your having to use an attorney or collection agency. You can escalate through all the following options:

- letters
- telephone calls
- registered letters, mailgrams, and telegrams
- cutting off credit
- threatening to report to a credit bureau
- threatening to use an attorney or collection agency
- using an attorney or collection agency

Of course, you should never threaten people unless you intend to back up your words. You must act decisively if, after threatening to take a certain action, you still are not paid. The use of attorneys, collection agencies, and small claims courts is discussed on pages 224-229. You will bear an expense in using an attorney or collection agency to collect, but you may still be able to get part of the money owed you. And you will have a reputation as someone who won't stand for clients who don't pay what they owe.

Sales and Miscellaneous Taxes

Many states and cities have taxes that affect photographers. Included here are sales taxes, unincorporated-business taxes, commercial occupancy taxes, and inventory taxes. You should check in your own state and locality to determine whether any such taxes exist and apply to you. By far the most common tax is the sales tax, however, and it deserves a more extensive discussion.

The sales tax is levied on sales of tangible personal property. If a book is sold by a bookstore, a sales tax must be paid. We will discuss the New York State sales tax, but sales taxes have many similarities from state to state. In New York State, the sale of reproduction rights is not considered to be a sale of tangible personal property. Reproduction rights are not tangible or physical; they are intangible. So no sales tax is charged on them.

Generally, no tax is charged on items that are going to be resold.

If a paper manufacturer sells paper to a printer who in turn manufactures books for a publisher who sells the books to a retailer, only the retailer should collect the sales tax and pay it to the State Sales Tax Bureau (which has local offices in many communities). Sales taxes are levied on the last sale when a product reaches the consumer, not on every step in the series of sales that are necessary to transform the raw materials into the finished product.

The photographer has a number of special considerations with respect to the sales tax. First, sale by the photographer of reproduction rights usually does not require the collection of the tax. (This particular exemption may not apply in some states. You should check the point carefully in your state.) But if the photographer also sells a physical object, such as a print or transparency, then sales tax must be collected on the full sale price (you can't try to separate the price of the print from the price of the reproduction rights). The photographer can hand over a print as long as it is returned—no sales tax has to be collected. But if the client retouches the photograph, a sales tax will have to be paid because the client has acted like the owner of the physical object (as opposed to just a licensee of reproduction rights).

A common question is whether sales tax must be charged on those components of a bill that don't relate to materials. For example, if your bill lists services, materials, and travel expenses, should you collect tax on the total bill or simply on parts of it? The Sales Tax Bureau insists that you collect and then pay tax on the entire bill. This is despite the fact that your services would not be subject to sales tax if billed separately because no tangible object is transferred. And some of the expenses you bill, such as models or travel, would not require collection of sales tax if billed separately. But when your bill relates to the transfer of a physical object, sales tax must be collected on the total billing. It also doesn't matter where the expenses were incurred. Whether they were incurred in or out of the state, the tax must still be collected on the total bill.

There is an exemption from collection of the tax for deliveries of tangible property sold to out-of-state clients. What often happens is that a client will have an office in state and out of state. If you in fact deliver out of state, you do not have to collect sales tax. However, you must be able to prove that the delivery was made out of state. Your proof should be a signed delivery receipt or a receipt from the common carrier taking your package to the client. This can be very important if you are audited.

Registering with the Sales Tax Bureau has one advantage. You receive a resale number. By presenting a resale form to stores that

you buy materials from, you don't have to pay sales tax on materials going into taxable products that you will resell. If, for example, your client keeps the film and you charge the client sales tax, you may use the resale exemption when buying the film. If you don't deliver the film or it is not a taxable transaction, you should not use the resale exemption when you buy the film. You may not have to pay state sales tax on cameras and other equipment if they are used in the production of tangible personal property for sale. This becomes complicated, especially since the New York City tax will have to be paid by those photograhers living in New York, so you should probably call the local sales tax office to check on your special situation.

It's worth keeping in mind that certain organizations don't have to pay sales taxes. These are mainly charitable or religious organizations that have tax-exempt status. If you seek to collect sales tax from them, they will present you with their tax-exempt resale certificate entitling them not to pay sales tax.

Of course, your clients will frequently give you resale forms, because they are planning to reuse what you give them in the final product they are preparing. If you accept such a resale form in the reasonable belief that the client will incorporate your materials into a property for resale, you are saved from liability for not collecting the tax. But if your client has no resale number and you have any doubt about whether to collect the tax, collect it. If you don't collect it and the Sales Tax Bureau decides you should have, you're going to be liable for the tax. Your client is also liable, but imagine how embarrassing it would be to go back to a client several years later to try to collect the sales tax. And the client may have gone bankrupt, moved to another state, or merged into another corporation. When in doubt, collect the sales tax and remit it to the Sales Tax Bureau. You can't go wrong that way.

Contact your local Sales Tax Bureau to find out whether such a tax exists where you are and, if so, the exact nature of your obligations to collect and remit the tax to the Sales Tax Bureau.

Small Business Administration

The Small Business Administration is interested in helping small businesses succeed. Its offices are located throughout the country. You can attend the many courses that SBA sponsors, such as "Free Pre-Business Workshop," "Preparing a Business Plan," and "Small Business Tax Workshop." Many of these courses are free; others charge a modest admission fee. The SBA also makes available many

publications to enhance the chances of a small business's being successful, such as "Checklist for Going into Business." One publication is titled *Photographic Dealers and Studios* and offers a brief overview of the field. A full bibliography of SBA publications is available from the nearest SBA field office or by writing to the SBA, Washington, D.C. 20416. The publications are either free or inexpensive.

In addition, you can call your local SBA office and speak to or meet with a counselor who will help you with your specific problem. While these counselors are likely to have had limited contact with photographers, you may still get some helpful advice. The Service Corps of Retired Business Executives (SCORE) has been formed under the SBA and brings the experience and wisdom of successful business people to the counseling program.

CHAPTER 8

Your Business Records

To make intelligent business decisions, you must have good business records. These records are also a necessity for completing your tax forms, keeping track of your jobs, and maintaining files of your photographs so you can take advantage of resale opportunities.

Tax Records

If you want to avoid trouble with the Internal Revenue Service, you must keep your books in order. One of the most common reasons for the disallowance of deductions is simply the lack of records to corroborate the expenses. Your records can, however, be simple. And you don't have to know a lot of technical terms. You only have to record your income and expenses accurately so that you can determine how much you owe in taxes for the year.

You will probably want to keep a simple ledger or diary in which you enter your items of income and expense as they arise. This would mean that you enter the items regularly as they occur—at least on a weekly basis—and don't wait until the end of the year to make the entries. If you're consistent this way, you will be able to take some expenses even if they're not documented by receipts or canceled checks. The ledger or diary should include a log of business travel, local automobile mileage, and the details of any entertainment or gift expenses.

It's wise to have either canceled checks or receipts for most of your expense items. You should open a business checking account so that the distinction between personal and business expenditures is clear. If an item raises a question, you will want to make a note in your records as to why it is for business and not personal.

You should also keep a permanent record of expenditures for capital assets—those assets that have a useful life of more than 1 year—such as a camera. This is necessary for you to justify the

depreciation expense you will compute for the assets. In addition, grant letters, contracts, and especially tax returns should be retained as part of your permanent files.

Even if you use an accountant, you will have to keep your records neatly and in a regular manner. To do this, you should have an Expense Ledger and an Income Ledger. The Expense Ledger could be set up in the form shown on this page. Each time you incur an expense, you make two entries. First you put the amount under Total Cash if you paid with cash or Total Check if you paid by check. Then you enter the amount under the appropriate expense heading. In this way, you can be certain of your addition, because the total of the entries under Total Cash and Total Check should equal the total of the entries under all the columns for specific expenses. If you paid cash for 10 rolls of film on January 2, 1981, the entry of $48 would appear once under Total Cash and once under Film and Processing. If, on January 4, you then hired for $150 each three models and paid them by check, the entry of $450 would appear under Total Check and under Model Fees. Ledger books with many-columned sheets can be purchased at any good stationery store.

Expense Ledger

Date	Item	Total cash	Total check	Legal and accounting fees	Film and processing	Office supplies	Salaries	Model fees	Advertising	Props and wardrobe	Entertainment	Rent	Utilities	Commissions	Freelance assistants and stylists	Meals and lodging	Transportation	Telephone	Equipment	Insurance	Miscellaneous

If you coordinate the expense categories in your Expense Ledger with those on Schedule C of your income tax form (pages 155-156) you can save a lot of time when you have to fill out your tax forms.

How should you file receipts you get for paying your expenses? A simple method is to have a Bills Paid file in which you put these receipts in alphabetical order. An accordian-type file works fine and you'll be able to locate the various receipts easily.

After you have set up your Expense Ledger, you have to set up your Income Ledger. This can be done with the following format:

Income Ledger

Date	Client or customer	Job no.	Fee	Billable Expenses	Sales tax	Other
1/3	Acme Advertising	35	$700	$375	$80	
1/6	Johnson Publishing	43	$315	$145		

We've assumed that you are using the simplest form of bookkeeping. If you were to use more complicated bookkeeping, you would probably have your books set up by an accountant and the entries made by a bookkeeper. However, if you accurately keep the records we've just described, you'll be able to support your deductions in the event of an audit.

Tracking and Billing Jobs

You should know the precise expenses for each job. If you're working for a fee plus expenses you usually need to show the client proof of expenses in the form of copies of receipts. If you're working on a flat-fee basis, you need to know whether you charged enough both to cover expenses and make a reasonable profit.

Most photographers handle this problem by setting up a "job envelope" or "job file" for each job. The envelope or file (we'll refer only to envelopes hereafter) creates one specific place where all the records for each job are placed—all the receipts, releases, contracts, and other documents. It should contain suppliers' receipts, labor cost invoices, and petty cash or other vouchers indicating the amounts of film you used from your own inventory, the car mileage used on your own car or a record of taxi trips, and the like. Thus, when the job has been completed, you or your accountant, secretary, or bookkeeper

can go to one single file or source to secure all the information needed to prepare an invoice.

On each job envelope you should mark the client's name and prospective shooting date. You should also establish a number for each job and write that on the envelope. All your job numbers should be in sequence. That way you will always be sure to bill for every job. Months later you can look at all your invoices. If a number is missing, you will know that a job was not billed and that you need to make further inquiry.

As an additional precaution, many photographers set up a job ledger that contains the information they are most frequently called on to look up about particular jobs. Each job is entered into the job ledger as soon as the assignment is given. The columns in the ledger might appear in this form:

Job Ledger

Job no.	Client	Shooting date	Fee	Reimbursed expenses	Sales tax	Total	Billing date	Payment date

Using this kind of ledger you can quickly monitor your billing procedures and determine how quickly (or slowly) you are being paid.

Filing Negatives, Transparencies, and Prints

The two goals of a filing system for your photographs are accessibility for stock sales and safety. Consider buying fire-retardant files. These may also provide a degree of protection against water damage, which is probably a more common hazard than fire.

You will need different-sized files for transparencies and negatives on the one hand, and prints on the other. Specially made drawers are available, both undersize for transparencies and negatives and oversize for prints.

Your time is much too valuable to spend rummaging through card boxes, searching out unindexed photographs. If that's your style, get a stock picture agent immediately. In order to ensure your own quick access for effective stock sales, you must have a detailed cross-index card file for all your photographs. This normally consists of a simple 3 × 5 card, filed alphabetically in accordance with the *subject matter* of each photograph.

Every photograph should be entered first under the subject of its principal characteristic, with subentries for all other important aspects of the photograph. For example, the photograph of a young couple

holding hands at sunset would probably have its main card entry under the subject "Couples," and the photograph itself would be stored with the "Cs" under Couples. Additional card entries, referring to the main card entry, might be in the "Ss" under "Sunsets" and in the "Ys" under "Youth." With this kind of cross-indexed file you can quickly locate all the relevant pictures in your files when someone makes a request for a stock photograph.

The main card entry in your file for each photograph should contain a record of all submissions and sales of that photograph, indicating date, price, limitations that restrict your use (if any), availability of model releases (by model's name), and the date when the photograph was made.

Your name, address, telephone number, and copyright notice should be rubber-stamped on the back of your prints. With 35mm transparencies you may wish to do the same thing on the slide mount, although many photographers simply stamp their name or copyright notice there.

Finally, you should keep a logbook for stock photo submissions. This could be either a separate book of entries for each submission you make indicating date, client, and number of photographs or simply a copy of every submission agreement you make out, filed chronologically (each submission should be accompanied by a submission memo as indicated on page 104-105). With this chronological file of submission agreements, you can quickly ascertain who needs to be prodded about a decision regarding usage or for return of your material.

Miscellaneous Files

There are a number of routine alphabetic files that you will need, including the following:

- Releases. If your photos are cross-indexed, as just described, the main card entry will include the model's name and an indication about the availability of a release. With that name you can then find the release if you have filed the releases alphabetically. If you have a large number of releases you may choose to keep a separate alphabetic file for each year. Since the card entry in the cross-index should indicate the year that the photograph was made, date-filing of releases will cause no problem.

 You may keep separate filing cabinet drawers with alphabetic separators for your alphabetic index, or, especially when starting

out, you may prefer the less complex accordion file. This type of file is available at any stationery store in a variety of sizes and consists of a self-contained expandable unit with a compartment for each letter of the alphabet.

- Bills payable and bills paid. The bills a photographer must pay are usually filed alphabetically in an accordion file (as described above) and processed on a monthly or semimonthly basis. Once a bill has been paid you should file the voucher or customer copy in your "bills paid" file. These files should be stored on an annual basis to conform to your tax records.
- Accounts receivable and accounts paid. You should make one or preferably two copies of every invoice you send out. These should be kept in a separate chronological file. You can check that file regularly to make sure you're being paid for all jobs on a reasonably timely basis. Once the bill has been paid, of course, the invoice copy should be transferred to an "accounts paid" file that, again, should be kept on an annual basis to conform to your tax records.
- Other files. Depending upon the amount of documentation you develop, you may want to have separate drawer or accordion files for such items as credit applications, copyright applications and contracts.

Where to Keep Your Records

You should have a part of your studio set aside for your records. It should be secure and not accessible to casual visitors. The records should be carefully organized in standard metal filing cabinets (letter or legal size, depending on your taste). The area you select for maintaining and reviewing the records should be free of clutter and unrelated activity, so that the recordkeeping can be done efficiently and without mistakes.

CHAPTER 9

Taxes

IN *The Wasteland,* T. S. Eliot called April "the cruelest month." But if you work at your tax records on a regular basis, you'll be prepared for April's arrival. It is true that photographers and other freelancers face a more difficult task in preparing their taxes than does the ordinary taxpayer who simply earns a salary. You should, however, be able to take advantage of many of the tax-saving ideas in this chapter. If you can't do it alone, you can certainly do it with the help of an accountant and a good recordkeeping system such as the one described in the previous chapter.

Tax Years and Accounting Methods

Your tax year is probably the calendar year, running from January 1 through December 31. This means that your income and expenses between those dates are used to fill out Schedule C, Profit or (Loss) From Business or Profession. Schedule C is attached to your Form 1040 when you file your tax return in April.

What's the alternative to using the calendar year as your tax year? You could have what's called a fiscal year. This means a tax year starting from a date other than January 1, such as from July 1 through June 30. Most photographers use the calendar year and, if you do use a fiscal year, you will almost certainly have an accountant. For these reasons, we are going to assume that you are using a calendar year.

But how do you know whether income you receive or expenses you pay fall into your tax year? This depends on the accounting method that you use. Under the cash method, which most photographers use, you receive income for tax purposes when you in fact receive the income. That's just what you would expect. And you incur an expense for tax purposes when you actually pay out the money for

the expense. So it's easy to know which tax year your items of income and expense should be recorded in.

What is the alternative to cash method accounting? It's called accrual accounting. Essentially it provides that you record an item of income when you have a right to receive it and record an item of expense when you are obligated to pay it. Once again, you will probably have an accountant if you use the accrual method, so we will focus on the more typical case of the photographer who uses the cash method.

One final assumption is that you are a sole proprietor and not a partnership or corporation. However, the general principles discussed in this chapter apply to all forms of doing business.

Income

Income for tax purposes includes all the money generated by your business—fees, royalties, sales of art, and so on. Prizes and awards will usually be included in income, unless they're the kind of prizes or awards that you receive without having to make any application (such as the Nobel prize). On the other hand, grants can frequently be excluded from income as long as they are not paid in return for services or primarily to benefit the grant-giving organization. Degree candidates can deduct the full amount of such grants. Photographers who are not working toward a degree can deduct grants only as follows:

- up to $300 per month
- for no more than 36 months (consecutive or otherwise) during the photographer's lifetime
- only if the grant comes from certain governmental, nonprofit, or international organizations

Expenses related to the grants are also excluded from income (and don't reduce the $300 per month limit for photographers who are not seeking degrees). You can find more information about the taxation of grants in IRS Publication 17, *Your Federal Income Tax,* Chapter 7, "What Income is Taxable." All IRS publications are available free of charge from your local IRS office.

It's worth mentioning that insurance proceeds received for the loss of photographs, negatives, or transparencies are income. And if you barter, the value of what you receive is also income. So trading a photograph for the services of an accountant gives you income in the amount of the fair market value of the accountant's services.

Types of Income

But all income is not the same. There are the following different kinds of income:

1. earned ordinary income, such as that from salary, fees, royalties, sales of art, and so on.
2. unearned ordinary income, such as interest on a savings account or dividends from stock.
3. short-term capital gains, which is profit from the sale of capital assets, such as stocks, bonds, and gold, that you have owned 1 year or less.
4. long-term capital gains, which is profit from the sale of capital assets that you have owned for more than 1 year.

The differences among these types of income are important because they are taxed differently:

- Earned ordinary income is never taxed more than 50 percent.
- Unearned ordinary income and short-term capital gains can be taxed as high as 70 percent.
- Long-term capital gains are never taxed more than 28 percent.

The advantage of having long-term capital gains is obvious. Unfortunately, photographers will almost always have earned ordinary income from their business activities.

The income tax rate, by the way, is progressive. The more money you earn, the higher is the percentage you have to pay in taxes. But the higher percentages apply only to each additional amount of taxable income, not to all your taxable income. So if your taxable income increases from $2700 to $3200 and you pay a tax of 15 percent on that $500 increment, the tax on that increment will always be 15 percent—even if your highest increment is above $102,200 of taxable income and is taxed at 70 percent.

Expenses

Expenses reduce your income. Any ordinary and necessary business expense may be deducted from your income for tax purposes. This includes film and other photographic supplies, office supplies and expenses such as typing paper and postage, messenger fees, prop rentals, transportation costs, business entertainment,

secretarial help, legal and accounting fees, commissions paid to an agent, books or subscriptions directly related to your business, professional dues, telephone expenses, rent, and so on. On Schedule C these expenses are entered on the appropriate lines or, if not listed, under "Miscellaneous."

Because your right to deduct certain expenses can be tricky, we're going to discuss some of the potential items of expense in detail.

Home Studio

If you have your studio at a location away from your home, you can definitely deduct rent, utilities, maintenance, telephone, and other related expenses. Under today's tax laws, you would be wise to locate your studio away from home if possible, because if your studio is at home, you will have to meet a number of requirements before you can take deductions for your studio. To put it another way, if you're going to have your studio at home, be certain you meet the tests and qualify to take a business deduction for rent and related expenses.

The law states that a deduction for a studio at home can be taken if "a portion of the dwelling unit is exclusively used on a regular basis (A) as the taxpayer's principal place of business, (B) as a place of business which is used by patients, clients, or customers in meeting or dealing with the taxpayer in the normal course of his trade or business, or (C) in the case of a separate structure which is not attached to the dwelling unit, in connection with the taxpayer's trade or business." Exclusivity means that the space is used only for the business activity of being a photographer. If the space is used for both business and personal use, the deduction will not be allowed. For example, a studio that doubles as a television room will not qualify under the exclusivity rule. The requirement of regularity means that the photographer must use the space on a more-or-less daily basis for a minimum of several hours per day. Occasional or infrequent use certainly will not qualify.

Once the work space is used exclusively and on a regular basis, the studio expenses can qualify as deductible under one of three different tests. First, they will be deductible if the studio is your principal place of business. But what happens if you must work at other employment or run another business in order to earn the larger part of your income? In this case, it would appear that the principal-place requirement refers to each business separately. Is the studio at home the principal place of the business of being a photographer? If it

is, the fact that you also work elsewhere shouldn't matter. However, you could not deduct a studio at home under this provision if you did most of your work in another studio maintained at a different location. The second instance in which the expenses can be deductible occurs when the studio is used as a place of business for meeting with clients or customers in the normal course of a trade or business. Many photographers do open their studio at home to clients in the normal course of their business activities, so this provision might well be applicable. Finally, the expenses for a separate structure, such as a storage shed, would qualify for deduction if the structure were used in connection with the business of being a photographer. If you are seeking to deduct home studio expenses as an employee rather than a freelancer, you must not only use the space exclusively on a regular basis for business and meet one of the three additional tests just described, but you must also maintain the space for the convenience of your employer. A photography teacher, for example, might argue that a studio at home was required by the school, especially if no studio space were available at the school and professional achievements in photography were expected of faculty members.

The photographer who does use the work space exclusively on a regular basis for one of the three permitted uses just discussed must pass yet one more test before being able to deduct the expenses. This is a limitation on the amount of expenses that can be deducted in connection with a studio at home. Deductible expenses for business use of the home include the cost of heating, water, electricity, air conditioning, cleaning, repairs, and similar expenses. The artist who rents can deduct the rental payments, while the artist who owns his home can deduct depreciation, mortage interest, and real estate taxes. Of course, all these expenses are divided between business and personal use, so only that portion of expenses applicable to business use is actually deductible on Schedule C.

The limitation placed on these expenses is basically that they cannot exceed your gross income from your business. For example, a photographer who rents his or her home uses one-quarter of it exclusively on a regular basis as his or her principal place of business. If the total expenses relating to the home are $8,000, the one-quarter share attributable to the business and therefore deductible is $2,000. But what happens if the photographer shows only $1,200 in gross income on Schedule C from his or her photography business? In that case, the expenses relating to the studio at home are deductible only to the extent of the $1,200. The calculation for the photographer who

owns his or her own home is very similar, but it is more complicated and you may need an accountant's help.

Educational Expenses

You may want to improve your skills as a photographer by taking a variety of educational courses. The rule is that you can deduct these educational expenses if they are for the purpose of maintaining or improving your skills in a field that you are already actively pursuing. You cannot deduct such expenses if they are to enable you to enter a new field or meet the minimal educational requirements for an occupation. For example, photography students in college cannot deduct their tuition when they are learning the skills necessary to enter a new field. A photographer who has been in business several years could deduct expenses incurred in learning better photographic techniques or even better business techniques. Both would qualify as maintaining or improving skills in the photographer's field.

Professional Equipment

You can spend a tremendous amount of money on cameras, lights, darkroom equipment, and the like. This equipment will last more than 1 year. For this reason, you cannot deduct the full price of the equipment in the year that you buy it. Instead, you must depreciate it over the years of its useful life. Depreciation is the process by which a part of the cost of equipment is deducted as an expense in each year of the equipment's useful life.

To take a simplified example, you might purchase a camera for $1,000. Based on your experience, you believe that a reasonable estimate of the useful life of the camera is 5 years. Using the simplest method of depreciation—straight-line depreciation—you would divide 5 years into $1,000. Each year for 5 years you would take a $200 depreciation deduction for the camera.

In fact, the calculation of depreciation is more complicated than this. The cost of the camera is called *basis*. It is basis that is depreciated. However, basis may have to be reduced by salvage value—the value the camera will have at the end of its useful life. Also, you may be able to take what is called bonus depreciation in the year that you purchase an asset. This is an extra 20 percent depreciation deduction that is allowed if the equipment has a useful

life of more than 6 years. And there are other methods of calculating depreciation that result in a quicker write-off. The complexities of these various options are discussed in IRS Publication 534, *Tax Information on Depreciation.* If you have a substantial investment in equipment, it would be worthwhile to have an accountant aid you in the depreciation computations.

Another tax benefit that comes from purchasing professional equipment is the investment tax credit. There is a distinction between a tax deduction and a tax credit. A deduction is subtracted from income. A credit is subtracted directly from your tax. Because of this, a credit is more favorable than a deduction. That is, a credit of $100 will save you more in taxes than a deduction of $100. The investment tax credit gives you a credit of 10 percent of the cost of equipment that you purchase if the equipment has a useful life of 7 years or more for depreciation purposes. If the useful life is 5 to 7 years, only two-thirds of the 10 percent credit is allowed. If the useful life is 3 to 5 years only one-third of the credit can be taken. Form 3468, *Computation of the Investment Credit,* is used to determine the amount of the investment credit.

Although the amount of the investment credit is based on the useful life for depreciation, taking the investment credit does not reduce the amount of depreciation you can take on the same equipment.

Travel

Many photographers are required to travel in the course of their work. Some examples of business travel include travel to do an assignment, to negotiate a deal, to seek new clients, or to attend a business or educational seminar related to your professional activities. Travel expenses (as opposed to transportation expenses which are explained later) are incurred when you go away from your home and stay away overnight or at least have to sleep or rest while away. If you qualify, you can deduct expenses for travel, meals and lodging, laundry, transportation, baggage, reasonable tips, and similar business-related expenses. This includes expenses on your day of departure and return, as well as on holidays and unavoidable layovers that come between business days.

The IRS has strict recordkeeping requirements for travel expenses. These requirements also apply to business entertainment and gifts, since these are all categories that the IRS closely scrutinizes for abuses. The requirements are for records or corroboration showing:

1. the amount of the expense
2. the time and place of the travel or entertainment, or the date and description of any gift
3. the business purpose of the expense
4. the business relationship to the person being entertained or receiving a gift.

If you travel solely for business purposes, all your travel expenses are deductible. If you take part in some nonbusiness activities, your travel expenses to and from the destination will be fully deductible as long as your purpose in traveling is primarily for business and you are traveling in the United States. However, you can deduct only business-related expenses, not personal expenses. If you go primarily for personal reasons, you will not be able to take the travel expenses incurred in going to and from your destination (but you can deduct legitimate business expenses at your destination).

If you are traveling outside the United States and devoting your time solely to business, you may deduct all your travel expenses just as you would for travel in the United States. If the travel outside the United States was primarily for business but included some pesonal activities, you may deduct the expenses as you would for travel primarily for business in the United States if you meet any of the following five tests:

1. You are an employee whose expenses are paid by an employer.
2. You had no substantial control over arranging the trip.
3. You were outside the United States a week or less.
4. You spent less than one-quarter of your time outside the United States on nonbusiness activities.
5. You can show that personal vacation was not a major factor in your trip.

If you don't meet any of these tests, you must allocate your travel expenses. This is explained in IRS Publication 463, *Travel, Entertainment, and Gift Expenses.*

By the way, if your spouse goes with you on a trip, his or her expenses are not deductible unless you can prove a bona fide business purpose and need for your spouse's presence. Incidental services, such as typing or entertaining, aren't enough.

The IRS is very likely to challenge travel expenses, especially if the auditor believes a vacation was the real purpose of the trip. To successfully meet such a challenge, you must have good records that

substantiate the business purpose of the trip and the details of your expenses. For more information with respect to travel expenses, you should consult IRS Publication 463.

Transportation

Transportation expenses must be distinguished from travel expenses. First of all, commuting expenses are not deductible. Traveling from your home to your studio is considered a personal expense. If you have to go to your studio and then go on to a business appointment, or if you have a temporary job that takes you to a location remote from your home and you return home each night, you can deduct these expenses as transportation expenses. But only the transportation itself is deductible, not meals, lodging, and the other expenses that could be deducted when travel was involved.

The IRS sets out guidelines for how much you can deduct when you use your automobile for business transportation. This is a standard mileage rate, presently 20 cents for the first 15,000 miles and 11 cents for every mile over 15,000. In addition, you can deduct interest on loans to purchase your automobile, state and local taxes (other than on gasoline), parking fees, tolls, and any investment credit.

However, you don't have to use the standard mileage rate. You may prefer to depreciate your automobile and keep track of gasoline, oil, repairs, licenses, insurance and the like. By calculating both possible ways, you may find that actually keeping track of your expenses gives you a far larger deduction than the standard mileage amount.

Of course, if you use your automobile for both business and personal purposes, you must allocate the expenses to the business use for determining what amount is deductible.

Entertainment and Gifts

The IRS guidelines for documenting entertainment and gift expenses were already set out when we discussed travel.

Entertainment expenses must be directly related to your business activities. You should definitely have a receipt if you spend more than $25 (although it's wise to have receipts or cancelled checks for all your expenses in any case). Business luncheons, parties for business associates or clients, entertainment and similar activities are all permitted if a direct business purpose can be shown. However, the expenses for entertainment must not be lavish or extravagant.

Business gifts are deductible, and you can give gifts to as many people as you want. However, the gifts are deductible only up to the amount of $25 per person each year.

For both entertainment and gift expenses you should again consult IRS Publication 463, *Travel, Entertainment, and Gift Expenses.*

Beyond Schedule C

So far we've mainly been discussing income and expenses that would appear on Schedule C. A completed Schedule C appears on pages 155-156 so you can see how the various types of entries might be made. It's worth mentioning that some accountants for photographers believe that high gross receipts themselves or a high ratio of gross receipts on line 1 to net profits on line 21 may invite an audit. If you incur many expenses that are reimbursed by your clients, these accountants simply treat both expenses and reimbursement as if they cancelled each other out. This results in the same net profit, but your gross receipts are less. The expenses and reimbursements are shown on a page attached to Schedule C or in a footnote indicating the total amounts at the bottom of the front page of Schedule C. Or you could include the reimbursement as part of gross receipts and then subtract the expenses as deductions.

Schedule C is not the only schedule of importance to the photographer. There are potential income tax savings—and obligations—that require using other forms.

Retirement Accounts

You, as a self-employed person, can contribute the lesser of $7,500 or 15 percent of net self-employment income to a retirement plan. This plan is called a Keogh plan, after the sponsor of the legislation that allowed such contributions. The amount that you contribute to the plan is deducted from your income on Form 1040. While you must set up the Keogh plan during the tax year for which you want to deduct your payments to the plan from your income, once you have set up the plan you are permitted to wait to make the actual payment of money until your tax return must be filed. The payments into a Keogh plan must be kept in certain special types of accounts, such as a custodial account with a bank, a trust fund, or special United States Government retirement bonds. You don't have to pay taxes on any income earned by money in your Keogh account, but you are penalized if you withdraw any money from the account

prior to age 59½ (unless you are disabled or die—in which case your family could withdraw the money). The money will be taxed when you withdraw it for your retirement, but you may be in a lower tax bracket then. In any case, you will have had the benefit of all the interest earned by the money that would have been spent as taxes if you hadn't created a Keogh retirement plan.

You can create a Keogh plan as long as you have net self-employment income. This is true even if you have another job and your employer also has a retirement plan for you. If you have only a small amount of self-employment income, you'll be able to make a minimum payment to a Keogh plan of the lesser of $750 or 100 percent of self-employment income.

If you have no Keogh plan and your employer does not provide any retirement plan either, you are eligible to create an Individual Retirement Account (IRA). You can create such a plan anytime before your tax return for the year must be filed and pay in your money at the same time. The money you pay in—the lesser of 15 percent of salary and professional fees or $1,500—is deducted from your income for the year covered by the tax return. If you have a nonworking spouse, you may be able to contribute $1750 to the plan as long as your spouse also benefits. In most other ways these accounts are similar to Keogh plans.

You can obtain more information about retirement plans from the institutions that administer them. Several IRS publications are also helpful, including Publication 560, *Retirement Plans for Self-Employed Individuals*, Publication 566, *Questions and Answers on Retirement Plans for the Self-Employed*, and Publication 590, *Tax Information on Individual Retirement Savings Programs*.

Child and Disabled Dependent Care

If you have a child or disabled dependent for whom you must hire help in order to be able to work, you should be able to take a tax credit for part of the money you spend. This is more fully explained in IRS Publication 503, *Child Care and Disabled Dependent Care*.

Charitable Contributions

Photographers cannot, unfortunately, take much advantage of giving charitable contributions of their photographs or copyrights. Your tax deduction is limited to the costs that you incurred in producing what you are giving away. You are penalized for being the

creator of the photograph or copyright, since someone who purchased either a photograph or copyright from you could donate it and receive a tax deduction based on the fair market value of the contributed item. Groups representing creators have been working since 1969 to amend this unfair aspect of the tax laws.

Bad Debts

What happens if someone promises to pay you $500 for a photograph that you deliver but then never pays you? You may be able to sue him or her for the money, but you cannot take a deduction for the $500, because you never recorded the money as income since you're a cash method taxpayer. The whole idea of a bad debt deduction is to put you back where you started, so it applies mainly to accrual basis taxpayers. If you lend a friend some money and don't get it back, you may be able to take a nonbusiness bad debt deduction. This would be taken on Schedule D as a short-term capital loss, but only after you had exhausted all efforts to get back the loan.

Income Averaging

If a taxpayer's income goes up sharply in one year, a tax-saving aid may exist in the form of income averaging. What income averaging essentially does is take part of your income for 1 year and spread it back over the 4 prior years. If you were in a lower tax bracket in the prior years, you can save taxes. You don't have to recompute your taxes for all the prior years, by the way, but instead simply fill out Schedule G for the year in which you intend to average. IRS Publication 506, *Computing Your Tax Under the Income Averaging Method,* can be helpful here.

Self-Employment Tax

In order to be eligible for the benefits of the social security system, self-employed people must pay the self-employment tax. This tax is computed on Schedule SE, *Computation of Social Security Self-Employment Tax.* Additional information about the self-employment tax can be found in IRS Publication 533, *Information on Self-Employment Tax.* Also, the Social Security Administration publishes several helpful pamphlets, including those titled "Your Social Security" and "If You're Self-Employed . . . Reporting Your Income for Social Security."

Estimated Tax Payments

Self-employed people should make estimated tax payments on a quarterly basis. In this way you can ensure that you won't find yourself without sufficient funds to pay your taxes in April. Also, you are legally bound to pay estimated taxes if your total income and self-employment taxes for the year will exceed taxes that are withheld by $100 or more. The estimated tax payments are made on Form 1040-SE, *Estimated Tax Declaration Voucher,* and sent in on or before April 15, June 15, September 15, and January 15. The details of estimated tax payments are explained in IRS Publication 505, *Tax Withholding and Declaration of Estimated Tax.*

Proving Professionalism

The IRS may challenge you on audit if they find that you've lost money for a number of years in your activities as a photographer. It's demoralizing when this happens, since the auditors will call you a hobbyist and challenge your professionalism. However, you have resources and should stand up for yourself. In fact, you should probably be represented by an accountant or attorney to aid you in making the arguments to prove you're a professional (use one of the volunteer lawyers for the arts listed on page 226 if you can't afford your own attorney).

First, if you have a profit in 2 years of the 5 years ending with the year they're challenging you about, there's an automatic presumption in your favor that you intend to make a profit. That's the crucial test for professionalism—that you intend to make a profit. But, if you can't show a profit in 2 years of those 5, there is no presumption saying you are a hobbyist. Instead, the auditor is supposed to look at all the ways in which you pursue your photographic business and see whether you have a profit motive. In particular, the regulations set out nine factors for the auditor to consider. You should try to prove how each of those factors shows your profit motive. But don't be discouraged if some of the factors go against you, since no one factor is dispositive. Here we'll list the nine factors and briefly suggest how you might argue your professionalism:

1. *The manner in which the taxpayer carries on the activity.* Your recordkeeping is very important. Do you have good tax records? Good records for other business purposes? Use of professional

advisors, such as an accountant, is helpful. Your marketing efforts show professionalism. Seeking a representative, stock agency, or gallery all show an intent to sell your work. Membership in professional associations suggests you are not a hobbyist. Similarly, grant and contest applications show your serious intent to make a profit. The creation of a professional studio and use of professional equipment also suggest you are not a hobbyist. Maintaining your prices at a level consistent with being a professional is important, but on the other hand the price level must not be so high as to prevent your obtaining assignments and selling your work.

2. *The expertise of the taxpayer or his or her advisers.* You would normally attach your résumé to show your expertise. You would make certain to detail your study to become a photographer—whether you studied formally or as someone's assistant. Any successes are significant. Have you sold your work, done assignments for clients, given shows in galleries? Reviews or other proofs of critical success are important. Teaching can be a sign of your expertise. Obtaining statements from leading photographers or one of the professional organizations as to your professionalism aids your cause. Even the place where you work can be important, if it is known as the location of many successful photographic studios. You should use your imagination in seeking out all the possible factors that show your expertise.

3. *The time and effort expended by the taxpayer in carrying on the activity.* You must work at your photography on a regular basis. Of course, this includes time and effort related to marketing your work and performing all the other functions that accompany the actual shooting of the photographs.

4. *The expectation that assets used in activity may increase in value.* This factor is not especially relevant to photographers. You might argue, however, that the photographs and copyrights you are creating are likely to increase in value. This is most believable if you place your photographs with stock agencies for resale or sell prints as original works.

5. *The success of the taxpayer in carrying on other similar or dissimilar activities.* If you have had success in another business venture, you should explain the background and show why that leads you to believe your photography business will also prove successful. If the success was in a closely related field, it becomes

even more important. You might expand this to include successes as an employee that encouraged you to believe you could be successful on your own.

6. *The taxpayer's history of income or losses with respect to the activity.* The regulations state, "A series of losses during the initial or start-up stage of an activity may not necessarily be an indication that the activity is not engaged in for profit." Everyone knows that businesses are likely to lose money when they start. The point is to show a succession of smaller and smaller losses that, in the best case, end up with a small profit. You might want to draw up a chart ranging from the beginning of your photographic career to the year at issue, showing profit or loss on Schedule C, Schedule C gross receipts, the amount of business activity each year, and taxable income from Form 1040. The chart should show shrinking losses and rising gross receipts. This suggests that you may start to be profitable in the future. By the way, you can include on the chart years after the year at issue. The additional years aren't strictly relevant to your profit motive in the year at issue, but the auditor will consider them to some degree.

7. *The amount of occasional profits, if any, that are earned.* It helps to have profits. But the reason you're being challenged as a hobbyist is that you didn't have profits for a number of years. So don't be concerned if you can't show any profitable years at all. It's only one factor. Also, keep in mind that your expectation of making a profit does not have to be reasonable; it merely has to be a good faith expectation. A wildcat oil outfit may be drilling against unreasonable odds in the hopes of finding oil, but all that matters is that the expectation of making profit is held in good faith. Of course, you would probably want to argue that your expectation is not only in good faith but reasonable as well, in view of the circumstances of your case.

8. *The financial status of the taxpayer.* If you're not wealthy and you're not earning a lot each year, it suggests you can't afford a hobby and must be a professional. That's why showing your Form 1040 taxable income can be persuasive as to your profit motive. If you are in a low tax bracket, you're really not saving much in taxes by taking a loss on Schedule C. And if you don't have a tax motive in pursuing your photography, it follows that you must have a profit motive.

9. *Elements of personal pleasure or recreation.* Since so many people have fun with cameras, it may be hard for the auditor to

understand that you are working when you use one. Explain that photography is a job for you as the auditor's job is one for him or her. The pleasure you get out of your work is the same pleasure that auditors get out of theirs, and so on. If you travel you're especially likely to be challenged, so have all your records in impeccable shape to show the travel is an ordinary and necessary business expense.

The objective factors in the regulations don't exclude you from adding anything else you can think of that shows your professionalism and profit motive. The factors are objective, however, so statements by you as to your subjective feelings of professionalism won't be given too much weight. An important case is *Churchman v. Commissioner,* 68 Tax Court No.59 (1977) in which an artist who hadn't made a profit in 20 years was found to have a profit motive.

Gift and Estate Taxes

The subject of gift and estate taxes is really beyond the scope of this book. It's important to plan your estate early in life, however, and the giving of gifts can be an important aspect of this planning. In addition to considering the saving of estate taxes and ensuring that your will indicates those whom you wish to benefit, you must also plan for the way in which your work will be treated after your death. These issues, including the giving of gifts and the choosing of executors, are discussed in detail in a new book for photographers and other creators edited by Tad Crawford and titled *Protecting Your Heirs and Creative Works* (Graphic Artists Guild, 30 East 20th Street, New York, New York 10003, $6.95).

Helpful Aids

We have mentioned that all IRS publications are available free of charge. Two publications of special interest are IRS Publication 17, *Your Federal Income Tax,* and IRS Publication 334, *Tax Guide for Small Business.* Keep in mind, however, that these books are written from the point of view of the IRS. If you're having a dispute on a specific issue, you should obtain independent advice as to whether you have a tax liability.

A good basic guide for income taxation, estate taxation, and estate planning is contained in Tad Crawford's *Legal Guide for the Visual Artist* (New York City, Hawthorn Books, $6.95). There are also two books that focus specifically on advising the creative person

about taxes. These are *The Tax Reliever: A Guide for the Artist* by Richard Helleloid (Drum Books, P.O. Box 16251, Saint Paul, Minnesota 55116, $4.95 plus 50¢ postage) and *Fear of Filing* (Volunteer Lawyers for the Arts, 36 West 44th Street, New York, New York 10036, $4.00).

Finally, for preparing a current return, the most comprehensive of the guides for the general public is *J.K. Lasser's Your Income Tax* (Simon & Schuster, 1230 Avenue of the Americas, New York, New York 10020, $3.95).

| SCHEDULE C (Form 1040) Department of the Treasury Internal Revenue Service | **Profit or (Loss) From Business or Profession** (Sole Proprietorship) Partnerships, Joint Ventures, etc., Must File Form 1065. ▶ Attach to Form 1040 or Form 1041. ▶ See Instructions for Schedule C (Form 1040). | 19**79** 09 |

Name of proprietor Jack Photographer

Social security number of proprietor 000 : 00 : 0000

A Main business activity (see Instructions) ▶ Photographer ; product ▶ Photography

B Business name ▶

C Employer identification number

D Business address (number and street) ▶ 33 Pine Street
City, State and Zip Code ▶ Grove City, Missouri 0,0,0,0,0,0,0,0,0

E Accounting method: (1) ☒ Cash (2) ☐ Accrual (3) ☐ Other (specify) ▶

F Method(s) used to value closing inventory:
(1) ☐ Cost (2) ☐ Lower of cost or market (3) ☐ Other (if other, attach explanation)

	Yes	No
G Was there any major change in determining quantities, costs, or valuations between opening and closing inventory? If "Yes," attach explanation.		X
H Did you deduct expenses for an office in your home?		X
I Did you elect to claim amortization (under section 191) or depreciation (under section 167(o)) for a rehabilitated certified historic structure (see Instructions)? (Amortizable basis (see Instructions) ▶)		X

Part I Income

1 a Gross receipts or sales	1a	44,385	
b Returns and allowances	1b		
c Balance (subtract line 1b from line 1a)	1c	44,385	
2 Cost of goods sold and/or operations (Schedule C–1, line 8)	2	8,448	
3 Gross profit (subtract line 2 from line 1c)	3	35,937	
4 Other income (attach schedule)	4		
5 Total income (add lines 3 and 4) ▶	5	35,937	

Part II Deductions

6 Advertising	1,245	31 a Wages	2,000	00
7 Amortization		b Jobs credit		
8 Bad debts from sales or services		c WIN credit		
9 Bank charges	60	d Total credits		
10 Car and truck expenses	822	e Subtract line 31d from 31a	2,000	00
11 Commissions	1,300	32 Other expenses (specify):		
12 Depletion		a Miscellaneous	289	
13 Depreciation (explain in Schedule C–2)	2,480	b		
14 Dues and publications	175	c		
15 Employee benefit programs		d		
16 Freight (not included on Schedule C–1)	340	e		
17 Insurance	650	f		
18 Interest on business indebtedness	340	g		
19 Laundry and cleaning	380	h		
20 Legal and professional services	1,200	i		
21 Office supplies	640	j		
22 Pension and profit-sharing plans		k		
23 Postage	362	l		
24 Rent on business property	4,241	m		
25 Repairs	1,012	n		
26 Supplies (not included on Schedule C–1)		o		
27 Taxes		p		
28 Telephone	975	q		
29 Travel and entertainment	1,500	r		
30 Utilities	705	s		

33 Total deductions (add amounts in columns for lines 6 through 32s) ▶	33	20,716	
34 Net profit or (loss) (subtract line 33 from line 5). If a profit, enter on Form 1040, line 13, and on Schedule SE, Part II, line 5a (or Form 1041, line 6). If a loss, go on to line 35	34	15,221	
35 If you have a loss, do you have amounts for which you are not "at risk" in this business (see Instructions)? ☐ Yes ☐ No			

Schedule C (Form 1040) 1979

Page **2**

SCHEDULE C–1.—Cost of Goods Sold and/or Operations (See Schedule C Instructions for Part I, line 2)

1 Inventory at beginning of year (if different from last year's closing inventory, attach explanation) .	**1**	
2 a Purchases **2a**		
b Cost of items withdrawn for personal use **2b**		
c Balance (subtract line 2b from line 2a) .	**2c**	
3 Cost of labor (do not include salary paid to yourself)	**3**	3,755
4 Materials and supplies .	**4**	4,693
5 Other costs (attach schedule) .	**5**	
6 Add lines 1, 2c, and 3 through 5	**6**	8,448
7 Inventory at end of year .	**7**	
8 **Cost of goods sold and/or operations** (subtract line 7 from line 6). Enter here and on Part I, line 2 . ▶	**8**	8,448

SCHEDULE C–2.—Depreciation (See Schedule C Instructions for line 13)
If you need more space, please use Form 4562.

Description of property (a)	Date acquired (b)	Cost or other basis (c)	Depreciation allowed or allowable in prior years (d)	Method of computing depreciation (e)	Life or rate (f)	Depreciation for this year (g)
1 Total additional first-year depreciation (do not include in items below) 20% of $3200.						640
2 Other depreciation:						
Buildings						
Furniture and fixtures . . .	1/2/79	8,000		straight line	5	1,600
Transportation equipment . .				straight line		
Machinery and other equipment .	2/28/79	3,200			8	240
Other (specify)						
3 Totals		11,200			3	2,480 00
4 Depreciation claimed in Schedule C–1					4	
5 **Balance** (subtract line 4 from line 3). Enter here and on Part II, line 13 ▶					5	2,480 00

SCHEDULE C–3.—Expense Account Information (See Schedule C Instructions for Schedule C–3)

Enter information for yourself and your five highest paid employees. In determining the five highest paid employees, add expense account allowances to the salaries and wages. However, you don't have to provide the information for any employee for whom the combined amount is less than $25,000, or for yourself if your expense account allowance plus line 34, page 1, is less than $25,000.

Name (a)	Expense account (b)	Salaries and wages (c)
Owner .		
1		
2		
3		
4		
5		

Did you claim a deduction for expenses connected with:	Yes	No
A Entertainment facility (boat, resort, ranch, etc.)? .		X
B Living accommodations (except employees on business)?		X
C Conventions or meetings you or your employees attended outside the U.S. or its possessions? (See Instructions) . .		X
D Employees' families at conventions or meetings? .		X
If "Yes," were any of these conventions or meetings outside the U.S. or its possessions?		X
E Vacations for employees or their families not reported on Form W–2?		X

CHAPTER 10

Insurance Protection

The Problem

CONSIDER THIS SITUATION: A photographer was recently informed by his physician that he needed an operation and would be unable to work for 3 to 4 months. Upon returning to his studio he found a "summons and complaint" (that is, notice of a legal action against him) to the effect that he was being sued for $25,000 for invasion of privacy. The claim was by a model who asserted that the photographer's client had made an unauthorized use of a photograph that the photographer had taken some 5 years ago.

Undaunted, the photographer went into his studio accompanied by a former associate who tripped over a tripod lying in front of the door and severely injured his head. Hearing this commotion, the studio assistant stormed over to the doorway to inform the photographer that the person who had broken into the studio the night before had stolen most of their cameras and lenses and had also dropped a lighted cigarette into the filing cabinet where all the photographer's tax returns, business records, and client lists were located.

The photographer was relieved to find out that his prize portfolio was not harmed in the turmoil since his agent had picked it up the day before to show it to a prospective ad agency client. Hours later the agent duly reported the inevitable. The agency couldn't find the portfolio, which had been left for an overnight review.

Surprisingly, insurance coverages, most of them available at reasonable cost, would afford protection in most of if not all the situations referred to above.

The amount of insurance you will need in any category depends on your personal circumstances. If you add up the cost (or replacement value, where that is what the insurance covers) for all your equipment and it comes to $10,000, then that is the amount to cover.

Similarly, if you earn $10,000 per year, then the insurance to protect that income in case of sickness or an accident should provide for a benefit of about $200 per week. In each case, simply ask yourself what is at risk. Then you will generally know how much coverage to secure.

When seeking insurance try to deal with an agent whose clients are in business for themselves. That agent will have greater exposure than usual to your type of problems. Naturally, the best solution is to find an agent who is already dealing with a few of the other photographers in your area. If you are unable to locate someone on your own, consult with one of the professional societies. For example, the American Society of Magazine Photographers (ASMP), 205 Lexington Avenue, New York, New York 10016, telephone (212) 889-9144, or the Professional Photographers of America (PPA) 1090 Executive Way, Des Plaines, Illinois 60018, telephone (312) 299-8161, may be of assistance. If the national headquarters of the organization doesn't have the information, a local chapter or affiliate can probably help you. Be sure to ask the headquarters office for the organization's local contact or phone number.

Finally, when buying insurance, there are some crucial strategies you must employ to keep the total cost at a level you can afford. These are covered below.

Strategy for Buying Insurance Economically

There are a few key points to bear in mind when buying professional insurance:

- *Package Purchasing.* Get your insurance all at once, and all at the same place, if possible. Many business risks in this field are so unusual they might never be covered if you had to have a separate policy for each (such as invasion of privacy insurance). But as part of a broad business package, the coverage can probably be secured, and possibly quite inexpensively.
- *High deductibles.* Look for policies in every area with high deductibles, that is, policies where you personally cover the first few hundred dollars (or more) of losses. A major cost for insurance companies is the administrative expenses of handling small claims. If you eliminate that problem for them on your policy, you may get a very substantial saving (often in the range of 20 percent to 40 percent). That approach will allow you to get more of the different coverages you need for this business.
- *High limits.* Get the highest coverage you can where the risk is

open-ended. For example, on "general liability" policies that cover personal injuries you (or your staff) might cause to innocent third parties, you should be covered up to about a million dollars. Jury awards of many hundreds of thousands of dollars and more are commonplace today.

- *Focus on major risks.* Focus especially on a situation that could wipe out all your personal or business assets, or your entire income. One would be the unlimited risk associated with bodily injury to third parties, just mentioned above, that are covered by general liability insurance. Another would be a disabling injury or illness that kept you from working for many years (your income could be replaced by disability income insurance). Obviously, these situations are more fraught with danger than loss of a few cameras or your portfolio. As one New York insurance expert with roots in Iowa put it: "Imagine that your business operation was a farm with cows that give milk. You can afford to lose a lot of milk (your product) and even some of the cows (your tools), but you're completely wrecked without the farm."

Business Protection

On the business side the basic coverages encompass the following:

1. *Injury to third parties. General liability insurance* covers claims of third parties for bodily injury and property damage incidents that occur inside or outside your studio. It can be extended to cover invasion of privacy, encompassing right of privacy and right of publicity claims, as well as plagiarism (including copyright violations), libel, and slander.

2. *Injured or sick "employees."* Those freelance assistants and stylists you hire on a day-to-day basis may be classified as employees in many states for the purposes of claims arising from injury on the job and sickness off the job. Accordingly, you may well be required by law to have *workmen's compensation insurance* to protect freelance (and of course regular) staffers in case of on-the-job injury and *disability benefits coverage* to provide income for employees who lose work time in the event of injury or sickness off the job.

 In addition, with a large staff, you may consider the usual medical, retirement, and disability income benefits programs often made available to longer-term employees.

3. *Your business property.* At stake here are your studio and

fixtures, equipment, photographs, business records, and cash accounts.

- *Studio and darkroom.* A *package policy* will cover studio contents against fire and theft. Special improvements such as a darkroom should be specifically indicated in the coverage. If your studio or darkroom is part of your home, your home-owner's or tenant's policy would cover these risks *if* the insurer is informed of the partial business use.

 Additions to the package policy may be of interest to established professionals: a so-called *extra expense rider* will cover extra expenses you incur to temporarily rent another place in the event of fire or other destruction at your own studio. Similarly, you can get *business overhead coverage* to temporarily pay for ongoing studio expenses while you are disabled from sickness or accident.

- *Cameras and equipment.* The most common coverage for photographers is the *camera floater,* which can encompass worldwide coverage for loss or damage to cameras, lenses, strobes, and other movable equipment. If you are just starting in business you may have a nonbusiness floater policy that you use to cover personal property, including your cameras. As your business becomes significant, you must convert the camera coverage to a commercial policy to be sure that the insurance is in effect in the event a loss occurs. Floaters cover only the specific items named in the policy. Therefore you must update the coverage list every 6 or 12 months with your new purchases during that period. Most policies insure only against losses up to the amount of your cost (less depreciation). That will not be enough to cover the cost of replacements, given the rapidly escalating price of equipment. Accordingly, you should consider getting "stated value" floaters, which will reimburse you for the current replacement cost in the event of loss. Of course, that increases the premium.

- *Photographs and business records.* The package policy cover-ing studio contents usually sharply limits recovery for loss of photographs or business records (often to as little as $500). To cover those items directly you need *valuable papers coverage.* Its best use is for the time and effort that might have to be spent to replace business records that are lost or damaged (in a fire, for example). Consider the problems that would arise if you lost the card index to your picture file, or all your tax

records. You can also use this coverage for negatives, transparencies, and prints. The problem is that these may be so numerous that the cost will be prohibitive. Many believe that the cheapest solution here is simply to store your best negatives and transparencies in the safe-deposit box of a bank vault.

Films damaged in a lab present special problems. Virtually all labs waive liability for any loss or damage (except to supply replacement film). Your best defense here is to take all film from important shootings and break it into separate batches that are sent to the lab over several days. In addition, never have your film processed on the first day after long holiday weekends when lab procedures may be slightly awry. For the established professional, the American Society of Magazine Photographers (ASMP) has developed an experimental insurance program covering film damaged any time during a shooting or in a lab. This is called *negative* or *shooting insurance* and is similar to policies currently in wide use in the motion picture business. (For additional information contact ASMP, 205 Lexington Avenue, New York, New York 10016, telephone (212) 889-9144.)

- *Cash accounts.* An established photographer may be jeopardized by the acts of a dishonest employee. While it happens very rarely indeed, an employee could forge your signature on studio checks or devise other means to secure unauthorized payments from the studio. Insurance for such situations is referred to a *fidelity coverage,* which, in effect, is a bonding procedure for your employees.

Personal Protection

On the personal and family side a photographer's insurance needs are similar to those of most other members of the public and should encompass the following:

- *Sickness and injury. Basic hospitalization* such as Blue Cross-Blue Shield (or other private plans) is essential but not enough. Extended hospitalization, intensive care, and major surgery make *major medical coverage* almost mandatory. Interestingly, once you have the basic hospitalization, the added expense of major medical is not great.

Often overlooked, however, is what happens to your income in the event of long-term or permanent disability due to sickness

or accident. Insurance coverage that provides income replacement is called *disability income* insurance and is generally considered essential for freelance people. If you elect a fairly long waiting period (say, 60 to 90 days of disability) before you start collecting, the cost can be quite reasonable.

- *Personal property.* The most common protection in this category is a homeowner's or tenant's policy to cover fire and theft risks associated with your house, apartment, and personal possessions. These policies often have options to cover general liability for injury to third parties who visit your residence. For expensive property that you take out of the residence such as cameras or other valuables, you need a floater, rider, or separate policy, which is an additional premium. Remember that business uses of your residence or property almost always require a separate commercial policy.

 Automobiles of course are covered separately for fire and theft under a comprehensive policy, and personnel injury or property damage to third persons under a general liability auto policy.

- *Life insurance and accidental death benefits.* Life insurance is necessary only in cases where others are dependent on your income or services. That could include your family or business partner. Life insurance can be obtained either as *term insurance,* which is purely a death benefit without cash value, or as a form of savings combined with the death benefit, referred to as *whole life.* Since photographers tend to travel extensively, they may also see value in an *accidental death and dismemberment* (AD&D) policy, which in effect is basic term life insurance, covering only the limited situation of accidental death. On an annual basis it is quite inexpensive, covering all possible accident situations, including travel. For example, it is certainly far less expensive than taking out coverage at the airport for each trip. AD&D coverage should not, however, be confused with medical coverage. AD&D pays only a death benefit and in certain cases pays for loss of sight or limbs.

PART III

Legal Guide

CHAPTER 11

Copyright

THE RIGHTS THAT YOU SELL to your photographs come from your copyright in those photographs. *All rights* or *world rights* is the transfer of your entire copyright; *first North American serial rights* is the transfer of a limited piece of your copyright. Your authority to sell rights to your photographs stems from the federal copyright laws that protect you. These laws were first enacted in 1790 and are periodically revised, the most recent revision taking effect on January 1, 1978.

If anyone wishes to use your copyrighted photographs, he or she must get your permission. You will then be able to set a suitable fee for the use the person wants to make of them. Anyone who violates your copyright is infringing upon your legal right, and you can sue for damages and prevent him or her from continuing the infringement. Your copyright is, therefore, important in two ways: it guarantees that you will be paid when you let others make use of your photographs, and it gives you the power to deny use of your photographs if, for example, the fee is too low or you don't believe that particular person or company will use the photographs in a way you consider esthetically satisfactory.

Rights to Copyrighted Photographs

If "copyrighted photographs" sounds ominous, it shouldn't. You have your copyright in a photograph as soon as you take it. This copyright is separate from the transparency or negative. For example, you can sell a transparency but reserve the copyright to yourself. The buyer would get a physical object—the transparency—but no right to reproduce your work. Or you could sell the copyright or parts of the copyright while retaining ownership of the transparency. It is common

practice to require the return of the transparency when selling reproduction rights.

As copyright owner, you have the following exclusive rights:

1. The right to authorize reproductions of your photographs.
2. The right to distribute copies of your photographs to the public (although a purchaser can resell a purchased copy).
3. The right to prepare derivative works based on your photographs. Derivative works are creations derived from another work of art. Thus a photograph could be the basis for a lithographic plate used to make fine prints. In such a case, the fine prints would be derivative works based on the original photograph.
4. The right to perform your work if it is audiovisual or a motion picture.
5. The right to display the photographs (except that the owner of a photograph can display it to people who are physically present at the place where the display occurs).

The exclusive rights are yours to keep or sell as you wish. Other users of these rights must first obtain your consent.

Transferring Limited Rights

You could always transfer *all rights* in your photographs, but that would be self-defeating. Whenever you sell rights, you naturally want to sell only what the user needs and is willing to pay for. The copyright law helps by requiring that transfers of exclusive rights of copyright be in writing. This requirement of a written transfer calls your attention to what rights are being given to the user. Such a transfer must be signed either by you or by your agent (if the agent has authorization from you to sign copyright transfers).

How can you tell whether the right that you are transferring is exclusive or not? Just ask the following question: If I transfer this right to two different users, will my transfer to the second user be a breach of my contract with the first user? If you transfer *first North American serial rights* to one magazine, you cannot transfer *first North American serial rights* to a second magazine. Obviously, both magazines could not be first to publish the work in North America. So *first North American serial rights* is an exclusive transfer and must be in writing and signed by you or your agent.

However, it is also possible to give a nonexclusive license to someone who wishes to use one of your photographs. Such a

nonexclusive license does not have to be written and signed but can be given verbally or in the course of dealing between the two parties. If you have not given a signed, written authorization, you know that you have sold only nonexclusive rights. This means that you can give the same license to two users without being in breach of contract with either user.

A photographer had done an advertising assignment for a cosmetics company and delivered a number of photographs. Nothing in writing was signed by the photographer. He asked: (1) Can I sell these photographs used by the advertiser to some other user? (2) What use can the advertiser make of the photographs? *Answer:* The photographer was free to resell the photographs to other users. Since no written transfer had been made, the advertiser had gotten only nonexclusive rights. As a practical matter, however, the photographer would almost certainly ask for the client's consent in order to keep on good terms and obtain future assignments. The question of what uses the advertiser can make of the photographs is harder to answer. If the advertiser's purchase order or the photographer's confirmation form or invoice specify what uses can be made, the problem may be solved. In the absence of a complete written contract, what the parties verbally agree to about usage would be considered. This can be quite difficult to prove and points to the value of having a clear written understanding before starting any assignment. Prior dealings between the parties or accepted practice in the field will also be considered by the courts if there is no written contract or the contract is ambiguous.

Since you want to sell limited rights, it's important to know how rights can be divided. Always think about the following bases on which distinctions can be made:

- exclusive or nonexclusive transfer
- duration of the use
- geographical area in which the use is permitted
- medium in which the use is permitted
- in a case involving words and photographs, the language in which use is permitted

If a magazine or book publisher wants to publish your photograph, you should make it a practice, whenever possible, not to sell *all rights* or even exclusive publishing rights. It is preferable to sell the

most limited rights that the publisher needs, since it is presumably paying for only those rights that it intends to use. Your transfer might be as follows: *exclusive first-time North American magazine rights*. The shorthand for this, of course, is *first North American serial rights*. Any of your exclusive rights as copyright owner can be subdivided and sold separately. The rest of the copyright still belongs to you for further exploitation.

Copyright Assignment Form

The copyright assignment form that appears on page 169 can be used if you are getting a transfer of *all rights* back from a user. This was frequently necessary under the old law, although it should not occur very often after January 1, 1978. Also, you could use this form to transfer all rights to a user, but you would be better off working with the Assignment Agreement Form on pages 95-96 that provides for a limited rights transfer.

Once you receive an assignment of a copyright, you should record it with the Copyright Office. This is easy to do, since you need only send $10 (there is an additional $.50 charge for each title over one) and the original or a certified copy of the assignment to the Copyright Office. The Copyright Office makes a microfilm copy of the assignment and returns the document to you along with a certificate of record. By recording the assignment within 1 month if it is made in the United States or within 2 months if made abroad, you establish your priority over others to whom the user may later, by mistake or otherwise, transfer the same copyright. In order to have priority, you will also have to register the copyright if it hasn't already been registered.

This system of recording is useful in another way. If you are trying to find out whether a work that you want to use is copyrighted and who the copyright owner is, the Copyright Office (for $10 per hour) will search its records to help you obtain this information.

Assignment of Copyright

For valuable consideration, the receipt of which is hereby acknowledged, *[name of party assigning the copyright]*, whose offices are located at *[address]* , does hereby transfer and assign to *[name of party receiving the copyright]*, whose offices are located at *[address]* , his heirs, executors, administrators, and assigns, all its right, title, and interest in the copyrights in the photographs described as follows: *[describe work, including registration number, if work has been registered]*
_____,
including any statutory copyright together with the right to secure renewals and extensions of such statutory copyright throughout the world, for the full term of said copyright or statutory copyright and any renewal or extension of same that is or may be granted throughout the world.

IN WITNESS WHEREOF, *[name of party assigning the copyright]* has executed this instrument by the signature of its duly authorized corporate officer on the _____ day of _____ , 198__ .

ABC Corporation

By: _____

Authorized Signature

Name Printed or Typed

Title

Copyright Notice

If you have copyright simply by taking a photograph you may wonder why you have to bother with copyright notice. The reason is that if you publish a photograph without copyright notice, you are likely to lose your copyright. Publication basically means public distribution, whether by sale, lending, leasing, gifts, or offering copies to other people for further distribution. Offering your photographs to a number of art directors is probably not a public distribution, but there is no harm in putting the copyright notice on the work before sending it out for submission.

The copyright notice has three parts:

1. "copyright" or "Copr." or ©
2. your name or an abbreviation from which your name can be recognized, or a pseudonym by which you're known
3. the year date of first publication

An example of a proper notice would be: © Jane Photographer 1980. The year date may be omitted from toys, stationery, jewelry, post-cards, greeting cards, and any useful articles. So if a photograph were used on greeting cards, proper copyright notice could be: © Jane Photographer or even © JP.

It's a good idea to have a stamp with your copyright notice: © Jane Photographer 19___. When your photographs are ready to leave your studio, you simply stamp the copyright notice on them. Since the photographs won't have been published yet, the year date you put in the copyright notice should be the year you made the photographs.

On publication, either in the United States or abroad, the year of first publication should appear in the notice. If the work is going to be distributed abroad, it is best to use ©, your full name, and the year date of first publication.

Placement of Copyright Notice

The copyright notice symbolizes your status as copyright owner. It warns the public of your rights over your creations. To fulfill these functions, the copyright notice must be placed on the photographs in a position and manner that will give reasonable notice of your claim of copyright.

For a print, the notice could go on the border or on the back. For a transparency, the notice could go on the mounting. For a photograph published in a book or magazine, the most obvious place for the notice would be adjacent to the photograph. However, there are a number of other placements that would be considered reasonable. If, for example, the magazine objected on esthetic grounds to an adjacent copyright notice, the notice could appear in any of the following locations:

1. For a photograph reproduced on a single page, notice can go under the title of the contribution on that page or anywhere on the same page if it's clear from the format or an explanation that the notice applies to the photograph.
2. For photographs appearing on a number of pages of a magazine, the notice can go under a title at or near the beginning of the spread, on the first page of the main body of the spread, immediately after the end of the spread, or on any of the pages comprising the spread if the spread is no more than 20 pages, the notice is prominent and set apart from other materials on the

page, and it is clear from the format or an explanation that the notice applies to the entire spread.

3. For photographs reproduced on either one page or a number of pages, the notice can go with a separate listing of the contribution by full title and author on the page bearing copyright notice for the magazine as a whole or on a table of contents or listing of acknowledgments appearing near the front or back of the magazine.

With so many possible placements to choose from, it is difficult for the magazine to deny use of the copyright notice on esthetic grounds. A magazine, by the way, is one type of collective work—a work including contributions by a number of creators. Other types of collective works would be anthologies and encyclopedias. The placements of copyright notice shown for magazines apply to all collective works.

While a single slide would have the notice on its mounting, a group of slides intended to be shown in sequence as an audiovisual piece would have the copyright notice appear on the projected image with or near the title, with credits and similar information at or immediately following the beginning of the work, or at or immediately before the end of the work. These placements apply to motion pictures.

A photographer sold *one time rights* in a photograph to a magazine. When she asked for copyright notice in her name, the magazine said that its copyright notice at the front of the magazine would protect the photographer's copyright. The photographer asks: Will the magazine's copyright notice actually protect my contribution to the magazine? If it will, why should I bother to ask for notice in my own name? *Answer:* The magazine is correct up to a point. The copyright notice for a collective work *will* protect the copyrights of individual contributors such as the photographer (although it will not generally protect the copyright in advertisements). However, the photographer will lose two benefits that come from having copyright notice in her own name. First, if someone wants to reproduce the photograph, he or she will probably go to the magazine since copyright notice is in the magazine's name. If the magazine sells reuse rights to that person, the photographer will have no right to sue the user for infringement. All the photographer can do, if she happens to find out such a use was made, is sue the magazine for the amount

received by the magazine. Second, the copyright law allows you to make a group registration for works first published as contributions to periodicals during a 12-month period, as long as your own copyright notice appeared on each contribution. A group registration saves you money by registering a number of works for a single $10 registration fee. Registration is not required to obtain your copyright, but it does offer a number of benefits, as the section on registration explains.

The Public Domain

Photographs and other artworks that are not protected by copyright are in the public domain. This means that they can be freely copied by anyone—they belong to the public at large. This includes photographs whose copyrights have expired and photographs that have lost copyright protection because of incorrect copyright notice.

However, the new copyright law gives you a number of opportunities to save your copyright if one of your photographs is published with an incorrect notice or without any notice at all.

First, an incorrect copyright notice will not affect the validity of your copyright in the following cases:

1. If an error is made in the name in the copyright notice.
2. If a year date in the copyright notice is earlier than the date of first publication.

If the wrong name appears in the copyright notice, a person who gets permission to use the photograph from the person named in the notice has a defense to your suit for infringement. You can cut off this defense by registering your work, or recording with the Copyright Office a document signed by the person named in the notice that states you are the copyright owner. In any case, however, the person named in the notice will have to give you any proceeds realized from licensing your photograph.

In the case of a year date earlier than the date of first publication, the term of the copyright runs from the earlier date. The term of copyright is your life plus 50 years, so it really doesn't matter if the copyright term starts earlier than the year of first publication. A photograph made in 1981 and published in 1983 will have a valid copyright until 50 years after the photographer's death, regardless of which date is used in the copyright notice.

Omitted Notice

The complete absence of the copyright notice on a published photograph raises the risk that your copyright will go into the public domain. Some types of incorrect notice are also treated as if the notice had been completely omitted:

1. the omission of your name or the date
2. the use of a year date that is more than 1 year after the year of first publication

However, even for a completely omitted notice, your copyright will remain valid in the following situations:

1. If the omission of copyright notice is from a relatively small number of copies, your copyright will remain valid without any further action on your part.
2. If the omission is from more than a relatively small number of copies, you can save the copyright from going into the public domain by registering within 5 years of the publication and making a reasonable effort to have copyright notice placed on the copies that lack notice.
3. If the copyright notice has been left off by a user in violation of an express written requirement that a condition of the use is placement of the copyright notice on the copies, your copyright will remain valid.

This last saving provision suggests that the stamp you use for copyright notice might be elaborated to make inclusion of the copyright notice a condition of any public distribution. Such a stamp could read:

COPYRIGHT © Jane Photographer 19___.
An express condition of any authorization to use this photograph is that copyright notice in the photographer's name appear on all publicly distributed copies of the photograph as follows: © Jane Photographer, year of first publication.

This provision could also be placed on your confirmation form or invoice, as long as the user is aware of this condition prior to making any use of your photographs.

Duration of Copyright

If you protect your copyright by requiring copyright notice at the time of first publication, your copyright will normally last for your lifetime plus 50 years. A photograph taken in 1983 by a photographer who dies in 2004 will have a copyright that expires in 2054. Copyrights run through December 31 of the year in which they expire.

If you create a work jointly with another photographer, the copyright will last until 50 years after the death of the survivor.

If you create a work anonymously or using a pseudonym, the copyright will last 75 years from the date of publication or 100 years from the date of creation, whichever term is shorter. However, you can convert the term to your life plus 50 years by advising the Copyright Office of your identity prior to the expiration of the term.

If you work for hire, as explained in the section on working for hire (pages 175-176), the copyright term will be 75 years from the date of publication or 100 years from the date of creation, whichever term is shorter. Remember, however, that when you do a work for hire you are no longer considered the creator of the work for copyright purposes. Instead, your employer or the person commissioning the work is considered the work's creator and completely owns the copyright.

For copyrights on photographs protected under the old federal copyright law (in other words, those works registered or published with copyright notice prior to January 1, 1978), the copyright term will be 75 years. However, the old copyright law required that copyrights be renewed at the end of 28 years. Pre-1978 copyrights that are in their first 28-year term must be renewed on Form RE.

Finally, you may have photographs that you created prior to January 1, 1978 but never registered or published. These photographs were protected by common law copyright. The new law provides that such photographs shall now have protection for the photographer's life plus 50 years. In no event shall the copyright on such photographs expire before the year 2002 and, if the photographs are published, the copyright will run at least until 2027.

Since copyrights remain in force after the photographer's death, estate planning must take copyrights into account. You can leave your copyrights to whomever you choose in your will. If you don't do this, the copyrights will pass under state law to your heirs.

Termination of Transfers

Because copyrights last for such a long time, the new copyright law adopted special termination provisions to protect photographers and other creators. It isn't possible to know how much a license or right of copyright will be worth in the distant future. So the law provides:

1. For licenses or rights of copyright given by the photographer on or after January 1, 1978, the transfer can be terminated during a 5-year period starting 35 years after the date of the transfer. If the right of publication is included in the transfer, the 5-year period for termination starts 35 years from the date of publication or 40 years from the date of the transfer, whichever is earlier.
2. For transfers made prior to January 1, 1978 by the photographer or the photographer's surviving heirs (as defined in the copyright law), the transfer can be terminated during a 5-year period starting 56 years from the date copyright was originally obtained, or starting on January 1, 1978, whichever is later.

The termination provisions do not apply to transfers made by will or to work made for hire. Also, a derivative work made prior to termination may continue to be exploited even after termination of the transfer in the photograph on which the derivative work is based.

Termination requires that you give notice of your intention to terminate 2 to 10 years in advance of the actual date of termination. If photographs of yours have maintained value for such a long period that the termination provisions could benefit you, it would be wise to have an attorney assist you in handling the termination procedures.

Work for Hire

You must be aware of one hazard under the copyright law. For an employee, work for hire means that the employer owns all rights of copyright as if the employer had in fact created the photographs. An employee can, of course, have a contract with an employer transferring rights of copyright back to the employee.

However, a freelance photographer may also be asked to do assignments as work for hire. This treats the photographer like an employee for copyright purposes, but doesn't give the photographer any of the benefits employees normally receive. The American

Society of Magazine Photographers and many other professional organizations representing creators have condemned the use of work-for-hire contracts with freelancers.

The copyright law safeguards freelancers by requiring that a number of conditions be met before an assignment will be considered work for hire:

1. The photographs must be specially ordered or commissioned.
2. The photographer and the user must both sign a written contract.
3. The written contract must expressly state that the assignment is done as work for hire (but also beware of any other phrases that sound as if you're being made an employee for copyright purposes).
4. The assignment must fall into *one* of the following categories:
 - a contribution to a collective work, such as a magazine, anthology, or encyclopedia
 - a supplementary work, which includes photographs done to illustrate a work by another author (but only if the photographs are of secondary importance to the overall work)
 - part of an audiovisual work or motion picture
 - an instructional text
 - a compilation (which is a work formed by the collection and assembly of many preexisting elements)
 - a test
 - answer material for a test
 - an atlas

If these four conditions are not satisfied, you cannot be doing work for hire.

If you do work for hire, you are giving the maximum in rights to the user. You can't terminate the rights that the user receives, the way you eventually could with an *all rights* transfer. Of course, the more rights you sell, the greater the payment that you should demand.

Contributions to Magazines

If you sell to a collective work such as a magazine without signing anything in writing specifying what rights you are transferring, the law presumes that you have transferred only the following nonexclusive rights:

1. the right to use your contribution in that particular collective work, such as that issue of the magazine
2. the right to use your contribution in any revision of the collective work
3. the right to use the contribution in any later collective work in the same series

If you sold your photographs to a magazine, that same magazine could reprint the photographs in a later issue without paying you (unless you agree or specify otherwise). But the magazine could not authorize a different magazine to reprint the photographs, even if the same company owned both magazines. If you sold your photographs to an anthology, they could be used again in a revision of that anthology (unless you agree or specify otherwise). However, they could not be used in a different anthology. Also, the owners of the collective work would have no right to change the photographs when reusing them.

A photographer has completed an assignment for a magazine. No agreement was ever reached about what rights were being transferred to the magazine. However, the photographer has now received a check with a legend on its back stating, "By signing this check, you hereby transfer all rights of copyright in your photograph titled _____ to this magazine." The photographer asks: (1) Can this legend on a check be a valid transfer of copyright? (2) Should I cash the check or return it and demand a check without such a legend? *Answer:* There has been a disagreement among copyright authorities as to whether signing such a check creates the written instrument required for a copyright transfer. The safest course is to return the check and request one that does not have the legend. You should definitely do this if you have not used a confirmation form specifying the rights transferred or if you have not yet completed the assignment. If you have completed the assignment in reliance on a confirmation form that specifies what rights you are transferring, you could cross out the legend and deposit the check without signing it. The best practice, however, is to have a clear understanding about rights before you start and simply return any check that recites a greater rights transfer than what you have previously agreed to. The failure of the magazine to pay according to the terms agreed to would be a breach of contract for which the publication would be legally liable.

Registration of Published Photographs

The forms for registering the copyrights in your photographs are shown on pages 188-190. To register, you send Form VA, two copies of your published photographs, and $10 to the United States Copyright Office, Library of Congress, Washington, D.C. 20559.

But if you have copyright the moment you take your photographs, why should you bother to register? The reason is that registration gives you the following benefits:

1. You must register to sue for a copyright violation.
2. Registration creates a presumption in your favor that your copyright is valid and the statements you made in the Certificate of Registration are true.
3. Registration in some cases limits the defense that can be asserted by infringers who were "innocent," that is, who infringed in reliance on the absence of copyright notice in your name.
4. You must register prior to an infringement's taking place if you are to be eligible to receive attorney's fees and statutory damages (except that a registration within 3 months of publication will be treated as if made on the date of publication).

If you have published contributions in magazines, the registration of the magazine will not register your contribution (unless you transferred all rights to the magazine, which you don't want to do). When registering your published contributions to magazines or newspapers, you need only deposit one complete copy of the magazine or of the section of the newspaper containing your contribution.

It is also possible to have a group registration for published contributions to periodicals, such as magazines and newspapers. In making such a group registration, you would use the basic Form VA and also use Form GR/CP shown on page 190. To qualify, your contributions must satisfy the following conditions:

1. Each contribution had identical copyright notice in your name.
2. All the contributions were published during one 12-month period (not necessarily a calendar year).

The group-deposit provision allows you to register many contributions for a single $10 registration fee. Additional regulations will be issued

by the Copyright Office to cover registration of groups of related published works.

Registration of Unpublished Photographs

So far, we have been discussing the registration of published photographs. However, you can also register unpublished photographs. In many cases, the registration of unpublished photographs will be easier and far less expensive than the registration of published photographs. The regulations provide that unpublished photographs may be registered in a group for a single $10 fee if:

1. The deposit materials are in an orderly format.
2. The collection bears a single title, such as "Collected Photographs of Jane Photographer, 1980."
3. The same person claims copyright in all the photographs.

There is no limit on the number of photographs you can register in a group registration of unpublished photographs—all for the same $10 fee.

Another advantage of an unpublished registration is that you have to deposit only one copy of each image. Your deposit materials all have to be the same size. Transparencies must be at least 35mm and fixed in cardboard, plastic, or similar mounts to facilitate identification, handling, and storage. Prints, contact sheets, or photocopies should be no less than 3 × 3 inches and no more than 9 × 12 inches. The preferred size is 8 × 10 inches. For color transparencies you can deposit color Xerox copies or photocopies in a contact-sheet type of layout. Color photographs or transparencies must be reproduced in color. It would be wise to place the deposit materials securely in a binder with the title and your name on the front.

Once you have registered a photograph as part of an unpublished group, you do not have to reregister it if it is later published. Keep in mind that the deposit materials must clearly show the entire copyrightable content of the work. For this reason, tacking a number of photographs up and shooting one photograph of all of them for deposit purposes is a poor technique and should be avoided.

Form VA is used for the group registration of unpublished photographs.

Infringement

If someone uses one of your photographs without permission, that person is an infringer. You can sue an infringer to stop the infringement. At the same time you have a right to be compensated for the infringement.

You're entitled to your actual damages caused by the infringement, plus any extra profits the infringer may have made that aren't covered by your actual damages. If it would be difficult to prove your damages or the infringer's profits, you can elect to receive statutory damages, which are an award of between $250 and $10,000 for each work infringed, the exact amount being determined in the court's discretion.

Lawsuits for copyright infringement are brought in the federal courts and are expensive for both parties. For this reason, infringement suits are frequently settled before trial.

The test for infringement, by the way, is whether an ordinary observer believes that one photograph has been copied from another. You should keep in mind that a drawing or a film can also infringe a photograph.

A photographer shows her lawyer the cover of a leading national magazine. On the cover is an illustration of a well-known doctor. The photographer produces her copyrighted photograph from which she believes the illustration on the cover has been copied. She asks: (1) Is this an infringement? (2) What should I do about it? *Answer:* The illustration will be an infringement if an ordinary observer would believe it to have been copied from the photograph. In this case, the attorney believes that it was, in fact, copied. Illustrators frequently work from files of photographs that they keep for reference. When working with a copyrighted photograph, they must change the image to such a degree that the ordinary observer would no longer feel the illustration had been copied. As a practical matter, the photographer's attorney will contact the magazine, which will probably settle. Of course, the magazine may argue that no copying took place, in which case an infringement action will be necessary.

Fair Use

Not every use of a copyrighted photograph will be an infringement. Fair use allows someone to use your copyrighted photographs

in a way that is noncompetitive with the uses that you would normally be paid for. A fair use is not an infringement. The law gives four factors to consider in deciding whether a use is a fair use or an infringement. If you're considering using someone else's photograph, you would weigh these factors to decide whether you should obtain permission for the use:

1. the nature of the use, including whether it's commercial or nonprofit and educational
2. the nature of the copyrighted work
3. how much of the copyrighted work is actually used
4. what effect the use will have on the potential market for or value of the copyrighted work

Fair use is frequently invoked for purposes such as criticism, comment, news reporting, teaching (including multiple copies for classroom use), scholarship, or research. For example, if a critic wants to write about your photography, the critic could use one of your photographs to illustrate the article without obtaining your consent. Similarly, if a news reporter wants to feature you in a news story, the reporter can include one of your photographs in the news story as an example of your work. These are fair uses.

A photographer has been retained by a corporate client to do an annual report. One of the photographs is to be a montage composed of other photographs already in the possession of the client—a lake in Arizona that the company has developed, a young woman in a bathing suit, scenic views of the countryside, and so on. The photographer asks: (1) Can I use these copyrighted photographs as a fair use, since the montage format creates a different image? (2) If I can't simply use these photographs, what should I do? *Answer:* The use is a commercial use. Changing the size of the photographs, or even cropping them, will not change the fact that they are being reproduced without permission. The photographer should contact the copyright owners of the photographs and ask for permission to use them. If a fee is required for the use, as is likely, it can be passed along to the client. At the same time, the photographer should obtain a model release from the woman in the bathing suit. Otherwise she may bring an invasion of privacy lawsuit.

How do you obtain permission to use a photograph? The best way is to have a standard form, such as the following one:

Permission Form

I hereby grant to *[photographer's name]* permission to use the following photographs:

Title Description

_____ _____

_____ _____

_____ _____

in the following manner: *[name of publication and extent of usage]*
As an express condition of this authorization a copyright notice and credit line shall appear in my name as follows: © *(owner's name)* 198__

Copyright Owner

Date

You would send an explanatory cover letter along with an extra copy of the permission form that the copyright owner would sign and return to you. You can also use this permission form when requests are made to use photographs that you have taken. Of course, you would carefully outline the rights you are giving and specify fees that must be paid for the usage.

Compulsory Licensing

Compulsory licensing deserves a brief mention. It is a provision in the law that allows nonprofit educational television stations, such as those in the Public Broadcasting Service, to use your published photographs without asking your permission. However, the Copyright Royalty Tribunal in Washington, D.C., sets rates of payment that these stations are obligated to pay to you if they make use of your work. The stations are also required to make semiannual accountings, setting forth what photographs and other graphic works they have

used. These accountings are filed with the Copyright Royalty Tribunal, 1111 Twentieth Street, N.W., Washington, D.C. 20036.

Moral Rights

Moral rights are widely recognized abroad. Included among them are the right to receive credit when photographs of yours are published and the right to have the photographs published without distortion. Since moral rights are not part of the copyright law in the United States, a moral rights bill has been introduced to amend the copyright law. The most important lesson here is that you must contractually protect your right to a credit line and the publication of your work without distortions. It might be possible to argue that a strong trade custom requires a credit line—for example, in the editorial field—or that a distorted photograph libels the photographer, since it is not in fact the photographer's work. But these can be difficult arguments to make in court, especially when a contractual provision would leave no doubt about your rights.

What Isn't Copyrightable

Your photographs will almost always be copyrightable. Even a home movie, such as the Zapruder film of the assassination of John F. Kennedy, was copyrighted. A photograph that is an infringement of a copyrighted work is not copyrightable. Ideas are not copyrightable, although the creative expression of an idea is. The idea to photograph a subject in a special way is not copyrightable, for example, but the photograph itself definitely would be copyrightable. Titles, names, and short phrases that may accompany your photographs are usually not copyrightable, because they lack enough creative expression. Also, the courts sometimes hold obscene photographs to be uncopyrightable, although the definition of obscenity presents a problem. The Copyright Office does not pass on obscenity. It's up to the courts to make this determination. Works of a useful nature will not be copyrightable, unless they also have an artistic element. A lamp base would not be copyrightable, but a photograph on the lamp base certainly would be. Photographs that are purely mechanical in their creation, such as X rays or microfilmed text, are not copyrightable.

Patents and Trademarks

Patents and trademarks are often confused with copyrights. Protection for photographs comes from the copyright law.

A utility patent can be obtained for inventions of machines or processes that are useful, original, and not obvious to people with skill in that field. A utility patent is far more expensive to obtain than a copyright, since the services of a patent attorney are almost always a necessity. These can cost $1,000 or more, depending on the complexity of the patent. A design patent is somewhat less expensive to obtain, and it protects manufactured items that have ornamental, original, and unobvious designs. A new process for developing film could qualify for a utility patent, but simply taking a photograph would not.

Trademarks are distinctive names, emblems, or mottos that manufacturers use to identify their products to the public. Using someone else's trademark is forbidden because the public would then become confused as to whose product it was buying. It's wise to consult an attorney before selecting a trademark, since you wouldn't want your trademark to be an infringement of someone else's. Trademarks gain protection simply by being used, although they can also be registered for federal and state protection.

The Old Copyright Law

The new copyright law—effective January 1, 1978—has taken long enough to explain without going back over what the law used to be before January 1, 1978. However, photographs taken before that date were governed by the old copyright law. If, for example, you published a photograph without copyright notice under the old law, it immediately went into the public domain. The new law doesn't revive these lost copyrights. Sales to magazines and rights in commissioned works were also governed by different presumptions. The details of the old copyright law are discussed in *Legal Guide for the Visual Artist,* by Tad Crawford (Hawthorn Books, New York City, $6.95). If your photographs taken before January 1, 1978 had copyright protection, after January 1, 1978 they are governed by the new copyright law.

A photographer took photographs of an automobile show in 1975 but never published them. In 1982 he is able to place the photographs with a magazine. His question: Since the photographs were taken before January 1, 1978, will the old copyright law govern the sale to the magazine? *Answer:* The new copyright law will govern the sale, because it takes place after January 1, 1978. If the photographer had sold the photographs to a

magazine in 1976, the old copyright law would have governed. This would be true even if a dispute arose as to the 1976 sale after January 1, 1978.

More Copyright Information

One of the best sources for copyright information is the Copyright Office. The *Copyright Information Kit* is available free by writing to the Copyright Office, Library of Congress, Washington, D.C. 20559. It contains all the registration forms as well as circulars describing the activities of the Copyright Office. The Office will also provide you with as many free copies of the registration forms as you may want. The Copyright Office will not, however, give you legal advice about copyright. A booklet focusing on the new copyright law as it applies to photographers and other artists is *The Visual Artist's Guide to the New Copyright Law,* by Tad Crawford (Graphic Artists Guild, 30 East 20th Street, New York, New York 10003, $5.50 per copy).

The Copyright Forms

No discussion of copyright would be complete without an explanation of the copyright forms. Form VA is the basic form used for photography—to register either published or unpublished photographs. Form GR/CP would be used in addition to Form VA if you wanted to register photographs published as contributions to periodicals that qualify for group treatment. Form VA has helpful instructions, but the following step-by-step approach cuts through any extra verbiage. We have not included the Copyright Office instructions for either Form VA or Form GR/CP, since you will automatically receive those instructions when you request the forms from the Copyright Office.

Looking at the Form VA on pages 188-189, let's assume first that you want to register a single unpublished photograph. In Space 1 you would give the title of the work and indicate "photograph" as the nature of the work. In Space 2 you would give your name as author and indicate the work is not work made for hire. You would also give your birth date, state your nationality, and indicate that your contribution to the work was neither anonymous nor pseudonymous. Where it says "Author of" you would again state "photograph." In Space 3 you would give only the years of completion—the year in which the photograph was made. Space 4 would have your name and address as those of the copyright claimant. In Space 5 you would

indicate that no earlier registration had been made for the work. Space 6 you would leave blank. In Space 7 you would give your name and address for correspondence. In Space 8 you would check the box for author, sign your name, print or type your name, and give the date. Finally, in Space 9 you would show your name and address so that the Certificate of Registration could be mailed to you. Of course, if your situation doesn't fit the facts in these answers, you would make the necessary changes as you go through the form.

Taking the next typical case, you want to make a group registration of unpublished works. You follow the directions just given for registering a single unpublished work with a few changes. In Space 1 the title of the work is the collection's title, such as "Collected Photographs of Jane Photographer, 1980." It is helpful to state the number of photographs in the collection. And in Space 3, the year of completion is the year in which the most recently completed photograph in the collection was finished.

Now let's assume that you want to register a published photograph. Again the steps are basically the same as for the registration of a single unpublished photograph, with the following changes. In Space 1 you would so indicate if the photograph had been published as a contribution to a collective work such as a magazine, an anthology, or an encyclopedia, and give the required information with respect to the collective work. In Space 3 you would give not only the year of creation, but also the date and nation in which the first publication took place. In Space 5 you would indicate whether the work had previously been registered and, if it had been, check the box indicating the reason for the new registration and give the year and number of the previous registration. Space 6 you would fill out only if the photograph had been derived in some way from another work— not a likely possibility. Everything else would be the same as for the registration of a single unpublished photograph.

Finally, you might seek to register a group of published contributions to periodicals, if you qualify as explained under the section on ˙registration of published photographs. To do this you would use not only Form VA, but also Form GR/CR shown on page 190. Form VA is filled out as for a published photograph, but with a few changes. Space 1 is left blank, except for the title where you write "See Form GR/CP, attached." In Space 3 you give the year of creation, but leave blank the information with respect to publication. Next you go to Form GR/CP. Here in Space A you indicate that Form VA is the basic application. In Space B you fill in the required information with

respect to each contribution and the periodical in which it appears. And that's all.

Once you send off your registration form, deposit materials, and fee, you'll have to wait while your application is processed by the Copyright Office. But your registration takes effect the moment that the proper forms, deposit materials, and fee are received by the Copyright Office, no matter how long it is before you actually receive the Certificate of Registration.

FORM VA

UNITED STATES COPYRIGHT OFFICE

REGISTRATION NUMBER
VA VAU
EFFECTIVE DATE OF REGISTRATION
Month Day Year

DO NOT WRITE ABOVE THIS LINE. IF YOU NEED ADDITIONAL SPACE, USE CONTINUATION SHEET (FORM VA/CON)

1 Title

TITLE OF THIS WORK:

NATURE OF THIS WORK: (See instructions)

Previous or Alternative Titles

PUBLICATION AS A CONTRIBUTION: (If this work was published as a contribution to a periodical, serial, or collection, give information about the collective work in which the contribution appeared.)

Title of Collective Work Vol No Date Pages

2 Author(s)

IMPORTANT: Under the law, the "author" of a "work made for hire" is generally the employer, not the employee (see instructions). If any part of this work was "made for hire" check "Yes" in the space provided, give the employer (or other person for whom the work was prepared) as "Author" of that part, and leave the space for dates blank.

1

NAME OF AUTHOR:

DATES OF BIRTH AND DEATH:
Born (Year) Died (Year)

Was this author's contribution to the work a "work made for hire"? Yes No

AUTHOR'S NATIONALITY OR DOMICILE:
Citizen of _____ (Name of Country) or Domiciled in _____ (Name of Country)

WAS THIS AUTHOR'S CONTRIBUTION TO THE WORK:
Anonymous? Yes No
Pseudonymous? Yes No
If the answer to either of these questions is "Yes" see detailed instructions attached

AUTHOR OF: (Briefly describe nature of this author's contribution)

2

NAME OF AUTHOR:

DATES OF BIRTH AND DEATH:
Born (Year) Died (Year)

Was this author's contribution to the work a "work made for hire"? Yes No

AUTHOR'S NATIONALITY OR DOMICILE:
Citizen of _____ (Name of Country) or Domiciled in _____ (Name of Country)

WAS THIS AUTHOR'S CONTRIBUTION TO THE WORK:
Anonymous? Yes No
Pseudonymous? Yes No
If the answer to either of these questions is "Yes" see detailed instructions attached

AUTHOR OF: (Briefly describe nature of this author's contribution)

3

NAME OF AUTHOR:

DATES OF BIRTH AND DEATH:
Born (Year) Died (Year)

Was this author's contribution to the work a "work made for hire"? Yes No

AUTHOR'S NATIONALITY OR DOMICILE:
Citizen of _____ (Name of Country) or Domiciled in _____ (Name of Country)

WAS THIS AUTHOR'S CONTRIBUTION TO THE WORK:
Anonymous? Yes No
Pseudonymous? Yes No
If the answer to either of these questions is "Yes" see detailed instructions attached

AUTHOR OF: (Briefly describe nature of this author's contribution)

3 Creation and Publication

YEAR IN WHICH CREATION OF THIS WORK WAS COMPLETED:

Year
(This information must be given in all cases.)

DATE AND NATION OF FIRST PUBLICATION:

Date _____ (Month) (Day) (Year)
Nation _____ (Name of Country)
(Complete this block ONLY if this work has been published.)

4 Claimant(s)

NAME(S) AND ADDRESS(ES) OF COPYRIGHT CLAIMANT(S):

TRANSFER: (If the copyright claimant(s) named here in space 4 are different from the author(s) named in space 2, give a brief statement of how the claimant(s) obtained ownership of the copyright.)

• Complete all applicable spaces (numbers 5-9) on the reverse side of this page
• Follow detailed instructions attached
• Sign the form at line 8

DO NOT WRITE HERE

Page 1 of pages

EXAMINED BY:	APPLICATION RECEIVED:	
CHECKED BY:		FOR COPYRIGHT OFFICE USE ONLY
CORRESPONDENCE ☐ Yes	DEPOSIT RECEIVED:	
DEPOSIT ACCOUNT FUNDS USED: ☐	REMITTANCE NUMBER AND DATE	

DO NOT WRITE ABOVE THIS LINE. IF YOU NEED ADDITIONAL SPACE, USE CONTINUATION SHEET (FORM VA/CON)

PREVIOUS REGISTRATION:

- Has registration for this work, or for an earlier version of this work, already been made in the Copyright Office? Yes...... No......

- If your answer is "Yes," why is another registration being sought? (Check appropriate box)
 - ☐ This is the first published edition of a work previously registered in unpublished form.
 - ☐ This is the first application submitted by this author as copyright claimant.
 - ☐ This is a changed version of the work, as shown by line 6 of the application.

- If your answer is "Yes," give: Previous Registration Number............... Year of Registration......

(5) Previous Registration

COMPILATION OR DERIVATIVE WORK: (See instructions)

PREEXISTING MATERIAL (Identify any preexisting work or works that this work is based on or incorporates.)

MATERIAL ADDED TO THIS WORK (Give a brief, general statement of the material that has been added to this work and in which copyright is claimed.)

(6) Compilation or Derivative Work

DEPOSIT ACCOUNT: (If the registration fee is to be charged to a Deposit Account established in the Copyright Office, give name and number of Account.)

Name

Account Number

CORRESPONDENCE: (Give name and address to which correspondence about this application should be sent.)

Name

Address

(Apt.)

(City) (State) (ZIP)

(7) Fee and Correspondence

CERTIFICATION: ✱ I, the undersigned, hereby certify that I am the: (Check one)
☐ author ☐ other copyright claimant ☐ owner of exclusive right(s) ☐ authorized agent of

(Name of author or other copyright claimant or owner of exclusive right(s))

of the work identified in this application and that the statements made by me in this application are correct to the best of my knowledge

Handwritten signature: (X)

Typed or printed name Date

(8) Certification (Application must be signed)

MAIL CERTIFICATE TO

(Name)

(Number, Street and Apartment Number)

(City) (State) (ZIP code)

(Certificate will be mailed in window envelope)

(9) Address For Return of Certificate

✱ 17 U S C § 506(e) FALSE REPRESENTATION — Any person who knowingly makes a false representation of a material fact in the application for copyright registration provided for by section 409, or in any written statement filed in connection with the application, shall be fined not more than $2,500.

☆ U.S. GOVERNMENT PRINTING OFFICE : 1977 O—249-638

Nov. 1977 –300,000

ADJUNCT APPLICATION
for
Copyright Registration for a
Group of Contributions to Periodicals

- Use this adjunct form only if you are making a single registration for a group of contributions to periodicals, and you are also filing a basic application on Form TX, Form PA, or Form VA. Follow the instructions, attached.
- Number each line in Part B consecutively. Use additional Forms GR/CP if you need more space.
- Submit this adjunct form with the basic application form. Clip (do not tape or staple) and fold all sheets together before submitting them.

FORM GR/CP

UNITED STATES COPYRIGHT OFFICE

REGISTRATION NUMBER		
TX	PA	VA

EFFECTIVE DATE OF REGISTRATION

. .
(Month) (Day) (Year)

FORM GR/CP RECEIVED

Page _____ of _____ pages

DO NOT WRITE ABOVE THIS LINE. FOR COPYRIGHT OFFICE USE ONLY

(A) **Identification of Application**

IDENTIFICATION OF BASIC APPLICATION:
- This application for copyright registration for a group of contributions to periodicals is submitted as an adjunct to an application filed on: (Check which)

☐ Form TX ☐ Form PA ☐ Form VA

IDENTIFICATION OF AUTHOR AND CLAIMANT: (Give the name of the author and the name of the copyright claimant in all of the contributions listed in Part B of this form. The names should be the same as the names given in spaces 2 and 4 of the basic application.)

Name of Author: .

Name of Copyright Claimant: .

(B) **Registration For Group of Contributions**

COPYRIGHT REGISTRATION FOR A GROUP OF CONTRIBUTIONS TO PERIODICALS: (To make a single registration for a group of works by the same individual author, all first published as contributions to periodicals within a 12-month period (see instructions), give full information about each contribution. If more space is needed, use additional Forms GR/CP.)

☐
Title of Contribution: .
Title of Periodical: . Vol. No. Issue Date Pages
Date of First Publication: . Nation of First Publication
 (Month) (Day) (Year) (Country)

☐
Title of Contribution: .
Title of Periodical: . Vol. No. Issue Date Pages
Date of First Publication: . Nation of First Publication
 (Month) (Day) (Year) (Country)

☐
Title of Contribution: .
Title of Periodical: . Vol. No. Issue Date Pages
Date of First Publication: . Nation of First Publication
 (Month) (Day) (Year) (Country)

☐
Title of Contribution: .
Title of Periodical: . Vol. No. Issue Date Pages
Date of First Publication: . Nation of First Publication
 (Month) (Day) (Year) (Country)

☐
Title of Contribution: .
Title of Periodical: . Vol. No. Issue Date Pages
Date of First Publication: . Nation of First Publication
 (Month) (Day) (Year) (Country)

☐
Title of Contribution: .
Title of Periodical: . Vol. No. Issue Date Pages
Date of First Publication: . Nation of First Publication
 (Month) (Day) (Year) (Country)

☐
Title of Contribution: .
Title of Periodical: . Vol. No. Issue Date Pages
Date of First Publication: . Nation of First Publication
 (Month) (Day) (Year) (Country)

CHAPTER 12

Invasion of Privacy and Releases

THE LAWS GUARANTEEING PRIVACY are a key area for you to understand. Photographers shoot people in every conceivable human situation for an immense variety of uses. Frequently you will need to obtain a release from the person you are photographing. This is because of that person's right of privacy, a right that can be invaded in the following ways:

1. by using a person's photograph, likeness, or name for purposes of advertising or trade
2. by disclosing embarrassing private facts to the public
3. by using a photograph in a way that suggests something fictional or untrue
4. by physically intruding into a person's privacy, for example, by trespassing to take a photograph

The law of privacy abounds with subtle interpretations. The best advice is to obtain a release if you have any doubt about whether the way you're taking the photograph or the use you intend to make of it could be an invasion of privacy. A number of standard release forms are gathered for your use at the end of the chapter on pages 209-211. However, there are many situations when you clearly will not need a release. This chapter will give examples of many common situations the photographer faces so you'll understand whether or not a release is needed.

Privacy

The creation of privacy as a legal right came about in 1903 by a statute enacted in New York State. Since that time, almost every state—with a few exceptions as of this writing—has either enacted a similar statute or recognized the right of privacy in court decisions.

The law with respect to privacy can differ from state to state, but New York has been the leader in the privacy area and most law with respect to privacy is the same in all jurisdictions. If you're wondering about a situation in which the law appears unclear, you should use a release or consult a local attorney.

Privacy is the right to peace of mind and protection from intrusions or publicity that would offend the sensibilities of a normal person living in the community. It is an individual right granted to living people. If a person's privacy is invaded by a photographer, that person must bring suit—not the spouse, children, or anyone else. The right to sue for an invasion of privacy ends upon the death of the individual whose privacy was invaded. If the lawsuit for the invasion was started prior to death, some states allow the legal representative to continue the lawsuit while other states dismiss the suit. Very few states, however, permit a lawsuit to be started after a person's death for an invasion of the deceased person's privacy. Also, because the right belongs to individuals, the names of partnerships or corporations are not protected by the privacy laws.

Advertising or Trade Purposes

The New York statute provides, "Any person whose name, portrait or picture is used within this state for advertising purposes or for the purposes of trade without . . . written consent . . . may maintain an equitable action in the supreme court of this state . . . to prevent and restrain the use thereof; and may also sue and recover damages for any injuries sustained by reason of such use."

What are advertising or trade purposes? For advertising, we naturally think of advertisements for products or services. For trade, the immediate association is with a photograph on a product that is being sold to the public. For example, when photographer Ronald Galella sent out a Christmas card with a photograph he had taken of Jacqueline Onassis on the card, a court found this to be an advertising use and an invasion of her privacy. Even an instructional use can, in certain cases, be for advertising purposes. A woman was photographed for a railroad company and appeared in a poster instructing passengers how to enter and leave the railcars safely. The court, in a 3-2 divided vote, decided that the unselfish purpose of the poster could not change its nature as advertising. The woman's privacy had been invaded.

If a photographer hangs a photographic portrait in the studio window with a sign advertising portrait services, the photograph is

being used for advertising purposes. The New York statute has a special provision, however, permitting a photographer to exhibit specimen photographs at the studio unless a written objection is made by the person in the photograph.

An example of a trade use would be placing a person's photograph on postcards for public sale. Such use is intended to create a desirable product that the public will purchase.

The problem is that advertising and, especially, trade purposes become more difficult to identify when the photographs are used in media protected by the First Amendment. Freedom of speech and press narrow the right of privacy.

The Public Interest

Public interest is the other side of the coin. The public interest is served by the dissemination of newsworthy and educational information. It is not limited to matters of current news but extends to whatever the public is legitimately interested in. Using a photograph to illustrate a news story about a person who has won a prize for public service in no way requires a release. A photograph of a scientist could be used with an article in a book commenting on the scientist's discoveries, even if these discoveries are not current news.

Unfortunately, it isn't always so easy to know whether a purpose is for advertising or trade as opposed to being for the public interest. The best way to get a feeling of what is permitted and what isn't is by examining situations that are likely to come up.

Specific Situations: Places, Subjects and Uses

PHOTOGRAPHING IN PUBLIC PLACES

You can usually photograph in public places without any restrictions on your right to shoot. Of course, if you're making a movie or photographing in such a way as to disrupt the community's normal flow of activity, you may need to get a permit from the local authorities. The main problem is not taking the pictures, but using them. Even though you took someone's photograph in a public place, you cannot use it for advertising or trade purposes without the person's consent. On the other hand, you are free to use such a photo in the public interest, such as for newsworthy purposes, without worrying about releases.

BYSTANDERS AT PUBLIC EVENTS—REQUIREMENT OF RELATEDNESS

Let's say you're taking some photographs of a parade. Along the route of the parade are bystanders who are watching the floats and listening to the bands. Your photographs of the parade itself naturally include a lot of shots of bystanders. Can you include bystanders in the photographs of the parade when the article is published? Yes, you can and you don't need a release. This is because the parade is newsworthy. When someone joins in a public event, he or she gives up some of the right to privacy.

But what if the magazine wants to use a photograph of the bystander on its cover—not just as one face among others, but singled out? Is this focusing on that bystander to such a degree that you'll need a release? This happened at *New York Magazine* when the editors used the photograph of a bystander on their cover beneath the caption "The Last of the Irish Immigrants." The bystander had, in fact, been photographed at the St. Patrick's Day Parade in New York City, but he was not Irish. And, while his name did not appear on the cover or in the article, he sued for the use of the photograph. Essentially he argued that the use would have been in the public interest if it had just been to illustrate an article, but placing the photograph on the cover made the primary purpose to sell the magazine—a trade use.

New York's highest court didn't agree. Even though the photograph was on the cover, it was illustrating an article about an event of genuine public interest. And the photograph was related to the contents of the article. This is a crucial requirement: that the photograph in fact be appropriate to illustrate the article. Since the bystander participated in the parade by being there, the use of the photograph on the cover was not an invasion of his privacy.

This same challenge comes up frequently with book jackets. Not long ago the well-known football quarterback, Johnny Unitas, sued for invasion of privacy when his photograph appeared on the jacket of a book about football. The court held for the publisher, saying that the photograph was related to the contents of the book and therefore was not for purposes of trade.

Going a step further, what about the cover of a company's annual report with the photograph of a customer purchasing an item in one of the company's retail stores? The customer turned out to be a lawyer who sued for the invasion of his privacy. The court stated that no case had ever held the annual report—required by the Securities Exchange

Commission—to be for purposes of advertising or trade. The court indicated that, if pressed, it would have decided that this use of a photograph of a customer in a retail store was related to the presentation of a matter in the public interest.

USES THAT ARE NOT RELATED

An Illinois case provides a good example of the possibility of an invasion of privacy by an unrelated use. An imprisoned criminal was slipped a pistol by his girlfriend, escaped from jail, and fatally shot a detective trying to recapture him. A magazine retold the story three months later in an article titled, "If You Love Me, Slip Me a Gun." A photograph of the deceased detective's wife was used to illustrate this story, showing her griefstricken over her husband's death. An appeals court concluded that this use could be found to be unrelated to the thrust of the story and shocking to basic notions of decency. The issue was whether use of the photograph served the public interest by providing newsworthy or educational information or merely served the publisher's private interest in selling more copies of the magazine. There is no doubt, by the way, that the photograph of the widow would have been in the public interest to illustrate a factual article about the death of her husband in the line of duty. But use in a sensationalized way that was not related to the article could make it for purposes of trade—to sell copies of the magazine by capitalizing on the widow's grief.

A classic case of unrelated use involved an article about street gangs in The Bronx in New York City. The photograph illustrating the article showed a number of people in a street scene in that area. The people who sued, and won, were in no way connected with street gangs, so the use of the photograph was for trade purposes.

FICTIONAL USE

If a photograph is used in a false way, it can't be legitimately related to an article in the public interest. The photograph can be perfectly innocent—for example, a young lady looking across a bay on a moonlit night. Now suppose a writer exercises all his or her ingenuity and comes up with a wild, entirely fictional story. Using the photograph to accompany the story raises the risk of an invasion of privacy lawsuit. The use of the photograph is not to illustrate a story or article in the public interest. Legally speaking, it is merely to entertain by highlighting an imaginative yarn. In fact, the general rule is that media used solely for entertainment are far more likely to

invade someone's privacy than media used in the public interest. A novel, a fictional film, or a television serial are held to be solely for entertainment value. The risk of invasion of privacy is greater in those cases than in a biography, a documentary, or a television news program. A fictional use of a photograph is for trade purposes, since its only goal is considered to be the enhancement of sales.

It would definitely be an invasion of privacy to use the photograph of a businessman carrying a briefcase to illustrate the escape of a desperate and violent bank robber with the loot. But what if that same photograph—of an ordinary businessman on his way home from the office—is used to accompany an article praising him for accomplishments he has not attained? It might say that he has just come from an international convention of scientists and is carrying in his briefcase the remarkable invention for which his peers have so justly applauded him. But the man isn't a scientist and has no invention. This fiction could be extremely embarrassing. It all adds up to an invasion of privacy. Famous baseball pitcher Warren Spahn successfully prevented publication of a biography of him because it contained so many mistakes. Not surprising, except for the fact that the mistakes were all laudatory—all designed to make him even more of a hero than he already was. Praise will not avoid an invasion of privacy, unless the praise has a basis in fact.

INCIDENTAL ADVERTISING USES

You've shot a famous baseball player for the pages of a sports magazine. The photographs properly accompany an article about the performance of the player's team. But then the magazine surprises you. They take those same photographs and use them to advertise the magazine. You feel shaky when you see the advertisement, because you never got a release. You knew it was for editorial use and you didn't see why you needed one.

This type of case has come before the courts a number of times—with an athlete, an actress, a well-known author, and others. The courts have uniformly held that no invasion of privacy takes place in these situations if the purpose of the advertisement is to show that the magazine carries newsworthy articles. The photographs for the original article were not an invasion of privacy because they were in the public interest. If the advertisement is to inform the public about the types of newsworthy and educational articles that the magazine runs, the advertisement is protected in the same way as the original article. This is true even if the advertisement is not advertising the

specific issue in which the article appeared, but rather advertising the magazine generally.

But you have to be very careful here. If the photographs are not used in the same way they were when they accompanied the original article, you may end up with an invasion of privacy. Obviously it would be an invasion of privacy to take the same photographs and say that the person endorsed the value of the magazine. Or to use the photographs on posters that are sold to the public. Advertising incidental to a protected editorial use—to show that the publication serves the public interest because of the nature of its contents—is a narrow exception to the general rule banning the use of photographs for advertising or trade purposes without the consent of the person portrayed.

A related case occurred when a newspaper photographed a paid model to illustrate a new bathing suit for a fashion item. The photograph included in the background several 10-year-old boys who happened to be at the swimming pool. The text accompanying the photograph ended by describing the bathing suit as "a bikini, very brief pants plus sawed-off tank top. Colored poor-looking brown, the suit is by Elon, $20, Lord & Taylor." Lord & Taylor did not pay to have the item appear. Rather, the newspaper published it as a newsworthy piece of information. The court agreed that the item was in the public interest and that the use of the boys in the photograph was not for advertising or trade purposes. So the boys lost their invasion of privacy suit. If Lord & Taylor had paid for the fashion "news" item to be run, the result would presumably have been different. Even though the item would seem to have been published for its current interest, it in fact would be an advertisement in disguise if paid for. This would have violated the boys' rights.

PUBLIC DISCLOSURE OF EMBARRASSING PRIVATE FACTS

The public disclosure of embarrassing private facts can be an invasion of privacy. Peculiar habits, physical abnormalities, and so on can easily be captured by the photographer. There is no benefit to the public interest, however, in making public such information about a private citizen. On the other hand, if the information is newsworthy, no invasion of privacy will occur. The examples discussed here show how disclosures that normally would invade privacy are protected when newsworthy.

One case involved a husband and wife photographed in the ice cream concession they owned. The man had his arm around his wife

and their cheeks were pressed together—a romantic pose. This photograph was then used to illustrate a magazine article about love. The court decided that the photograph was not embarrassing or offensive. In fact, the couple had voluntarily assumed the pose in a public place. And, in any case, it did relate to an article serving the public interest. So the couple lost their invasion of privacy suit.

In another case a body surfer well known for his daring style gave an interview in which he told of his peculiar behavior—eating insects, putting out cigarettes in his mouth, pretending to fall down flights of stairs, and fighting in gangs as a youngster. When he found out that these odd traits would be included in the magazine article, he sued on invasion of privacy grounds. The court decided that these facts could be included in the article because they were relevant in explaining his character. And his character was of public interest since it related directly to his exploits as a body surfer. But if his body surfing had not been legitimately newsworthy, the disclosure of facts of that kind could certainly have been an invasion of privacy.

CRIMINALS AND VICTIMS

The commission of a crime and the prosecution of criminals are certainly newsworthy, since they are of legitimate concern to the public. Photographs of alleged or convicted adult criminals can thus be used in the course of reporting news to the public. However, many states protect the identity of juvenile defendants and victims of certain crimes, such as rape. You have to check your own state's laws to determine what restrictions you may face. It's worth noting that the United States Supreme Court decided recently that the disclosure of the identity of a deceased rape victim did not give grounds for an invasion of privacy action. The court pointed out that the victim's identity was a matter of public record. The embarrassment caused to the victim's father who initiated the lawsuit could not outweigh the value of communicating newsworthy information to the public. And a recent state court decision has denied a 14-year-old rape victim recovery in an invasion of privacy suit based on the disclosure of her identity as a victim of a rape. The reasoning is again that the identity is newsworthy and, therefore, cannot be an invasion of privacy.

PUBLIC FIGURES

Public figures must sacrifice a great deal of their right of privacy. This follows from the fact that public figures are, by definition, newsworthy. The public wants to know all about them. The media are

merely serving this public interest by making the fullest disclosure of the activities of public figures. So the disclosure of a private fact—which would be an invasion of privacy if a private citizen is involved—may very well be newsworthy and permissible if a public figure is being discussed. For example, a braless tennis professional competing in a national tournament momentarily became bare-chested while serving. A photographer captured this embarrassing moment and the photograph appeared nationwide. The event was newsworthy. But in a similar case—a private citizen's skirts being blown up in the funhouse at a county fair—the event was not newsworthy and publication of the photograph was an invasion of privacy.

Who is a public figure? Anyone who has a major role in society or voluntarily joins in a public controversy with the hope of influencing the outcome is a public figure. This includes politicians, famous entertainers, well-known athletes, and others who capture the public imagination because of who they are or what they've done—whether good or bad. Beyond this, however, it also encompasses private citizens who take a stand on a controversy of public interest, such as a housewife publicly campaigning to defeat the budget of a local school board. However, the United States Supreme Court has decided in one case that "public figure" does not include a woman who is in the process of getting divorced from a well-known businessman. When the grounds for her divorce decree were incorrectly reported in a national magazine, the court found she was a private citizen who had not voluntarily become involved in activities of public interest—despite her social status and the fact she had voluntarily given several press conferences to provide information about her divorce to the press.

The more famous the public figure, the greater the right of privacy that the public figure sacrifices. The president of the United States has almost no right of privacy, since practically everything about the life of the president is of interest. A housewife speaking out about a matter of public interest, however, would sacrifice far less of her right of privacy than the president.

One of the leading invasion of privacy cases arose from photographer Ron Galella's pursuit of Jacqueline Onassis. Faithful to the creed of the *paparazzi,* he jumped and postured about her while taking his photographs, bribed doormen to keep track of her, once rode dangerously close to her in a motorboat while she was swimming, invaded her children's private schools, leapt in front of her son's bicycle to photograph him, interrupted her daughter on the tennis courts and romanced a family servant to keep himself current on the

location of the members of her family. Could she prevent Galella from harassing her in this way? Or did her status as a public figure make her fair game for whatever tactics a *paparazzi* might choose to employ?

The court's decision struck a compromise between Onassis' right to privacy and the legitimate public interest in knowing of her life. It prohibited Galella from approaching within 25 feet of her. It prohibited him from blocking her movements in public places or from doing anything that might reasonably be foreseen to endanger, harass, or frighten her. But it did not stop him from taking and publishing his photographs, because that served the public interest.

The right of the public to know the appearance of public figures is simply an extension of the rules relating to what is newsworthy and informational. It's important to realize, however, that public figures keep their right of privacy with respect to commercial uses. If you use a public figure's photograph to advertise a new aftershave lotion, you have definitely committed an invasion of privacy. In fact, the right of publicity discussed in the next chapter shows that public figures can actually have a property right in their names, portraits, or pictures (see pages 212-213).

If an invasion of privacy is found to have occurred, the intention behind the invasion won't matter in the ordinary case involving a private person who is not involved in a matter of public interest. But the courts have determined that a higher standard should apply to false reports of matters in the public interest, including reports involving public figures. To recover for invasion of privacy in cases involving public figures, the public figure must show that the false report was published with knowledge of its falsity or a reckless disregard as to whether or not it was true. This can be a difficult standard to meet, but it reflects the concern of the United States Supreme Court to protect the First Amendment rights of the news media.

STALE NEWS

At some point news becomes stale and the use of someone's photograph is no longer newsworthy. For example, motion pictures of a championship boxing match were no longer newsworthy when, 15 or 20 years after the bout, they were used as part of a television program titled "Greatest Fights of the Century." The boxer's claim, based on invasion of privacy, could not be defeated on the ground that the program disseminated news. Similarly, the story of a sailor who saved his ship by sending a wireless message was newsworthy when it happened. But to use the sailor's name and portray him by an actor in

a commercial film released one month later was a trade use and an invasion of the sailor's right of privacy. Its dissemination was no longer protected as newsworthy.

On the other hand, a child prodigy remained newsworthy 25 years later, despite having vanished completely from public sight. In fact, the prodigy hated his early fame and had sought obscurity, but the court concluded that the public interest would be served by knowing whether his early promise had ever been realized. The magazine article about him, although it embarrassed him and brought him into the public view in a way he dreaded, was not an invasion of his privacy.

RECOGNIZABLE PERSON

One way photographers avoid invasion of privacy problems is by retouching photographs so the people aren't identifiable. If you can't identify someone, no invasion of privacy can occur.

A novel case involved a photograph of the well-known actress, Pola Negri, used to advertise a pharmaceutical product. The advertiser argued that the photograph of the actress had been made 40 years before. Today her appearance was quite different, so no invasion of privacy could take place. Needless to say, the court rejected this argument. Whether the photograph was made last year or 40 years ago doesn't matter if it is put to an advertising use and the person pictured is still alive.

A recognizable likeness, even if not an exact photograph as originally made, can also constitute an invasion of privacy. For example, *Playgirl* magazine ran a picture showing a nude black man sitting in the corner of a boxing ring with his hands taped. Although the picture was captioned "Mystery Man," it clearly was a likeness of boxer Muhammed Ali. In fact, an accompanying verse referred to the figure as "the Greatest." The picture was fictional and offensive. It certainly was not newsworthy or instructive since it didn't even accompany an article. The court decided that an invasion of Ali's privacy had occurred. The nude picture was for purposes of trade—to attract the public's attention and sell the magazine.

PARTS OF THE BODY

If a person must be recognizable for an invasion of privacy to occur, it follows that you can photograph unidentifiable parts of the body for advertising and trade use without fear of causing an invasion of privacy. Arms, legs, the backs of heads, and so on are all right as long as the person is not identified.

But why do most agencies still insist on a release from models in these cases? Simply because the release serves as the contract between the photographer and the model. It gives written proof that the model agreed to render services for a specified fee that you (or the agency) agreed to pay. While you may not have to be concerned about an invasion of privacy suit, it also saves you from having to worry about a breach of contract suit.

DOGS, HORSES, CARS, AND HOUSES

What about photographing property belonging to someone else, such as a German Shepherd or the interior of a house? This shouldn't be an invasion of privacy, especially if the owner isn't identified in any way by the photograph. For example, you could photograph a horse running in a field and use the photograph in an advertisement. The owner would have no right to object, since the right of privacy protects people, not animals. By the same token, there's no reason why you shouldn't be able to use a car, the interior of a house, or other private property in an advertisement as long as the owner cannot be identified. But if you promised to pay for the right to photograph the person's property, or if you took or used the photographs in violation of an understanding that you reached with the owner, you may very well face a breach of contract lawsuit. As a practical matter, you should seriously consider obtaining a release if you plan to use the photograph for advertising or trade uses, since it could also serve as your contract with the owner and would eliminate any risk of a lawsuit—however frivolous.

TRESPASSING

You can't trespass to get photographs, even if the photographs are newsworthy. A trespass—an unlawful entry on a person's property—can serve as the basis for an invasion of privacy lawsuit. And it doesn't matter whether you publish the photographs, since the invasion is based on the trespass, not the publication.

A Florida case involving a police raid on a controversial private school stated this prohibition colorfully. The police had television news cameramen accompany the raiding party that rousted students and faculty from bed. The cameramen took embarrassing footage that was televised. The court said that to permit such conduct

could well bring to the citizenry of this state the hobnail boots of a nazi stormtrooper equipped with glaring lights invading a couple's bedroom at midnight with the wife hovering in her nightgown in an attempt to

shield herself from the scanning TV camera. In this jurisdiction, a law enforcement officer is not as a matter of law endowed with the right or authority to invite people of his choosing to invade private property and participate in a midnight raid of the premises.

But in a similar case, a newspaper photographer, at the request of police, took photographs of the silhouette of the body of a girl who had died tragically in a fire. Her mother learned of the death by seeing the published photographs taken inside the burned-out home. She sued for an invasion of her own privacy. The court concluded that the photographs were newsworthy and, under the circumstances, the photographer had not committed a trespass in coming on the mother's premises without her permission.

Nor can trespass be justified when a public figure is involved. Breaking into a senator's office to obtain newsworthy information is an invasion of privacy. The First Amendment does not protect you against illegal acts committed in the course of getting newsworthy or informative photographs.

INTRUSION INTO PRIVATE PLACES

Photographing a private citizen without consent in the seclusion of his or her home may of itself be an invasion of privacy. Certainly there are public places that can become as private as the home. A person using a public restroom or going into a hospital does so with the understanding that he or she will have the same privacy as at home. Because of this, photographs taken in these places can be an invasion of privacy.

One case involved employees of *Life* magazine seeking to expose a quack doctor. Pretending to be patients, they gained access to the doctor's home and took photographs with hidden cameras. Subsequently *Life* used the photographs in an exposé about the doctor. While the story was newsworthy, the intrusion was an invasion of privacy. And the court said that the later publication of the photographs could be used as a factor in increasing the damages flowing from the invasion.

Photographs taken of patients also present problems. For example, the publication of a patient's photograph to accompany an article written by the doctor could be regarded as for the purposes of advertising the doctor's skills. Or the exhibition of a film showing a birth by Caesarian section could be a trade use if admission is charged. However, if the use is in the public interest, such as an article about a new medical development or an instructive film (especially if

no admission fee is charged), you are on safer ground. To avoid uncertainty, you will usually want a release from the patient. In addition to the releases shown on pages 209-211, the American Medical Association has release forms designed for doctors who wish to photograph patients or bring outsiders into the operating room.

SURVEILLANCES

Surveillance of people who have a personal injury claim against an insurance company is not uncommon. The purpose is to show that the injuries sustained by the person in an automobile or other accident are not as severe as claimed. The insurance company will often retain a private investigator and a photographer who will use a motion picture camera to record the claimant's physical condition.

In such cases, the surveillance is not an invasion of privacy as long as it is conducted in a reasonable manner. For example, following at a reasonable distance behind a claimant's car and photographing her while driving and in other public places would not invade her privacy. In fact, the court felt that there is a social value in the investigation of claims that may be fraudulent. However, harassment or outrageous conduct could violate a claimant's privacy.

BUSINESS PREMISES

The right of privacy does not protect corporate or other business names. The taking and use of photographs of business premises cannot, therefore, be an invasion of the privacy of the corporation or other business. It could be a trespass, unfair competition, or breach of contract, however, as discussed in the next chapter.

Two cases illustrate this. In one case a satiric magazine used a photograph of a real bar to illustrate a fictitious story titled, "The Case of the Loquacious Rapist." The actual name of the bar—"Busy Bee"—appeared in the photograph, although the fictional bar in the accompanying satire was called "The Stop and Frisk." There simply was no invasion of privacy here. Nor did an invasion of privacy occur when a photograph of the business name "Jollie Donuts" and the premises of the donut shop appeared in a nationally televised broadcast. This was not the name, portrait, or picture of a person.

What about a patron who is photographed on the business premises? Can he sue? After a bomb threat, a government building was evacuated and a number of the employees went to a nearby hotel bar. A television camera crew photographed a government employee

in the bar and broadcast the film on the evening news. The employee lost his invasion of privacy suit, since he had become, however involuntarily, an actor in an event of public interest.

EXHIBITION OF PHOTOGRAPHS

As more photographers exhibit in galleries, the question is often asked whether an exhibition can be an invasion of privacy. The very fact that the New York statute made a special exemption to allow exhibition of specimen photographs under certain conditions suggests that this type of exhibition is an advertising use when the conditions aren't met. It is publicizing the photographer's services.

The courts have also found that the *sale* of postcards, portraits, or posters based on someone's photographic portrait is a trade use. A single photograph or limited edition exhibited for sale in a gallery might also be a trade use. It could be argued, however, that the exhibition and sale of a photographic work of art is in the public interest, much like the sale of a photograph in a book collecting examples of a photographer's work. Looking at it from this point of view, the courts might consider the media used, the nature of the subject matter, and the extent of the invasion. Presumably a person striking a voluntary pose in a public place would have a much harder time recovering than someone who was photographed in an embarrassing pose in a private place. That doubt exists in this area, however, suggests the wisdom of obtaining a release.

If the photograph were exhibited in a museum for educational purposes and not for sale, it would not appear to be a trade use. No case has held this with respect to a photograph, but several cases state that the exhibition of a film without an admission charge is not a trade use. So it is less likely that an invasion of privacy would occur if an exhibition were for educational purposes and the photograph not offered for sale. However, an embarrassing photograph taken in a private place might still cause an invasion of privacy.

What about a poster—or photograph exhibited in a gallery—of a political figure campaigning? While the poster was offered for sale, the court decided that it served the public interest by disseminating knowledge about political candidates. The candidate, by the way, was comedian Pat Paulsen, who had licensed the right to make posters to a competitive company. If Paulsen had not been running for public office in 1968 when the distribution occurred, he might have found protection under the right of publicity discussed in the next chapter.

Not only is the area of exhibition likely to see more lawsuits in

the future, but also the laws may differ from state to state. Again, the safest course is to obtain a release.

Damages

It can be difficult to measure what damages should be payable to someone who wins an invasion of privacy suit. After all, the injury is to peace of mind and the right to seclusion. Yet a person suing for invasion of privacy has a right to recover substantial damages, even if the only damage suffered is his or her mental anguish. The fact that the damages are difficult to ascertain or can't be precisely determined in terms of money is not a reason to deny recovery for the invasion. Nor are the damages limited to compensation for the mental anguish that a person of ordinary sensibilities would suffer in the situation. The damages can extend beyond this to cover any actual financial losses. The exact amount of damages is decided on a case-by-case basis, depending on the facts involved.

If someone commits an invasion of privacy, it really doesn't matter what the motives were. It's the acts constituting the invasion that create a right to sue. The New York statute does state that anyone who "knowingly" invades another's privacy may be subject to punitive damages. These are extra damages awarded not to compensate the person who has been injured, but rather to punish the offender and prevent similar acts in the future. As to false reports about public figures, see page 200.

Releases

New York's statute requires that a release be in writing, but in most other states an oral release will be valid. The release gives you the right to use someone's photograph without invading his or her right of privacy. However, you would be wise always to have written releases, such as those that appear on pages 209-211. This is because the releases must be appropriate for the use you intend to make of the photograph. Also, the details of oral understandings tend to fade from memory and can be difficult to prove in court.

The release must be signed by the proper person—normally the subject of the photograph. But if that person is a minor, the parent or guardian must sign. Most states have now adopted 18, rather than 21, as the age of reaching majority, but you should check the law in your own state.

The release should specify what use will be made of the

photograph. For example, the model might consent to the use of the photograph "for advertising dress designs in trade magazines." Use of the photograph in other situations, such as advertising cigarettes on a billboard, would at the least be a breach of contract. So you might want to broaden the release by use of a phrase such as "any and all purposes, including advertising in all forms."

The release should give permission to the party that will actually use the photograph—not just you, but also the advertising agency or other businesses to which you might assign the right of usage. So you will want to recite that the release gives consent not only to you, but also to agents, assigns, and legal representatives.

You should always get your own release form signed, even if an advertising agency or a new client gives you its form that you also have the model sign. If, for some reason, you are relying on the client's form and not getting your own form signed, you should check very closely to see that the client's form protects you. If you feel it doesn't, you should request that the client indemnify you—that is, agree to pay your losses and expenses that may result if the release is, in fact, inadequate to protect you.

The payment of money to the model isn't necessary for a valid release, but it may be a wise step to take. In this way a release differs from a contract, since you must give something of value if you want to make a contract binding. Normally for a release you would give a fee and, if you do, you naturally should state that in the release. One revealing case involved a woman who received no fee for consenting to use of her photograph in advertising for a perfume. Twenty years later she was able to revoke her consent, despite the money spent by the manufacturer to obtain a trademark and develop the market for the product. In fact, you might want not only to pay to prevent the revocation, but also to specify in the release how long the subject's consent is to be effective. When a man agreed at the age of 24 to the advertising use by a health spa of before-and-after photographs of himself, the advertising use of such photographs 10 years later was an invasion of privacy. Nor did the man even revoke his consent in this case. But he hadn't received a fee and the court felt his consent lasted only for a reasonable time after the making of the photographs.

Tough cases develop when photographs are altered. Does the release permit such changes? Or are they perhaps allowed by trade custom?

A model agreed to do an advertisement for a bookstore. The release gave an irrevocable consent to the bookstore and its assigns to use her photograph, "for advertising purposes or purpose of trade,

and I waive the right to inspect or approve such . . . pictures, or advertising matter used in connection therewith." The bookstore's advertisement showed the model reading in bed and was captioned "For People Who Take Their Reading Seriously." The bookstore then violated its contract with the photographer by assigning rights of use to a bedsheet manufacturer known for its offensive advertisements. The manufacturer altered the advertisement so the model in bed was in the company of an elderly man reading a book titled *Clothes Make the Man* (described by the court as a "vulgar" book). The implication was that the model had agreed to portray a call girl for the bedsheet advertisement. These changes in the content made a different photograph in the view of the court and gave the model a right to sue for invasion of privacy. So while the photograph could be assigned for other advertising uses, it could not be altered in such an objectionable manner. To protect yourself from liability, it's wise to limit in your confirmation or invoice forms the uses that can be made of the photograph to those permitted in the release you've obtained.

On the other hand, a basketball player signing a release allowing the advertising use of photographs of himself in "composite or distorted" form could not complain when a glass of beer was added to make an advertisement for beer. Nor could an actress complain when the photographs used for a movie poster were altered to emphasize the sexuality of the woman portrayed. Since the actress had consented to the use of her "likeness" in advertising for the movie, the court felt trade usage permitted the sexual emphasis. But in a very similar case involving a movie actor shown in a composite photograph notifying his admirers by telegraph where to see his new film, the court said the actor's release for publicity only extended to a true photograph—not a composite portraying something that never occurred. This points up how dangerous it can be to rely on trade custom. If trade custom conflicts with a clear written contract, it won't even be admissable in court. So a carefully drafted release is a far safer approach.

When using a release always fill in the blanks—the date, the model's name, your name, any addresses, any fees, and so on. It's important that you keep records enabling you to relate the release to the photographs for which it was given. This can be done by use of a numbering system matching the releases to the negatives or transparencies. Or you might date the film so the date will be the same as that of the signed release you obtained at the shooting session.

You should make a practice of getting the release signed at the session. Don't put it off, even if you're not exactly certain what the

final use of the photograph will be. Also, while you don't have to have a witness for the release, it can help in proving proper execution of the release.

The releases shown here follow the principles that we've discussed. The form can, of course, be modified to meet special needs that you may have.

Release—Short Form

In consideration of $_____$, receipt of which is acknowledged, I, _____ , do hereby give _____ , his (her) assigns, licensees, and legal representatives the irrevocable right to use my name (or any fictional name), picture, portrait, or photograph in all forms and media and in all manners, including composite or distorted representations, for advertising, trade, or any other lawful purposes, and I waive any right to inspect or approve the finished product, including written copy, that may be created in connection therewith. I am of full age.* I have read this release and am fully familiar with its contents.

Witness: _____ Signed: _____

Address: _____ Address: _____

 Date: _____ , 19 _____

Consent (if applicable)

I am the parent and guardian of the minor named above and have the legal authority to execute the above release. I approve the foregoing and waive any rights in the premises.

Witness: _____ Signed: _____

Address: _____ Address: _____

 Date: _____ , 19____

*Delete this sentence if the subject is a minor. The parent or guardian must then sign the consent below.

Model Release—Long Form

In consideration of _____ Dollars ($_____), receipt of which is acknowledged, I do hereby irrevocably authorize _____, of _____ (address), City of _____, County of _____, State of _____ , his (her) legal representatives, assigns, and those acting under his (her) permission and on his (her) authority, to copyright, publish, and use in all forms and media and all manners for advertising, trade, promotion, exhibition, or any other lawful purpose whatsoever, still, single, multiple or moving photographic portraits or pictures of me in which I may be included in whole or in part, or composite or distorted in character, or form, in conjunction with my own or a fictitious name, or reproductions thereof in color or otherwise or other derivative works made through any medium.

I do hereby waive any right that I may have to inspect or approve the finished product or the advertising or other copy that may be used in connection therewith or the use to which it may be applied.

I hereby release and agree to hold harmless _____, his (her) legal representatives, assigns, and all persons acting under his (her) permission or authority, from any liability by virtue of any blurring, distortion, alteration, optical illusion, or use in composite form whether intentional or otherwise, that may occur or be produced in the taking of the pictures, or in any processing tending toward the completion of the finished product, unless it can be shown that they and the publication thereof were maliciously caused, produced, and published solely for the purpose of subjecting me to conspicuous ridicule, scandal, reproach, scorn, and indignity.

I do hereby warrant that I am of full age and have every right to contract in my own name in the above regard.* Further, I have read the above authorization and release, prior to its execution, and I am fully familiar with the contents thereof.

Witness: _____ Signed: _____

Address: _____ Date: _____ , 19_____

Consent (if applicable)

I am the parent and guardian of the minor named above and have the legal authority to execute the above release. I approve the foregoing and waive any rights in the premises.

Witness: _____ Signed: _____

Address: _____ Date: _____, 19_____

*Delete this sentence if the subject is a minor. The parent or guardian must then sign the consent paragraph.

Release—By Owner of Property

In consideration of the sum of _____ Dollars ($_____), receipt of which is acknowledged, I do hereby irrevocably authorize _____, of _____ (address), City of _____, County of _____, State of _____, his (her) legal representatives, assigns, and those acting under his (her) permission and on his (her) authority, to copyright, publish and use in all forms and media and in all manners for advertising, trade, promotion, exhibition, or any other lawful purpose whatsoever still, single, multiple or moving photographic portraits or pictures of the following property that I own and have sole authority over to license for the taking of photographic portraits or pictures:

regardless of whether said use is composite or distorted in character or form, in conjunction with my own or a fictitious name, or reproduction thereof is made in color or otherwise or other derivative works are made through any medium.

I do hereby waive any right that I may have to inspect or approve the finished product or the advertising or other copy that may be used in connection therewith or the use to which it may be applied.

I hereby release, discharge and agree to hold harmless _____ _____, his (her) legal representatives, assigns, and all persons acting under his (her) permission or authority, from any liability by virtue of any blurring, distortion, alteration, optical illusion, or use in composite form whether intentional or otherwise, that may occur or be produced in the taking of the pictures, or in any processing tending toward the completion of the finished product, unless it can be shown that they and the publication thereof were maliciously caused, produced, and published solely for the purpose of subjecting me to conspicuous ridicule, scandal, reproach, scorn, and indignity.

I do hereby warrant that I am of full age and have every right to contract in my own name in the above regard. Further, I have read the above authorization and release, prior to its execution, and I am fully familiar with the contents thereof.

Witness: _____ Signed: _____

Address: _____ Date: ____, 19____

CHAPTER 13

Beyond Privacy

INVASION OF PRIVACY is not the only risk you face when taking and publishing your photographs. Both private individuals and the public are protected by other laws drawn from a variety of sources. This chapter will elaborate on what you must know about in addition to privacy so you can pursue your professional activities without violating any laws or legal rights.

Right of Publicity

The right of publicity is possessed by athletes, entertainers, and other people who seek to create a value in their name or likeness by achieving celebrity status. It is different from the right of privacy, which protects peace of mind and the right to live free of unwanted intrusions. The right of publicity is a property right based on the value inherent in a celebrity's name or likeness. The right of privacy protects everyone. The right of publicity protects only those who have succeeded in becoming celebrities. The right of privacy cannot be assigned. The right of publicity, like other property rights, can be assigned. The right of privacy ends when the person whose privacy was invaded dies. The right of publicity can survive the celebrity's death and benefit his or her heirs or assignees.

If you photograph a baseball player for a company that manufactures baseball cards, the company is going to need a license from the player in order to use the photograph on its baseball cards. Or if you photograph a football player for a company that wants to use the photograph in a game for children, a license from the player will be needed to avoid having the game violate his or her right of publicity. In one interesting case, a baseball player gave a license to a sporting goods company and its assignees to use his name, facsimile signature, initials, portrait, or nickname in the sale of its gloves, baseballs, and so on. The sporting goods company sold baseballs to a meat company

for use in a promotion with meats. They also gave the meat company the right to use the player's name and likeness in connection with the promotion. The player sued to prevent the meat company from using his name and likeness in this way, but he lost because he had assigned his right of publicity without limiting what types of companies it could be assigned to.

The right of publicity protects against commercial exploitation. It cannot prevent the reporting of events that are newsworthy or in the public interest. For a guide to what is newsworthy or in the public interest, you can refer back to the many examples given in the chapter on privacy.

The courts have said that the right of publicity will survive a celebrity only if that person exploits the right while alive. This means that celebrities must take steps to exercise these rights—for example, by means of contracts to use their name or likeness for endorsements or on products—if assignees or heirs are to be able to assert the right after the celebrity's death. If a celebrity's right of publicity would be violated by the commercial use of a photograph, a license should be obtained from the celebrity.

Libel

Libel is communicating to the public a false statement about someone that damages the person's reputation. Retouched photographs can create a false image and damage someone's reputation. So can errors in the lab.

But the most common area of libel in photography is the association of an innocent photograph with a text that is libelous. There is, by the way, no reason why the photographer would be responsible in such a case if he or she had nothing to do with the offending text. For example, a photograph might show a man and woman riding in a carriage. It can't possibly say anything false. But suppose the picture is printed in a newspaper and the caption says the man and woman are husband and wife, and this isn't true. In fact, the woman is married to someone else. A woman in such a case sued the newspaper, claiming that the public impression would be that she was not married to her real husband. If that were the case, she would have been living with him in sin. This was not true and injured her reputation. The case arose in 1929 in England, where the court agreed with the woman and gave judgment for her. What is damaging to the reputation can change from one time and place to another.

The First Amendment cuts into the individual's protection

against libel. In a libel suit brought by a public official or public figure over a report that is newsworthy, the person suing must show that the false statement was made with reckless disregard for whether it was true or false or with actual knowledge that it was false. This is a very difficult standard to meet. The question of who is a public figure, already discussed under invasion of privacy, becomes important in libel because of the higher standard of proof required. For private individuals who become involved in matters of public interest, the states may set a lower standard. For example, the private individual might have to show only negligence in the publication of the false material in order to recover. For private individuals suing for libel over a matter not in the public interest, proof that the defendant knew the statement was false would be necessary only to get the extra damages called punitive damages.

Libel is in general of less concern to photographers than to writers. However, if you fear that use of a photograph may libel someone, you should consult an attorney and consider obtaining a release from the person who might bring the libel suit.

Private Property

In the last chapter we discussed whether photographs of dogs, horses, automobiles, interiors of houses, and other private property could cause an invasion of privacy. As long as the owner was not identified, it did not appear that his or her privacy could be invaded. Two cases, however, illustrate some risks other than invasion of privacy that you should keep in mind.

A photographer was commissioned to photograph a woman's dog. The woman purchased several prints, and, as far as she was concerned, the transaction was finished. The photographer, however, sold the dog's photographs to an advertising agency that used them for dog biscuit advertisements in local and national newspapers. The woman sued the photographer, his agent, the advertising agency, the dog biscuit company, and the newspapers based on the use of the photographs of the dog. The court decided that the photographer and his agent had breached the original contract with the woman, since the customer is the owner of all proprietary rights in works done on commission. Because of this, the photographer and his agent would have to pay damages for their breach of contract, while the other defendants would merely be barred from running the advertisement again.

If the dog had been wandering the streets and the photographer had taken the picture on his own initiative, the owner would presumably not have had any right to object to a subsequent advertising use, since the photographer would have owned all the proprietary rights. An intriguing point here, however, is that the copyright law has changed since this case was decided. After January 1, 1978 the photographer owns the copyright in the photographs of the dog, whether the owner commissions the photographs or the dog is photographed running free in the streets. Could this change the result of the case if it were to come up again? We don't think so, because the courts would probably conclude that an implied provision of the contract to photograph the dog is that the photographs will be only for the owner's use. Despite the photographer's owning the copyright, the contract would implicitly forbid reuse for purposes other than those intended by the owner. But we will have to await future litigation before we know with certainty the effect of the new law.

The other case may be unique, but it's certainly worth taking into account. It arose out of the New York World's Fair of 1964. A postcard company took photographs of the buildings, exhibits, and other activities going on inside the fairgrounds. These were then sold on postcards, albums, and related items. Admission was charged for entrance to the World's Fair, and, in fact, the World's Fair Corporation had entered into a contract with another company to exploit similar photographs of the buildings, exhibits, and so on. In addition to this, the postcard company had bid for the right to make the photographs and sell the commercial items both inside and outside the fairgrounds. On considering these special facts, the court decided that an injunction should be granted to prevent the postcard company from continuing its commercial exploitation. The court likened the buildings and exhibits to a show in which the World's Fair Corporation had a property interest. Two of the five judges dissented, however, and said they didn't think anything could prevent selling items incorporating photographs of the exteriors of the buildings. This case is probably limited to its unique facts—an unsuccessful bidder commercially using photographs of unusually attractive buildings on private grounds to which admission is charged. It could hardly prevent you from making postcards from photographs of the Empire State Building or the New York City Skyline. But the cautious photographer will take the case into account before launching a similar enterprise.

Trespass

We discussed when trespasses might give individuals a right to recover for invasion of privacy. And in discussing business premises, we indicated that businesses were not protected by a right of privacy. However, businesses are protected against trespasses, even when the news media are involved.

The leading case involves a television news team doing a report on a New York City restaurant charged with health code violations. The camera crew and its reporter burst noisily into the restaurant. The reporter gave loud commands to the crew who turned their lights and camera on in the dining room. In the resulting tumult, the patrons waiting to be seated left the restaurant, many of those seated covered their faces with their napkins, and others waiting for their checks simply left without paying. For this trespass, the court decided the television station would have to pay damages to the restaurant in the amount of $1,200. Beyond this, however, the jury had originally awarded $25,000 as punitive damages, but this was reversed because an important witness for the defense hadn't been heard. A new trial was ordered at which punitive damages would be awarded if the jury concluded that the television crew had acted with reckless indifference or an evil motive in trespassing. The First Amendment, the court noted, does not give the news media a right to trespass.

Unfair Competition

Unfair competition seeks to prevent confusion among members of the public as to the source of goods or services. It is a right that is highly flexible. For example, titles are not copyrightable. Yet unfair competition could be used to prevent one title from too closely imitating another. If the public came to identify a work by one title—such as *The Fifth Column,* by Ernest Hemingway—no one could use a similar title for a competing work. An obvious application would be to prevent one photographer from using the name of another in order to pass off his or her own work. So if Jane Photographer is well known, another photographer adopting her name would be unfairly competing. Nor could one photographer imitate the style of another and try to pass off the work. In a case involving cartoon strips, the court stated that using the title of a cartoon strip and imitating the cartoonist's style was unfair competition.

There is another aspect to the doctrine of unfair competition. In

some cases photographers have tried to use unfair competition to prevent distorted versions of their work from being presented to the public by licensees. The reasoning is that the distorted version is not truly created by the photographer. Presenting it to the public injures the photographer's reputation and unfairly competes with his or her work. Such an attempt to create moral rights (discussed on page 183) from American legal doctrines is difficult at best.

Obscenity

Censorship has a long history. Few people realize today that the censors' fascination with pornography is relatively recent, dating from the era of Queen Victoria. Prior to that, censors focused on supressing sedition against the Crown and heresy against the Church. In the United States, censorship conflicts with the First Amendment guarantees for free speech and free press. The result is an uncomfortable and rather arbitrary compromise as to what sexually oriented materials can be banned. Works of serious artistic intention are protected from censorship under guidelines set forth by the United States Supreme Court. Specifically, the factors in determining obscenity are:

(a) whether 'the average person, applying contemporary community standards' would find that the work, taken as a whole, appeals to the prurient interest . . .; (b) whether the work depicts or describes, in a patently offensive way, sexual conduct specifically defined by the applicable state law; and (c) whether the work, taken as a whole, lacks serious literary, artistic, political, or scientific value.

This definition applies to conduct that takes place after June 21, 1973.

The laws affecting obscene materials prohibit such uses as possession for sale or exhibition, sale, distribution, exhibition, importation through customs, and mailing. Distributors are usually the defendants, although in some jurisdictions eager prosecutors have now started going after actors in films on a conspiracy theory. Especially on the contemporary community standard as applied by the average person, it is difficult to know what the result of an obscenity prosecution may be from one locality to the next. The court has clarified that the average person in the community does not include children, since a much lower "average" would be reached for judging what is obscene if children were included.

A number of statutes outlaw the use of children in the pho-

tographing of sexually explicit acts, whether or not the acts are obscene. Whether these laws would apply to photographs of minors used in an educational context would appear to raise substantial First Amendment questions. Beyond this, however, the courts have ruled that pornographic materials intended for an audience of minors can be subjected to higher standards than those of the average citizen applying contemporary community standards.

The First Amendment does provide procedural safeguards in cases raising issues of obscenity. Essentially, before materials may be seized as obscene, an adversary hearing must be held at which both sides are able to present their views with respect to whether or not the items are obscene. Only after this review can law enforcement officials confiscate materials that have been determined to be obscene.

Flag Desecration

State and federal flags are protected from desecration by both state and federal statues. Desecration includes mutilation, defacement, burning, or trampling on such a flag. It also covers the use of any representation of a flag for advertising or commercial uses, such as product packaging or business stationery. Each statute has special exceptions, so that the New York statute does not apply to the use of the flag on an "ornamental picture, article of jewelry, stationery for use in private correspondence, or newspaper or periodical, on any of which shall be printed, painted or placed, said flag, standard, color, shield or ensign disconnected or apart from any advertisement."

The police power to prevent desecration of the flag is not absolute but must be weighed against the right of the individual to have freedom of expression. When the use of a flag is a form of speech, the First Amendment may protect conduct that would otherwise be criminally punishable as a desecration. In one case an artist made artworks using the United States flag in conjunction with a Vietcong flag, a Russian flag, a Nazi swastika, and a gas mask. The United States flags were wrapped around the shapes of a gun caisson and an erect penis. Antiwar music played in the background to accompany the exhibit. After losing several times in the courts, the gallery owner finally won vindication from a criminal conviction for flag desecration. His First Amendment rights outweighed the danger to the community posed by these uses of the flag.

If you are considering the use of flags, especially for advertising or commercial purposes, you should definitely seek advice from an attorney to be certain that you aren't committing a criminal offense.

Other Protected Symbols

Both state and federal statutes protect a variety of official or well-known names and insignias from unauthorized use, especially if the use is commercial. For example, special federal regulations govern the use of all the following emblems, insignia, and names:

- "Smokey Bear" character or name
- "Woodsy Owl" character, name, or slogan
- Use of likeness of the great seal of the United States, or the seals of the president or vice president
- "Johnny Horizon" character or name
- "The Golden Eagle Insignia"
- Swiss Confederation coat of arms
- 4-H Club emblem fraudulently used
- Red Cross emblems
- Badges or medals of veterans' organizations
- Military medals or decorations
- Official badges, identification cards, or other insignia
- Misuse of names, words, emblems, or insignia in such a way as to mislead the public to believe that one is acting on official business

Violations vary from item to item on this list but include advertising, product packaging, and uses designed to mislead the public. The safest course is to consult with the secretary of the appropriate agency if you are planning to use its emblem, insignia, or name. For example, you would consult the Secretary of the Interior if you wanted to use the "Johnny Horizon" character or name or "The Golden Eagle Insignia." If this doesn't seem practical or problems arise, you should get help from your own attorney.

State statutes also protect many badges, names, or insignia of governmental agencies and various orders and societies (such as the United States Spanish War Veterans, Veterans of Foreign Wars of the United States, the American Legion, and so on). As a general rule, if you are going to make use of any insignia belonging to a private group or governmental body, you should check in advance to be certain you are not violating the law. Contacting the group is a good way to start, but ultimately you may again want advice from your attorney.

Coins, Bills, and Stamps

Counterfeiting statutes limit the freedom with which you can reproduce currency and stamps. The purpose of the counterfeiting statutes, of course, is to prevent people from passing off fake currency or stamps. Because of this, you can probably make copies as long as you are certain there is no chance of the copies being mistaken for real currency or stamps.

However, to be completely safe, you would be wise to follow the restrictive guidelines that have been set out in the law. Printed photographs of paper money, checks, bonds, and other obligations and securities of the United States and foreign governments are permissable for numismatic, educational, historical, and newsworthy purposes, and for numismatic advertising (but not for general advertising purposes). In the permissible cases, the printed photographs must be in black-and-white and either less than three-quarters or more than one and a half times the size of the photographed currency. The photograph should directly relate to the permissible purpose and not simply be used because it is decorative or eye-catching.

Films, microfilms, and slides of paper money, checks, bonds and so on can be made in color or black-and-white for projection on a screen or broadcasting. They cannot be used in advertising, however, except for numismatic advertising. Nor can any prints or reproductions be made from the film or slide without the permission of the Secretary of the Treasury.

Photographs of canceled or uncanceled United States postage stamps are permissible for philatelic, educational, historical, and newsworthy purposes in articles, book, journals, newspapers, or albums. Black-and-white photographs may be of any size, as may color photographs of canceled stamps. However, color photographs of uncanceled stamps must be either less than three-quarters or more than one and a half times the size of the actual stamp. For uncanceled foreign stamps, the same restrictions apply as to permissible uses. Black-and-white photographs of uncanceled foreign stamps may be of any size, but color photographs must meet the same size limitations as photographs of uncanceled United States stamps. Also, while philatelic advertising is permitted, the size limitations must be met for color photographs of either United States or foreign stamps that have not been canceled. Cancellation, by the way, requires an official cancellation—the stamp must actually have been used for postage.

Films, microfilms, and slides of both United States and foreign

stamps may be in either black-and-white or color for projection or broadcasting. However, advertising in such cases is still limited to philatelic purposes.

Once the photograph of currency or a stamp has been used, the plate and negatives, including any glossy prints, should be destroyed.

You may notice that coins aren't mentioned at all. This is because photographs, films, or slides of United States or foreign coins may be used for any purposes including advertising. Such photographs of coins don't present the type of risk that the counterfeiting statutes are designed to guard against.

The United States Secret Service has responsibility for enforcing the laws relating to counterfeiting. Its representatives will give you an opinion as to whether the particular use you intend to make is legal, but their opinion would not prevent a later prosecution by either the Department of Justice or any United States Attorney. The address for obtaining such an opinion is Office of the Director, United States Secret Service, Department of the Treasury, Washington, D.C. 20223.

Deceptive Advertising

The Federal Trade Commission Act, passed in 1914, provides that "unfair methods of competition are hereby declared unlawful." One of the important areas in which the Federal Trade Commission has acted is misleading or false advertising. If you work for advertising agencies, the total impression of the advertisement must not be false or misleading. While some puffery of or bragging about products is permitted, the advertisement must not confuse even an unsophisticated person as to the true nature of the product. It isn't difficult to imagine how photography can be used to mislead. One example would be the use of props that don't fairly represent the product, such as a bowl of vegetable soup with marbles in the bottom of the bowl to make the vegetables appear thicker. This isn't permissible. On the other hand, the advertising agency doesn't want to create trouble for its client. So in most cases the agency's legal staff will take the necessary steps to ensure the advertising is not misleading or deceptive.

Aside from the activities of the Federal Trade Commission, there are a number of ways that advertising is controlled. Other federal laws govern the advertising and labeling of a number of specific products. State laws form a patchwork of regulations over different products. The Council of Better Business Bureaus has adopted its own *Code of*

Advertising to ensure that fair standards are followed. Many individual industries have set standards to govern the advertising of their products, although the application of these standards to local distributors or dealers can be difficult. Often the media that sell advertising will refuse to accept advertisements that are not considered in good taste. And self-regulation by individual advertising agencies has recently been followed by the creation of the National Advertising Review Council.

The Council's purpose is "to develop a structure which would effectively apply the persuasive capacities of peers to seek the voluntary elimination of national advertising which professionals would consider deceptive." The Council is composed of the Council of Better Business Bureaus and three groups representing the advertising industry—the American Advertising Federation, the American Association of Advertising Agencies, and the Association of National Advertisers. The Council has an investigative division (the National Advertising Division of the Council of Better Business Bureaus) and an appeals division (the National Advertising Review Board). However, it cannot force an advertiser to stop making deceptive claims; it can only bring peer pressure to bear.

A typical case involved an advertisement for dog food that photographically depicted "tender juicy chunks" that appeared to be meat but in actuality were made from soybeans. The investigative division demanded that the deceptive advertising be corrected. After sufficient time for a response had passed without the division's hearing from the dog food company, officials referred the matter to the appeals division. After the referral, however, the dog food company did respond and stated that the advertising in question had been changed to eliminate the elements found to be deceptive. Because of this, the appeals division dismissed the complaint. This is a good illustration of the disposition of a typical complaint.

Most advertising agencies want to avoid problems as much as you do. You should be able to rely on their expert attorneys for guidance in any area that raises questions. And if you truthfully present the product, you certainly shouldn't have anything to worry about.

Photographing in Courtrooms

Photography is being permitted in more and more courtrooms across the country. Concern about the effect of such filming, photography, and broadcasting is still expressed by many attorneys, and some jurisdictions even forbid photographing anywhere in court

buildings. However, many states have now enacted either permanent or experimental rules permitting the coverage of court proceedings. These rules vary with each court. The best way to find out whether cameras are allowed is to contact the clerk of the court in which you wish to photograph. If he or she advises you that cameras are permitted, you'll also be able to find out all the applicable conditions and rules.

CHAPTER 14

Choosing a Lawyer

WHAT DO YOU DO when you need a lawyer? You've been handed a contract and don't want to try to navigate through the legalese without some expert advice. Or you opened your favorite magazine and saw one of your photographs, which was very nice except that you never got paid by the magazine or by anybody else. Or somebody smacked into your car and the insurance company doesn't want to settle. Or you've just had your first child and are wondering whether you need a will.

Of course, many photographers already have a lawyer and are pleased with his or her performance. But what if you don't have a lawyer; where do you turn? That depends on the nature of your legal problem. This is a time of greater and greater specialization in the field of law. You have to evaluate whether your problem needs a specialist or can be handled by a lawyer with a general practice. For example, suppose you haven't been paid for an assignment you successfully completed. Any lawyer with a general practice should be able to handle this for you. What if you've been offered a book contract for a collection of your photographs? Here you'd be wise to find a lawyer with a special understanding of copyright law and the publishing field. Or you think that you should draft your will. Do you have a lot of assets, including special property in the form of negatives and transparencies, or do you have a very modest estate? If your estate is complex, you'll want to use an estate planning specialist, particularly if you're concerned about who will own your photographs and how they will be treated after your death. But if your estate is modest and you're not especially concerned about what happens to your photographs, a general practitioner should be able to meet your needs.

One implication of legal specialization, by the way, is that you may not use the same lawyer for each legal matter you have to solve.

On the other hand, if you have a good relationship with your regular lawyer, he or she should direct you to specialists when you need them. This is probably the best way of making sure you have access to the expertise that is called for.

Lawyer's Fees

Before discussing ways of contacting the lawyer you need, it's worthwhile to stop a moment and discuss the cost of legal services. You *can* afford these services. In the long run, using lawyers at appropriate times will save you money and, quite possibly, a lot of anguish.

How do you find out what a lawyer charges? Ask! If you're worried about paying for that first conference, ask on the phone when you call. If you're worried about what the whole legal bill will run, get an estimate the first time you sit down with the lawyer. Keep in mind that some lawyers will work on a contingency arrangement if you can't afford to pay them. This means that they will take a percentage of the recovery if they win but not charge you for their services if they lose. Or they may combine a flat fee with a contingency or require you to pay the expenses but not pay for their time. Some will even barter legal services for photographs. In other words, it isn't all cut and dried.

And you don't necessarily need a law firm with five names in the title—maybe a legal clinic can do the trick or one of the volunteer lawyers for the arts groups. So let's move ahead to the problem of contacting the right lawyer for you.

Informal Referrals

Ask a friend, another photographer, or your uncle who won that lawsuit the summer before last. People usually know when they've received good legal service. If your problem is similar to theirs, their lawyer may be right for you. You certainly know other professionals in the photography business. If you start asking them, you'll probably come up with a good lead.

This may not sound scientific, but it's the way most people do find lawyers and it's not a bad way. It gives you a chance to find out about the lawyer's skills, personality, and fees. It gives you confidence because the recommendation comes from someone you know and trust. Of course, when you talk to the lawyer, make sure that he or she is the right person for your special problem. If he or she hasn't

handled a case like yours before, you may want to keep looking. Or if a particular lawyer doesn't feel your problem is what he or she handles best, you should request a referral to another lawyer.

Volunteer Lawyers for the Arts

All across the country lawyers are volunteering to aid needy photographers, writers, composers, and other artists. There's no charge for these legal services, but you have to meet certain income guidelines and, perhaps, pay the court costs and any other expenses. If you qualify that's great, but even if you don't qualify for free help you may get a good referral to someone who can help you.

Rather than listing all the volunteer lawyers groups, we're giving you the names of three of the most active. You can call the group nearest you to find out whether there are any volunteer lawyers for the arts in your own area.

Bay Area Lawyers for the Arts
Fort Mason Center Building 310
San Francisco, California 94123
(415) 775-7200

Lawyers for the Creative Arts
111 North Wabash Avenue
Chicago, Illinois 60602
(312) 263-6989

Volunteer Lawyers for the Arts
36 West 44th Street
New York, New York 10036
(212) 575-1150

Professional Associations

We can't emphasize enough the value of belonging to an appropriate professional organization of photographers. But whether or not you belong, you might still try contacting such an organization in your area to ask for a lawyer who understands photographers' legal problems. The society's members have probably had a problem similar to yours at one time or another. The executive director or office manager should know which lawyer helped that member and

how the matter turned out. If they can't give you a name immediately, they can usually come up with one after asking around among the members. Needless to say, you're going to feel more comfortable asking if you belong to the organization. Professional organizations are listed on pp.233-234.

Legal Clinics

Legal clinics are easy to find, since they advertise their services and fee schedules in media such as newspapers and the Yellow Pages, where they are listed under "Attorneys" or "Lawyers." Another good way to find a clinic is through your network of friends and acquaintances, some of whom have probably either used a clinic or know of one to recommend. In many ways, a clinic is just like any other law firm. The good clinic, however, will have refined its operation so it can handle routine matters efficiently and in large volume. This allows the institution of many economies, such as using younger lawyers and paralegals (who are assistants with the training necessary to carry out routine tasks in a law office), having forms and word processing equipment, and giving out pamphlets to explain the basic legal procedures relevant to your case. Not all clinics, by the way, call themselves "clinics." They may simply use a traditional law firm name but advertise low-cost services based on efficient management.

What types of matters can the legal clinic handle for you? Divorce, bankruptcy, buying or selling real estate, wills, and other simple, everyday legal problems. What types of problems should you not take to a clinic? The complicated or unusual ones, such as book contracts, invasion of privacy suits, questions about copyright, and so on. The clinic can be efficient only when it handles many cases like yours. The special problems faced by the photographer will not be the problems the clinic can handle best. And if you're wondering whether there are legal clinics specially designed for photographers and other creators of artistic works, the answer is not yet. But it's not a bad idea, especially for an urban area where many photographers earn their livelihood.

Lawyer Referral Services

A lawyer referral service is usually set up by the local bar association. It can be found in the Yellow Pages under "Lawyer Referral Service." If it's not listed there, check the headings for "Attorneys" and "Lawyers." If you still can't find a listing, call your

local or state bar association to find out whether such a lawyer referral service is being run for your area.

Unfortunately, the 300 local referral services are not of uniform quality. Two criticisms are usually levied against them: first, their not listing lawyers by area of specialty and, second, their listing lawyers who need business rather than the best legal talent available. Even referral services that do list lawyers by specialty may not have a category that covers photographers' unique needs.

But the advantages of a good referral service shouldn't be overlooked. A good service puts you in touch with a lawyer with whom you can have a conference for a small fee—$10 or $15. If you don't like that lawyer, you can always go back to the service again. Some services do assign lawyers on the basis of specialty and, in fact, send out follow-up questionnaires to check on how the lawyers perform. This tends to improve the quality of the legal services. And a number of services require the lawyer to have malpractice insurance so you can recover if the lawyer is negligent in representing you. Such services are certainly another possible avenue for you to take in searching for a good lawyer.

Collection Agencies

While we're on the subject of lawyers, it's certainly worth briefly mentioning a few alternatives. If, for example, you are having trouble collecting some of your accounts receivable, you might consider using a collection agency. Such agencies are easy to find, since they're listed in the Yellow Pages. They will go after your uncollected accounts and dun them with letters, phone calls, and so on until payment is made. Payment for the agency is either a flat fee per collection (such as $8 for a debt under $75, $22 for a debt between $75 and $200, and so on) or a percentage of the amount recovered. These percentages vary from as little as 20 percent to as much as 45 percent. If the agency can't collect for you, you're right back where you started and need a lawyer.

What are the pros and cons of using collection agencies? On the plus side is the fact that you have a chance at recovering part of the money owed to you without the expense of hiring a lawyer. The negative side is the agency's fee and the fact that some agencies resort to unsavory practices. Needless to say, this may lose you clients in the long run. But a reputable collection agency may be able to aid you by recovering without the need to go to court.

Small Claims Courts

When small sums of money are involved and your claim is a simple one, using a lawyer may be too expensive to justify. Most localities have courts that take jurisdiction over small claims, those ranging from a few hundred dollars in some areas to a few thousand dollars in other areas, and you can represent yourself in these small claims courts. To find the appropriate small claims court in your area, look in the phone book under local, county, or state governments. If a small claims court is not listed there, a call to the clerk of one of the other courts is a quick way of finding out whether there is such a court and where it's located.

The procedure to use a small claims court is simple and inexpensive. Your filing fee will vary from about $3 to $15 depending on the locality. You fill out short forms for a summons and complaint. These include the defendant's accurate name and address, the nature of your claim stated in everyday language, and the amount of your claim. If you aren't sure of the defendant's exact business name and it isn't posted on the premises, the clerk of the county in which the defendant does business should be able to help you. The clerk will set a date for the hearing and send the summons to the defendant requiring an appearance on that date. If you have witnesses, you bring them along to testify. If the witnesses don't want to testify or if you need papers that are in the possession of the party you're suing, ask the court to issue a subpoena to force the witnesses to come or the papers to be produced. Of course, you bring along all the relevant papers that you have, such as confirmation forms, invoices, and so on.

The date for your hearing will probably be no more than a month or two away. Many small claims courts hold sessions in the evening, so don't worry if you can't come during the day. The judge or referee will ask you for your side of the story. After both sides have had their say, the judge will often encourage a settlement. If that's not possible, a decision will either be given immediately or be sent to you within a few weeks. The decision can be in favor of you or the other party or it can be a compromise. After winning, you may need the help of a marshall or sheriff to collect from a reluctant defendant, although most losers will simply put their check in the mail. Of course, the laws governing small claims courts vary from jurisdiction to jurisdiction, so it's helpful if you can find a guide specially written for your own court. Asking the clerk of the court is one way to find out whether such a guide exists. Or you might give a call to your Better Business Bureau or Chamber of Commerce.

Appendix A

Grants

THE MOST WIDELY KNOWN grant sources for photographers are the National Endowment for the Arts (NEA), Visual Arts Program, 2401 E Street N.W., Washington, D.C. 20506, (202) 634-6369; The John Simon Guggenheim Memorial Foundation, 90 Park Avenue, New York, New York 10020, (212) 687-4470; and a few state supported funds including New York's Creative Artists Public Service Program (CAPS), 250 West 57 Street, New York, New York 10019, (212) 247-6303; and in Massachusetts, Artists Foundation Inc., 100 Boylston Street, Boston, Massachusetts 02116, (617) 482-8100.

While annual grants from these organizations attract wide attention, the amounts of money involved are usually modest ($3,000 to 12,000 per person) and the number of individuals winning awards is quite low. (About 75 per year for all the above programs, out of thousands of applicants.)

In fact, these sources represent only a tiny fraction of the *potential,* but largely untapped, funding sources for photographers. Finding and attracting the hidden grant sources, however, requires much more sophistication than filling out a form and sending it to the NEA or CAPS.

Two factors are at work here. First, for a variety of tax reasons, most foundations are obliged to lend support *only to nonprofit organizations.* They are usually not structured to provide help to individuals. Second, the foundation world's interest in photography *per se* is probably minimal. Nonetheless, there is often genuine interest in photographic documentation relating to a foundation's special interest (health care, urban decay, the environment, and so on).

Entirely new approaches to grant getting have emerged from this situation. In one format we see groups of individual photographers joining together to form a nonprofit corporation set up in order to document an important aspect of the social or environmental scene. They then seek help from a foundation known to be interested in that specific area.

The basic tool they use in this connection is *The Foundation Grants Index,* published by The Foundation Center, 888 Seventh Avenue, New York, New York 10019, (212) 975-1120 ($27). This invaluable book lists alphabetically some 400 United States foundations that made over 19,000 specific grants of $5,000 or more in the past year and indicates the specific purpose and nature of each such grant. The back of the book is even more

important. It provides a subject index of all those grants. Using that index, you can find each foundation that, during the past year, supported the subject you are interested in. You will know how much they gave and for what type of project.

A number of examples of photographers successfully establishing nonprofit organizations in this fashion are provided by Lida Moser in her book *Grants in Photography—How to Get Them* (New York: Amphoto, 1978). The book also contains other useful information about "grantsmanship."

Another new approach is to work with an established scholar who can utilize his or her university (therefore nonprofit) affiliation to secure foundation grants. In one such project a photographer and sociologist secured foundation funding for documentation of urban growth and change in Texas, with the funds channeled through the sociologist's university. Again, *The Foundation Grants Index* supplied information about which foundations might be receptive to a project of this nature.

In sum, two basic systems for grant getting have emerged. The first and most common is through application to the NEA or one of the state agencies (there are more than 20) that support the artistic pursuits of their residents. A complete list of all the state arts agencies and an indicator of which ones provide grants to individuals is available from *American Council for the Arts* (ACA), 570 Seventh Avenue, New York, New York 10018, (212) 354-6655. The Council also publishes a number of other titles relating to fund raising and the arts that could be of interest to photographers. Closely related to governmental support are individual awards from a few traditional sources such as The Guggenheim Foundation. These sources are set forth in the book *Grants in Photography—How to Get Them,* referred to above.

The second and newer approach is photographers' seeking support based on the documentary rather than on the purely artistic value of the project. This requires foundation support channeled through the photographer's own nonprofit group or through a university or other affiliation (usually on behalf of a scholar associated with the project). In either event the basic research tool becomes *The Foundation Grants Index* published by The Foundation Center.

The Foundation Center at 888 Seventh Avenue, New York, New York 10019, (212) 975-1120, is a free library of information about all aspects of philanthropic activity. It contains detailed reports on foundations, their activities, directors, and so on. It also has most of the important research books in the field. The Center has national libraries in New York City and Washington, D.C. In addition, it has field offices in Chicago, Cleveland, and San Francisco. Finally, its materials can also be found at an array of some 60 cooperating institutions and libraries throughout the country. The Center will, upon request, provide you with the name and address of the facility nearest you.

Appendix B

Professional Organizations and Associations

American Society of Magazine Photographers (ASMP)
205 Lexington Avenue, New York, New York 10016, (212) 889-9144. Photographers working in communications media including advertising, industrial, journalism, and related fields. Outside the New York National Office, ASMP has chapters in Atlanta, Boston, Chicago, Houston, Los Angeles, Philadelphia, San Francisco, and Seattle. Contact the New York office for details.

American Society of Photogrammetry
105 N. Virginia Avenue, Falls Church, Virginia 22046, (703) 534-6617. Photographers and others working in the field of photogrammetry.

American Society of Picture Professionals (ASPP)
Box 5283 Grand Central Station, New York, New York 10017. Photo researchers and photographers heavily involved in the use of stock photography.

Associated Photographers International
23024 Ardwick Street, Woodland Hills, California 91364
Box 206 Woodland Hills, California 91365, (213) 888-9270. Aids member photographers in locating certain freelance markets and provides information, publications, and some discounts.

Association of Federal Photographers
7210 Tyler Avenue, Falls Church, Virginia 22042, (703) 573-5448. Promotes the status and activities of photographers in federal employment.

Biological Photographic Association
Suite 112, 6650 Northwest Highway, Chicago, Illinois 60631. Specialists in the biomedical field.

California Press Photographers Association
Box 191, San Diego, California 92112, (714) 299-3131.

Evidence Photographers International Council
601 Brookview Court, Oxford, Ohio 45056, (513) 523-8092. Photographers employed in the civil evidence and law enforcement areas.

Industrial Photographers Association of New York (IPANY)
c/o Bruce Hoffman, U.S. Trust Company, 45 Wall Street, New York, New York 10005. (There are also a number of industrial photographers' organizations affiliated with the Professional Photographers of America—see below.)

International Center of Photography (ICP)
1130 Fifth Avenue, New York, New York 10028, (212) 860-1777. Primarily a leading cultural organization that also offers a number of seminars and courses that may be of interest to professionals.

International Photographers (IATSE)
Unit still photographers on motion picture and television productions.
Local 659: 7715 Sunset Boulevard, Hollywood, California 90046, (213) 876-0160.
Local 666: 327 S. LaSalle Street, Chicago, Illinois 60604, (312) 341-0966.
Local 644: 250 West 57th Street, New York, New York 10019, (212) 247-3860.

Joint Ethics Committee (JEC)
Box 179 Grand Central Station, New York, New York 10017. A mediation and arbitration body organized by visual arts organizations representing photographers, graphic artists, art buyers, and representatives. Acts to settle disputes when appointed by the parties. Serves metropolitan New York area and has developed a code of fair practice for the industry. Does not act as a collection agency.

National Press Photographers Association (NPPA)
Box 1146 Durham, North Carolina 27702, (919) 489-3700. Newspaper photographers and other photojournalists.

Overseas Press Club of America
52 East 41 Street, New York, New York 10017 (212) 679-9650. Members of the writing and photographic press.

Photographic Administrators, Inc. (PAI)
319 East 44 Street, New York, New York 10017, (212) 233-2605. Executives, administrators, and others associated with the photography field.

Professional Photographers of America (PPA)
1090 Executive Way, De Plaines, Illinois 60018, (312) 299-8161. Portrait, wedding, commercial, and industrial photographers. PPA has chapters and affiliates throughout the country in each of these disciplines. Contact the National Office for details.

Society of Photographers and Artists Representatives (SPAR)
Box 845, FDR Station, New York, New York 10022, (212) 832-3123. Photographers' and artists' representatives, primarily for the New York City area.

Society of Photographic Scientists and Engineers
1411 K Street NW, Washington, D.C., (202) 347-1140.

West Reps
Suite 102, 1258 North Highland Avenue, Los Angeles, California, (213) 469-2254. West Coast-based photographers' and artists' representatives.

BIBLIOGRAPHY A

Books

The page number at the end of an entry refers to a discussion of the work in the preceding text. Additional publishing information such as the date of publication, price and address of the publisher is included in that text discussion.

Marketing

A Survey of Motion Picture, Still Photography and Graphic Arts Instruction, Eastman Kodak Company, Rochester, New York (page 38).

American Showcase, American Showcase, New York, New York (pages 15 and 49).

American Universities and Colleges, American Council on Education, Washington, D.C. (page 12).

Art Director's Index to Photographers, John Butsch and Associates, Chicago, Illinois (page 49).

Audio-Visual Market Place, R.R. Bowker, New York, New York (page 11).

Business Publications, Standard Rate and Data Service, Skokie, Illinois (page 19).

Consumer Magazine and Farm Publications, Standard Rate and Data Service, Skokie, Illinois (page 18).

Contact Book, Celebrity Service, New York, New York (page 23).

Contract—Directory of Sources, Gralla Publications, New York, New York (page 34).

Decor "Sources" Annual, Commerce Publishing Company, St. Louis, Missouri (page 33).

Gebbie Press All-In-One Directory, Gebbie Press, New Paltz, New York (page 17).

Gift and Decorative Accessory Buyers Directory, Geyer McAllister Publications, New York, New York (page 32).

How to Start a Professional Photography Business, Ted Schwarz, Contemporary Books, Chicago, Illinois (page 25).

Interior Design Buyers Guide, Interior Design Publications, New York, New York (page 34).

L.A. Work Book, Alexis Scott, Los Angeles, California (pages 15 and 23).

Literary Market Place, R.R. Bowker, New York, New York (page 11).

Madison Avenue Handbook, Peter Glenn Publications, New York, New York (page 10).

Magazine Industry Market Place '80, R.R. Bowker, New York, New York (page 20).

Mail Order Business Directory, B. Klein Publications, Coral Springs, Florida (page 24).

Membership Directory, American Institute of Graphic Arts, New York, New York (page 14).

New York Publicity Outlets, Public Relations Plus, Washington Depot, Connecticut (page 20).

O'Dwyer's Directory of Corporate Communications, J.R. O'Dwyer Co., New York, New York (page 13).

O'Dwyer's Directory of Public Relations Firms, J.R. O'Dwyer Co., New York, New York (page 22).

Photographer's Market, Writer's Digest Books, Cincinnati, Ohio (pages 35 and 61).

Photography Market Place, second edition, Fred W. McDarrah, R.R. Bowker, New York, New York (pages 14, 21, 35 and 61).

Standard Directory of Advertisers, National Register Publishing Company, Skokie, Illinois (page 13).

Standard Directory of Advertising Agencies, National Register Publishing Company, Skokie, Illinois (page 9).

The Best Ever, Mead Corporation, Dayton, Ohio (page 15).

The Creative Black Book, Friendly Publications, New York, New York (pages 41, 48 and 58).

The International Buyer's Guide of the Music-Tape Industry, Billboard Publications, New York, New York, and Los Angeles, California (page 20).

The Photograph Collector's Guide, New York Graphic Society, Boston, Massachusetts (page 37).

Ulrich's International Periodicals Directory, R.R. Bowker, New York, New York (page 19).

Working Press of the Nation, Vol. V: Internal Publications Directory, National Research Bureau, Burlington, Iowa (page 16).

World Travel Directory, Ziff-Davis Publishing Company, New York, New York (page 23).

Business

IN GENERAL

ASMP Guide to Professional Business Practices in Photography, edited by Arie Kopelman, ASMP (American Society of Magazine Photographers), New York, New York (page 82).

Grants in Photography—How to Get Them, Lida Moser, Amphoto, New York, New York (page 232).

Legal Guide for the Visual Artist, Tad Crawford, Hawthorn Books, New York, New York (pages 153 and 184).

Photographic Dealers and Studios, United States Small Business Administration, Washington, D.C. (page 130).

Photography for the Professionals, Robin Perry, Livingston Press, Waterford, Connecticut.

The Blue Book of Photography Prices, Thomas I. Perrett, Photography Research Institute Carson Endowment, Carson, California (page 82).

The Foundation Grants Index, The Foundation Center, New York, New York (page 231-232).

The Writer's Legal Guide, Tad Crawford, Hawthorn Books, New York, New York (page 110).

TAXES

Child Care and Disabled Dependent Care, Internal Revenue Service, Washington, D.C. (page 148).

Computing Your Tax Under the Income Averaging Method, Internal Revenue Service, Washington, D.C. (page 149).

Protecting Your Heirs and Creative Works, Tad Crawford, editor, Graphic Artists Guild, New York, New York (page 153).

Fear of Filing, Volunteer Lawyers for the Arts, New York, New York (page 154).

Information on Self-Employment Tax, Internal Revenue Service, Washington, D.C. (page 149).

J.K. Lasser's Your Income Tax, Simon & Schuster, New York, New York (page 154).

Legal Guide for the Visual Artist, Tad Crawford, Hawthorn Books, New York, New York (pages 153 and 184).

Questions and Answers on Retirement Plans for the Self-Employed, Internal Revenue Service, Washington, D.C. (page 148).

Retirement Plans for Self-Employed Individuals, Internal Revenue Service, Washington, D.C. (page 148).

Tax Guide for Small Business, Internal Revenue Service, Washington, D.C. (page 153).

Tax Information on Individual Retirement Savings Programs, Internal Revenue Service, Washington, D.C. (page 148).

Tax Withholding and Declaration of Estimated Tax, Internal Revenue Service, Washington, D.C. (page 150).

The Tax Reliever: A Guide for the Artist, Richard Helleloid, Drum Books, St. Paul, Minnesota (page 154).

Travel, Entertainment and Gift Expenses, Internal Revenue Service, Washington, D.C. (page 145).

Your Federal Income Tax, Internal Revenue Service, Washington, D.C. (page 139).

Legal

Copyright Information Kit, United States Copyright Office, Library of Congress, Washington, D.C. (page 185).

Legal Guide for the Visual Artist, Tad Crawford, Hawthorn Books, New York, New York (pages 153 and 184).

Photography and the Law, fifth edition, George Chernoff and Hershel B. Sarbin, Amphoto, New York, New York.

Photography—What's the Law?, revised edition, Robert M. Cavallo and Stuart Kahan, Crown Publishers, New York, New York.

The Visual Artist's Guide to the New Copyright Law, Tad Crawford, Graphic Artists Guild, New York, New York (page 185).

The Writer's Legal Guide, Tad Crawford, Hawthorn Books, New York, New York (page 110).

BIBLIOGRAPHY B

Periodicals

Commercial Arts and Print Media Communications

Among the magazines reproducing exceptional results of work done for clients there are certain areas of emphasis. For *CA—Communication Arts* it is often corporate media, for *Art Direction* usually advertising, for *Print* editorial illustration. Nonetheless, all these publications review a wide spectrum of commercial work in most of the related areas.

In addition, *U&lc* covers the creative use of typography (occasionally in conjunction with photography), *Push Pin Graphic* focuses on conceptual issues in illustration, design and, more recently, photography and *Graphics New York* and *Graphics U.S.A.* provide short notes on the doings of art directors and designers including some job and account changes.

Art Direction, Room 802, 19 West 44 Street, New York, New York 10036 (212) 354-0450.

CA—Communication Arts, P.O. Box 10300, Palo Alto, California 94303 (415) 326-6040.

Graphics New York, 120 East 56 Street, New York, New York 10022 (212) 759-8813.

Graphics U.S.A., 120 East 56 Street, New York, New York 10022 (212) 759-8813.

Print, 355 Lexington Avenue, New York, New York 10016 (212) 682-0830.

Push Pin Graphic, 67 Irving Place, New York 10003 (212) 674-8080

U&lc, 2 Hammarskjold Plaza, New York. New York 10017 (212) 371-0699.

Photographic Art, Technique, and General Interest

One of the more interesting developments in recent years is the appearance of *American Photographer*, whose audience appears to tend toward the professional and highly accomplished amateur. This has not, however, affected the major standing of widely distributed magazines such as *Popular Photography*, *Modern Photography*, and *Petersen's Photographic*, which primarily serve advanced amateur enthusiasts. *Camera 35—Photo World* remains active in publishing portfolios of the better talents and reprints some of the color photography appearing in the French publication

Photo. In the more "art"-oriented realm, *Aperture* in the United States and *Camera* from Switzerland maintain traditional renown. *Zoom* and *Photo* published in France and *Picture* from California provide somewhat more off-beat material. (Both *Zoom* and *Camera* have English-language editions.) The latest entry in the field is *Darkroom Photography.*

American Photographer, 1515 Broadway, New York, New York 10036 (212) 975-7911.

Aperture, Elm Street, Millerton, New York 12546 (518) 789-4491.

Camera, c/o European Publishers, 11-03 46 Avenue, Long Island City, New York 11101 (212) 937-4606.

Camera 35—Photo World, 714 Fifth Avenue, New York, New York 10019 (212) 582-9510.

Darkroom Photography, 609 Mission Street, San Francisco, California 94105 (415) 543-8020.

Modern Photography, 825 Seventh Avenue, New York, New York 10019 (212) 265-8360.

Petersen's Photographic, 8490 Sunset Boulevard, Los Angeles, California 90291 (213) 657-5100.

Photo, 65 Champs-Elysées, Paris 75008, France.

Picture, 4121 Wilshire Boulevard, Suite 110, Los Angeles, California 90010 (213) 386-6083.

Popular Photography, 1 Park Avenue, New York, New York 10016 (212) 725-3500.

Zoom, c/o European Publishers, 11-03 46 Avenue, Long Island City, New York 11101 (212) 937-4606.

Photographic Business and Trade

Free-lance Art Monthly, P.O. Box 332B, Wheeling, Illinois 60090 (312) 251-0790. Marketing and business tips; reproduces photographers' portfolio pieces.

Industrial Photography, 475 Park Avenue South, New York, New York 10016 (212) 725-2300.

International Photography, Eastman Kodak Co., 343 State Street, Rochester, New York 14650 (716) 724-3962. Kodak's liveliest picture magazine.

News Photographer, Robert Brush, 43 Paula Drive, Bergenfield, New Jersey 07621. Journal of the NPPA (National Press Photographers Association).

Photo Letter, Osceola, Wisconsin 54020 (715) 248-3800. Market tips and calls for stock photos.

Photo Methods, 1 Park Avenue, New York, New York 10016 (212) 725-3500.

Professional Photographer, 1090 Executive Way, Des Plaines, Illinois 60018 (312) 298-4680. Journal of the PPA (Professional Photographers of America).

Rangefinder, 1312 Lincoln Boulevard, Santa Monica, California 90406 (213) 451-8506. Articles on marketing and technical subjects.

Shutterbug Ads, Box 730, Titusville, Florida 32780 (305) 269-3660. Classifieds to buy and sell equipment and services.

Simon Says: Photography Newsletter, 316 West 79 Street, New York, New York 10024 (212) 873-5978. Independent technical and equipment reports.

Studio Light, Eastman Kodak Co., 343 State Street, Rochester, New York 14650 (716) 724-3962. Kodak's picture magazine for active studio photographers.

Studio Photography, 250 Fulton Avenue, Hempstead, New York 11550 (516) 489-1300. For portrait, commercial, and wedding photographers.

Technical Photography, 250 Fulton Avenue, Hempstead, New York 11550 (516) 489-1300.

Underwater Photographer, Box 608, Dana Point, California 92629.

About the Authors

ARIE KOPELMAN served for five years as executive director of the American Society of Magazine Photographers (ASMP) and is the editor of their book *Professional Business Practices in Photography.* Currently General Counsel for the Society of Illustrators, he devotes his New York law practice to the business and legal problems of photographers and other visual artists. He is also an Honorary Trustee of the American Society of Picture Professionals.

TAD CRAWFORD serves as General Counsel for the Graphic Artists Guild. Author of the books *Legal Guide for the Visual Artist* and *The Writer's Legal Guide,* he teaches courses on art law at the School of Visual Arts and lectures frequently on related topics throughout the country. He also serves on the Board of Directors of the Foundation for the Community of Artists.

Both authors have been instrumental in creating courses and weekend seminars on the subject of business guidance for photographers and other visual artists under the sponsorship of the Graphic Artists Guild in New York City. They are currently collaborating on a book titled *Selling Your Graphic Design and Illustration* for publication by St. Martin's Press in 1981.

Index